FORMULA 1 CARS

Published by Collins
An imprint of HarperCollins Publishers
1 Robroyston Gate
Glasgow
G33 1JN
collins.reference@harpercollins.co.uk
collins.co.uk

HarperCollins Publishers
Macken House
39/40 Mayor Street Upper
Dublin 1
D01 C9W8
Ireland

First published 2025

© HarperCollins Publishers 2025

Collins® is a registered trademark of HarperCollins Publishers Ltd

All rights reserved. No part of this publication may be reproduced, stored in a retrieval system, or transmitted, in any form or by any means, electronic, mechanical, photocopying, recording or otherwise without the prior permission in writing of the publisher and copyright owners.

Without limiting the exclusive rights of any author, contributor or the publisher, any unauthorised use of this publication to train generative artificial intelligence (AI) technologies is expressly prohibited. HarperCollins also exercise their rights under Article 4(3) of the Digital Single Market Directive 2019/790 and expressly reserve this publication from the text and data mining exception.

The contents of this publication are believed correct at the time of printing. Nevertheless the publisher can accept no responsibility for errors or omissions, changes in the detail given or for any expense or loss thereby caused.

HarperCollins does not warrant that any website mentioned in this title will be provided uninterrupted, that any website will be error free, that defects will be corrected, or that the website or the server that makes it available are free of viruses or bugs. For full terms and conditions please refer to the site terms provided on the website.

A catalogue record for this book is available from the British Library

ISBN 9780008711030

10 9 8 7 6 5 4 3 2 1

Printed in India

This book contains FSC™ certified paper and other controlled sources to ensure responsible forest management.

For more information visit: www.harpercollins.co.uk/green

FORMULA 1 CARS

The greatest F1 cars from 1950 to the present day

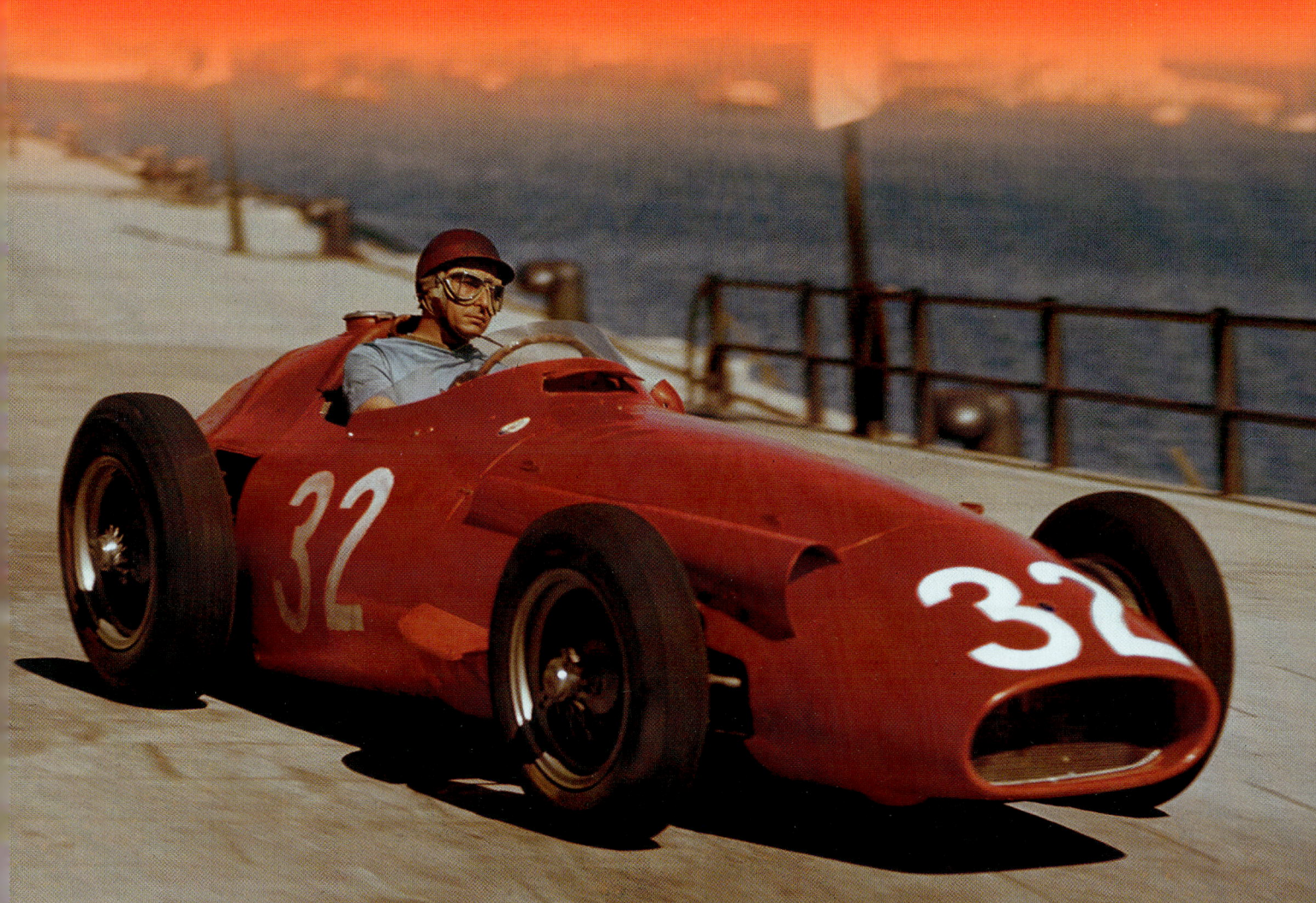

MAURICE HAMILTON

CONTENTS

Foreword	6	Renault RS10	136
Introduction	8	Ligier-Ford JS11	140
Alfa Romeo 158	10	Williams-Ford FW07	144
Mercedes-Benz W196	14	Brabham-Ford BT49C	150
Lancia D50	18	McLaren-Ford MP4	154
Maserati 250F	24	Brabham-BMW BT52	160
Vanwall VW4	30	McLaren-TAG MP4/2	164
Ferrari Dino 246	36	Williams-Honda FW11	168
Cooper T51	40	McLaren-Honda MP4/4	174
Ferrari Dino 156	44	Ferrari 640	180
BRM P57	48	Williams-Renault FW14B	186
Lotus-Climax 25	52	Benetton-Ford B194	192
Honda RA272	58	Williams-Renault FW18	196
Brabham-Repco BT19/BT20	62	McLaren-Mercedes MP4-13	200
Eagle-Weslake AAR-103	68	Jordan-Mugen Honda 199	204
Lotus-Ford 49	72	Stewart-Ford SF3	208
McLaren-Ford M7A	78	Ferrari F2004	212
Matra-Ford MS80	82	Renault R25	218
March-Ford 701	86	McLaren-Mercedes MP4-23	222
Lotus-Ford 72	90	Brawn-Mercedes BGP001	226
Tyrrell-Ford 003	96	Red Bull-Renault RB9	230
McLaren-Ford M23	102	Mercedes W11	234
Ferrari 312T	108	Red Bull-RBPT RB19	240
Tyrrell-Ford P34	114	McLaren-Mercedes MCL38	246
Wolf-Ford WR1	118	Index	250
Lotus-Ford 79	122	References	255
Brabham-Alfa Romeo BT46B	128	Image credits	255
Ferrari 312T4	132	Acknowledgements	256

FOREWORD BY MARTIN BRUNDLE OBE

Formula 1 cars are, in many ways, a personal thing, a landmark in your life. In my case – whether I've been racing them, watching from trackside, or commentating – various F1 cars have become etched in my mind. They mean something, and that can be because they're part of a great moment in motor racing history, or a personal memory that makes us smile. Racing cars have the power to do that. They're a living, breathing thing; each with its own performance capabilities, achievements, and striking appearance.

I've been fortunate enough to get behind the wheel of 70 F1 cars, and counting. Many of them are in this book and cover a period of 75 years. As you will see, a lot has changed in racing car design, but the one common factor when driving a thoroughbred F1 car – be it in an actual race, or up the hill at the Goodwood Festival of Speed, or as part of a piece for Sky F1 – is that successful cars all have an inherent sense of balance and driveability. They just 'work'. It's immediately a partnership, and they are a joy to drive.

When I was racing, my main job seemed to be stopping many of the cars I drove from crashing. It's not like that with the dominant machines of their era. The older generation of racing car may move around a lot more, but they slide in a balanced unison. They don't want to fight you. They're easy to get on with, so much so that there have been times when, with the TV cameras rolling, I'd simply jump in, set off and start voice recording inside my crash helmet without having to worry about wrestling the car or wondering what it's going to do next.

That, to me, defines a great racing car. This applies across the decades, from Juan Manuel Fangio's 1954 W196 streamliner to the more recent Mercedes-Benz that Lewis Hamilton used to win the championship in 2018.

Which is the best of the great cars I've driven? Lewis's 2008 McLaren-Mercedes MP4/23 was memorable because it produced tremendous grip and confidence, mainly due to, in simple terms, being one massive aerodynamic tunnel, as permitted by the regulations of the day.

When it comes to the most beautiful single seater of all time, Dan Gurney's Eagle-Weslake V12 wins it for me. I'd always wanted to drive that car, but when my chance came at Goodwood, I struggled to reach the pedals. They had to put loads of foam padding behind me in the cockpit thanks to the car being designed around Dan – who stood 193 cm (6 foot 4 inches) in his flameproof socks.

The Maserati 250F is often cited as being one of the most elegant F1 cars. When I drove that one, I had no trouble reaching the pedals – but the problem was remembering that, highly unusually, the throttle was in the middle and the brake pedal on the right.

Getting comfortable in Ayrton Senna's McLaren-Honda MP4/4 was not easy either. This was a really tight fit but, once behind the wheel, the experience was unforgettable. Apart from the MP4/4 looking and sounding fabulous, I drove it at Interlagos which, of course, was Ayrton's home track. It was incredible. The passionate crowd loved it and even seasoned F1 people were hanging off the pit wall and enjoying the moment as this iconic car came past screaming at full throttle.

I raced against Ayrton in a Benetton-Ford B192, one of my favourite cars. The B192 is not actually in this book because, although it did win races, it was eventually superseded by the championship-winning B194 of 1994, by which time I was at McLaren. Driving the B194 is on my wish list, mainly because I recall the B192 so fondly.

As I mentioned earlier, personal memories such as these are a fundamental part of being imbued with motor racing, whether it's through going wheel-to-wheel with some of these cars and drivers, or having watched them relentlessly winning and creating a stepping stone in my journey through motor sport.

No matter which driver you supported, every great car they sat in has a fascinating back story. It's a pleasure to see them gathered between the covers of one book. Enjoy this trip down memory lane.

INTRODUCTION BY MAURICE HAMILTON

Even the swiftest glance at a Formula 1 car can roughly determine which era it came from. The technical diversity and progress generated by 75 years of Grand Prix racing has been clearly defined by the shape of the cars gracing the following pages. The physical change has been massive and yet the sense of purpose behind each example remains both permanent, and possessing the same emotive influence on grinning on-lookers.

The fastest F1 car of the day continues to be exactly that. A combination of guttural sound and tingling performance has the same effect regardless of whether the driver, in his linen headgear, can be seen wrestling the large steering wheel, or whether he is deep within the all-enveloping cockpit of an aerodynamic missile, cornering at mind-boggling speed.

Each car is outstanding in its own period and within the admiring minds of spectators, some of whom might not necessarily be immersed in the sport. As a result, every single one of the 50 iconic racing cars in this book will prompt a warm memory somewhere; the recall, perhaps, of a moment when the sound and fury of the automotive art in question sparked the realisation that Grand Prix racing is something special. And from that, the growth of hero worship of a particular driver; so much so that a single image can instantly trigger warm memories of a racing superstar taking that car to the limit – and sometimes beyond the maximum its designer thought possible.

For that reason, these F1 classics are in chronological sequence rather than attempting the prejudicial folly of arranging them in some sort of order of merit. Had the latter been the case, the Lotus-Ford 49 would have been my number 1, not only because of its revolutionary make-up, clean lines and far-reaching effect on F1's future, but also because it was driven by the incomparable Jim Clark, whom I saw win his last race in the UK with the Lotus 49 before his untimely death nine months later in April 1968. F1 cars may be, in essence, a collection of finely honed parts, but they are sentimental symbols for many.

When HarperCollins first mooted the idea for this book, we wondered how many cars there were likely to be. When 50 was suggested as a meaningful number, an initial thought was that I might be hard-pressed to find that many worthy of inclusion. It turned out to be quite the reverse, the problem – a nice one to have, admittedly – being that interesting arguments could be put forward for one or two that have been omitted from these pages. Equally, it could be claimed that the March 701 is scarcely a great F1 car in the strictest sense. But it was a highly significant one on the simple pretext that it was there at all, given the outrageous ambition of the team's founders. And the March 701 did win a Grand Prix, which is the common denominator among the 50.

During the course of research and writing – always a delight since I have had the pleasure of seeing all but nine of these cars actually race – it became apparent that the various back stories provided a broad chronology of Formula 1. This is demonstrated by the rapidly advancing technology, the recognition of a relentless quest for safety, and the changing circumstances in which the cars raced.

Jack Brabham's British Grand Prix winning Cooper-Climax T51 would have been overseen by a team numbering no more than ten in total and taken in a van from Surbiton in Surrey to the race track at Aintree. Sixty-five years later, more than 250 trucks were required to transport the cars and trappings associated with the pair of McLaren-Mercedes MCL38s raced by Lando Norris and Oscar

Piastri at Silverstone. There was an operational trackside team of 58 people – only because that was the cost-cutting limit imposed on the number of personnel at the races. In excess of ten times that number remained at McLaren's HQ in Woking. But the prime objective of the weekend – to win the Grand Prix – had not changed in the slightest through the decades. Back in the Fifties, F1 may have achieved that aim with less pomp and paraphernalia, but the race car has remained the high-tech focus of preparation and admiration, depending which side of the spectator fence you are on.

Of the thousands of different cars raced in Formula 1, the 50 gathered here have, in one way or another, done something special. Rather than take each one apart bolt by bolt, the accompanying narrative places these iconic machines in perspective by outlining their significance at the time. That includes detail of the wizards responsible for the design, and profiles of those skilled and fortunate enough to get behind the wheel. Martin Brundle OBE, with 158 Grands Prix starts to his credit, is one of the latter. I am extremely grateful for Martin agreeing to write the Foreword, largely because of his unique experience in so many of these cars and the ability - as enjoyed during his work covering approximately another 400 Grands Prix on Sky Sports F1 - to describe sensations most of us can only begin to imagine.

It has been an unparalleled pleasure simply watching these fabulous machines exploring the edge of performance. My hope is personal exhilarating moments will spring from the pages as you move through times when cars could be easily recognised by their shape rather than the advertising they carry.

Alfa Romeo 158

'In sentimental terms, the Alfetta was perhaps my favourite car because it gave me the chance to be World Champion for the first time.'

Juan Manuel Fangio

The Alfa Romeo 158 (and its derivative, the 159) is considered to be one of the most successful racing cars of all time. An extraordinary fact is that the design heritage stretched back to 1937. The outbreak of World War II prolonged its life to such an extent that the 158 – also known as the Alfetta (Little Alfa) – was still competitive 13 years later. The Alfetta had been a cut above the rest from the outset and its consistent performance was a tribute to the Italian team's ability, post war, to regroup and massage the red car into a majestic front-runner. When the Alfa Romeo 158 turned up at a race, it usually won. It also helped the Italian team to have drivers of the highest calibre, keen to get behind the wheel.

In 1950, motor sport's governing body, the FIA, created a world championship for drivers. The first race would be the British Grand Prix at Silverstone. Having spent a year away from racing, Alfa Romeo returned in force. Apart from the usual entry of three cars, Alfa Romeo brought along a fourth for Reg Parnell as a token of respect for the British driver and his home Grand Prix.

The cherry-red cars would completely dominate the event, with the entire Alfa Romeo team occupying the four-car-wide front row of the grid. They led from start to finish, occasionally engaging in a mock battle for a lead that was actually never in doubt, victory going to Giuseppe Farina, who had started from pole. The veteran driver Luigi Fagioli was second in his 158, with Parnell coming home third, almost a minute behind. The fourth Alfa Romeo blotted an immaculate copy book when Juan Manuel Fangio spun off and damaged an oil line, which caused the engine to fail.

Fangio and Farina would win three races each in 1950, with Farina becoming the first World Champion thanks to having scored more points. Alfa Romeo may have been unbeatable, but the writing was on the wall at the final race at Monza when a resurgent Ferrari team provided a serious threat that was ultimately stymied by a failure of their powerful but fragile V12 engine.

Alfa Romeo continued development of their supercharged eight-cylinder engine and, to all intents and purposes, nothing appeared to have changed when the cars from Milan won the first three Grands Prix of 1951. The status quo was upset at Silverstone, however, when José Froilán González gave Ferrari their first victory in a championship Grand Prix. The battle between Ferrari and Alfa Romeo went to the wire, with Fangio securing the championship at the final round. Alfa Romeo may have taken the title for the second year in succession but they knew as well as anyone that the British Grand Prix had been a major turning point. The days of the fabulous Alfetta had finally drawn to a close.

THE CAR

This straightforward car was originally designed in 1937 for Voiturette racing (effectively, a second division class of racing). At its heart was a twin overhead camshaft, straight-eight engine, initially delivering 195 bhp through a four-speed gearbox. The chassis was made of standard oval section tubes. The independent front suspension and rear swing-axle were similarly orthodox for the time. The 159, introduced in 1951, was a development of the 158 with a more powerful engine (405 bhp) and suspension modifications. A growing disadvantage was the supercharged engine's thirst for methanol fuel, with a return of 1.6 mpg requiring Alfa Romeo to make more pit stops than the increasingly competitive Ferraris during Grands Prix frequently lasting for more than 483 km (300 miles).

Engine	Alfa Romeo 8-cylinder in-line, supercharged
Size	1479 cc
Power	350 bhp
Weight	700 kg (1543 lb)
Wheelbase	2500 mm (90 in)

TEAM HISTORY

Alfa Romeo manufactured road cars in Italy and had been involved in motor racing since 1911. There is an irony in the fact that the 158, Alfa Romeo's most successful racing car, was born out of defeat. Having been regularly crushed by Mercedes-Benz and Auto Union in the Grands Prix,

Alfa Romeo switched to the lesser class, Voiturette racing. Even more surprising, perhaps, the 158 was conceived in the workshops of Enzo Ferrari, team manager since Alfa Romeo had outsourced their competitions department. When the relationship ended in 1938 and Ferrari went off in a huff, Alfa Romeo re-established their own racing department.

The 158 won its first race in 1938 and its last in 1951. When the Germans took control of northern Italy during World War II, the Grand Prix cars had been spirited to the village of Melzo where, legend has it, the 158s were hidden in a cheese factory. Throughout its lengthy history, the Alfetta suffered only three major defeats, one of which was Ferrari's breakthrough victory in the 1951 British Grand Prix. Alfa Romeo withdrew from Grand Prix racing at the end of that year.

Various F1 teams would use Alfa Romeo engines over the years before the Italian marque returned to F1 as a constructor from 1979 to 1985. Between 2017 and the end of 2023, Alfa Romeo had a commercial partnership with the Sauber F1 team.

THE DESIGNER

The Alfa Romeo 158 was designed by Gioacchino Colombo. The Italian engineer worked as an apprentice to Vittorio Jano, who had inspired earlier race-winning cars for Alfa Romeo. Following his success with the Alfetta, Colombo moved to Maserati, where he was responsible for the 250F.

FAMOUS DRIVERS

When Alfa Romeo entered the new World Championship, beginning at Silverstone in 1950, they had one of the strongest teams of drivers of the time. Italians Giuseppe Farina and Luigi Fagioli joined Argentina's Juan Manuel Fangio – a combination known as the 'three Fs'. It was also a relatively senior partnership with a combined age of 134, Fangio being considered a youngster at a mere 38 years old. Over the years, Alfa Romeo employed many great drivers, including the legendary Achille Varzi, who died when his Alfa Romeo 158 skidded off the wet road during practice for the 1948 Swiss Grand Prix at Bremgarten.

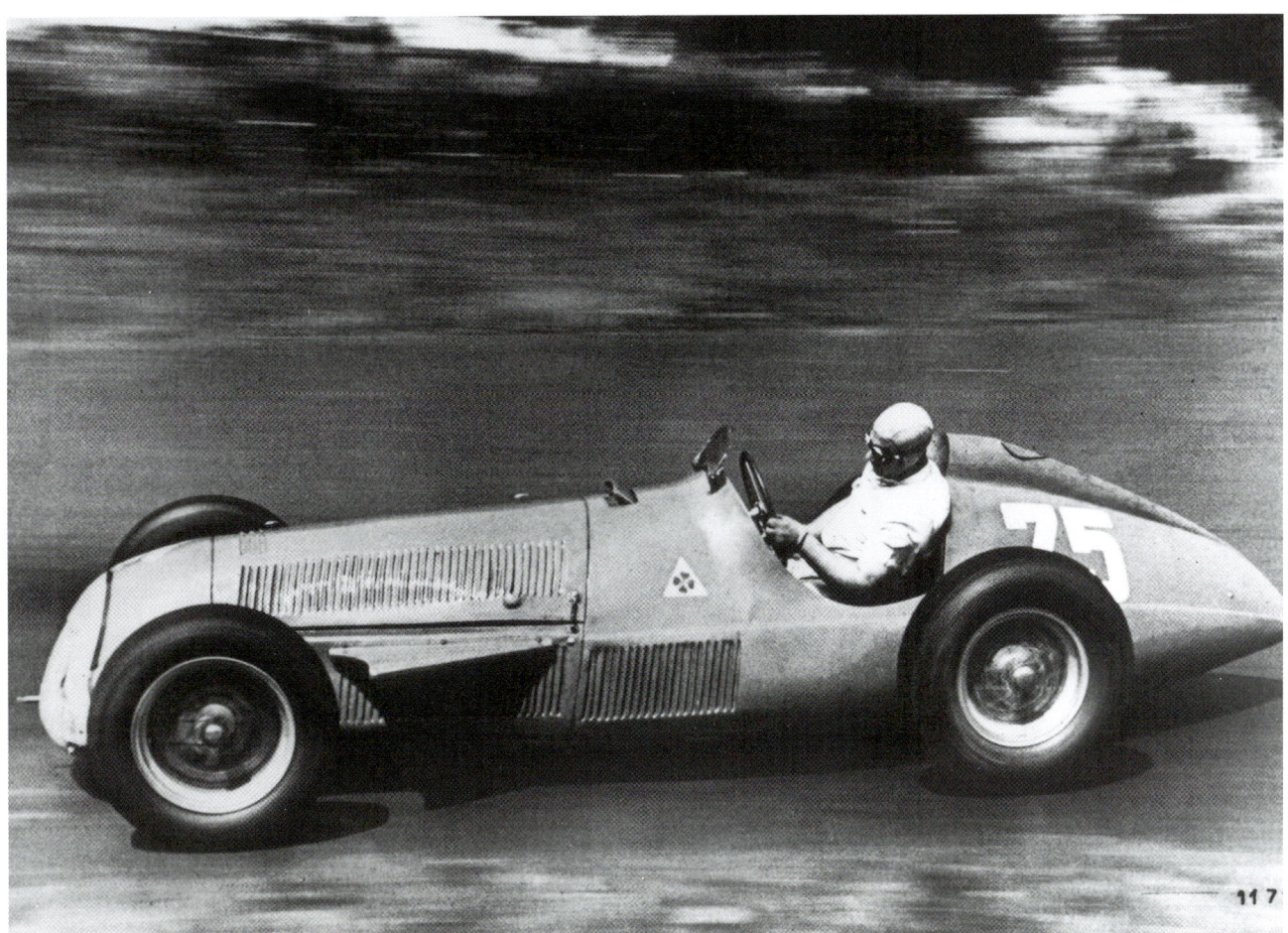

Demonstrating typical composure at the wheel of his Alfa Romeo 159, Juan Manuel Fangio takes the 1951 development of the 158 to second place in the German Grand Prix. The Argentine driver set the fastest lap of the daunting Nürburgring Nordschleife.

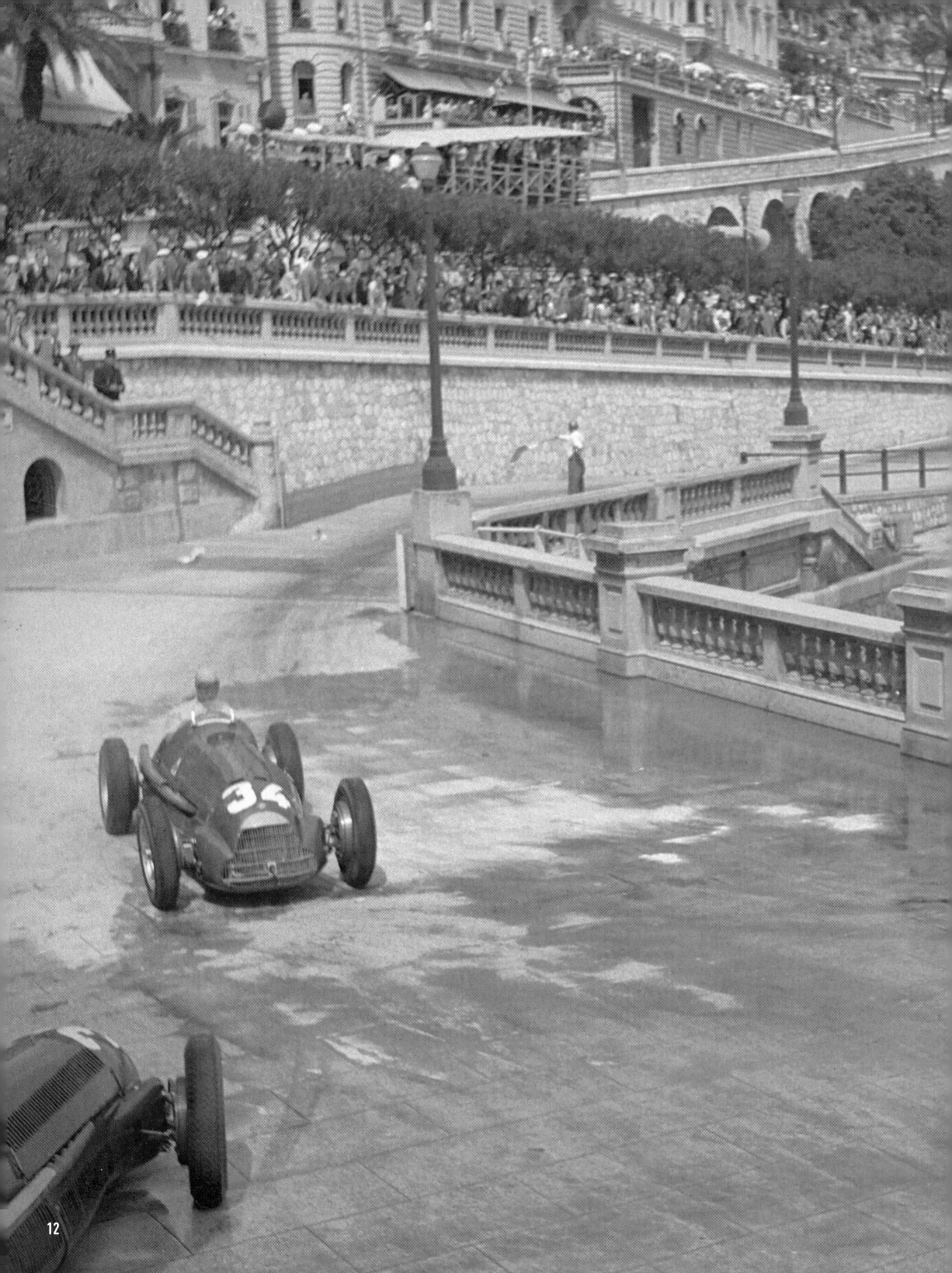

MEMORABLE RACE

When Alfa Romeo entered the second round of the 1950 World Championship at Monaco, Fangio won pole position and took the lead from Farina halfway through the first lap. As he powered through Tabac corner on the harbour front, Fangio noticed the wind had carried spray onto the track. Farina, following closely, did not see it and spun across the road, triggering a multi-car collision that blocked the exit of Tabac.

Oblivious to the mayhem, Fangio accelerated out of the chicane and onto the quayside for the second time. In the absence of warning flags, he seemed destined to crash into the unsighted wreckage. Then, for no apparent reason, he backed off before Tabac, motored gently round the corner, picked his way through the chaos and continued to victory 98 laps later. How had he known to slow down?

Fangio later explained that something didn't look right when he came onto the harbour front and aimed for Tabac. The crowd seemed to be a different colour. Fangio realised he wasn't seeing the spectators' faces, yet he was leading the race. Something else was attracting their attention. That's when he recalled a photograph of a similar accident at Tabac in 1936. He automatically slowed down. It was a perfect example of the intuitive skills that would help the Argentine driver go on to win the first of five World Championships in 1951, and Alfa Romeo's second.

Juan Manuel Fangio tackles Tabac corner on his way to victory in the 1950 Monaco Grand Prix. The abandoned Alfa Romeo 158 of his team-mate, Giuseppe Farina, remains in the foreground after spinning on the wet track and triggering the multi-car collision that Fangio managed to avoid.

Mercedes-Benz W196

'From the very first test, I was sure that I had in my hands the perfect car, the sensational machine that drivers dream about all their lives.'

Juan Manuel Fangio

Formula 1 teams were filled with a sense of foreboding at the final race of the 1953 season. The appearance in the Monza pit lane of legendary team manager Alfred Neubauer meant just one thing, Mercedes-Benz were considering a comeback to Grand Prix racing – it had only been a matter of time. World War II may have taken its toll on the German firm but a resurrection of the competitions department had been high on the list of priorities, given the knowledge and kudos gathered from their success in the past.

A change in formula – engines to be limited to 2.5 litres unsupercharged – would provide the perfect moment for Mercedes-Benz to re-join at a point when everyone was more or less starting from scratch. The portly presence of Neubauer, complete with stop watches around his neck, indicated the need for Ferrari, Maserati and Lancia to be on their A-game going into 1954.

Surprisingly, Mercedes were not ready for the first two championship rounds. Any hope of a shaky return was to be wiped out when the Daimler-Benz transporters rolled into the paddock at Reims. The three silver cars simply took the breath away when they were disgorged from the trucks.

During the race, Mercedes-Benz laid on a demonstration of such superiority that rivals blew their engines while attempting to keep up. Only 6 of the 21 starters survived – with the Mercedes of Juan Manuel Fangio leading home Karl Kling in an impressive staged finish. The third W196 of Hans Herrmann had suffered a massive engine failure – but not before the German driver had set the fastest lap, albeit 3.5 seconds slower than Fangio's pole position time.

Mercedes would be by no means dominant for the rest of the season. Streamlined bodywork, a striking and novel

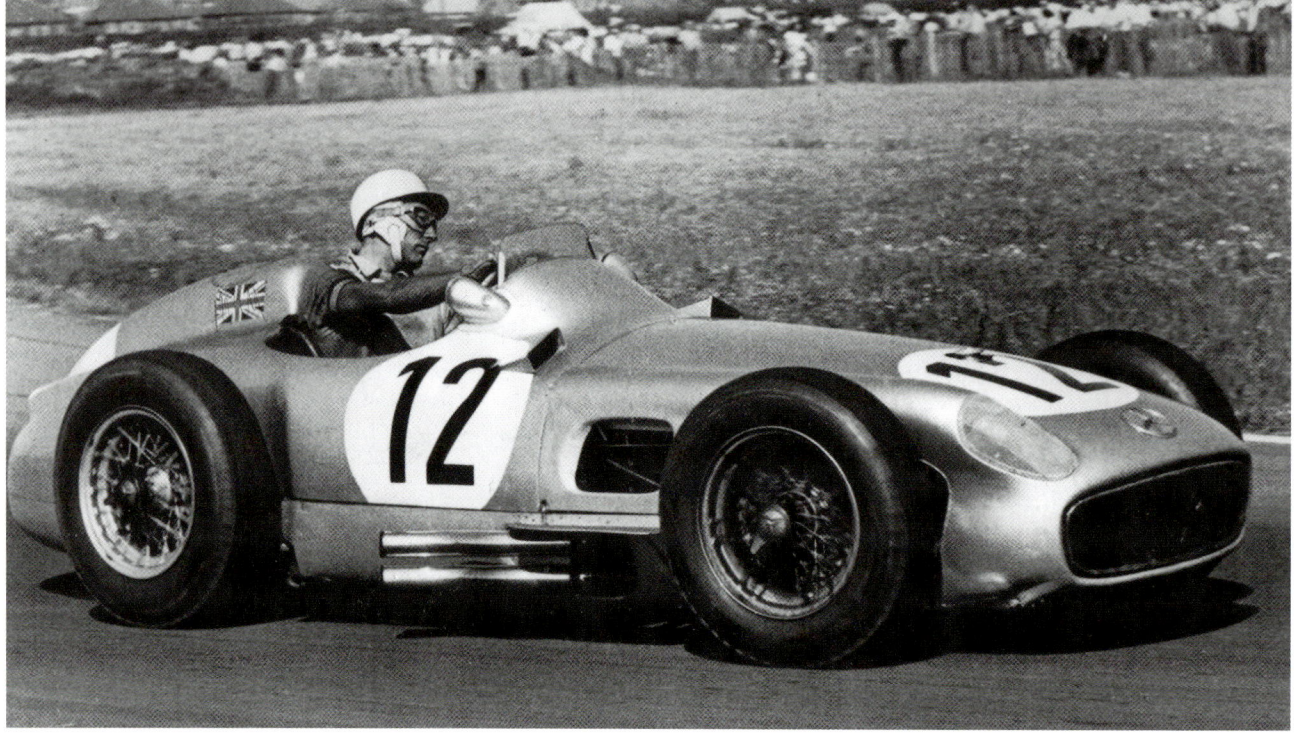

Stirling Moss led a 1–2 finish for the Mercedes-Benz W196 in the 1955 British Grand Prix at Aintree. Moss never knew if Juan Manuel Fangio allowed the English driver to win at home.

14

aspect of the silver cars, may have been all well and good on the long straights of Reims but, judging by the battered nose cone on Fangio's car, it was not ideal when trying to place the W196 through Copse, Maggotts and Becketts at Silverstone. Saying that, Fangio was on pole, destined to finish second.

It was a sign of Mercedes' professionalism and adaptability that they turned up without the streamlining at the Nürburgring, and also at the following Swiss Grand Prix at Bremgarten – the W196 wearing angular bodywork with exposed wheels in the more traditional manner. Fangio won both races, as well as the Italian Grand Prix at Monza, where the streamlining had been recalled, and Fangio benefitting from Stirling Moss retiring his Maserati from the lead with nine laps to go.

Moss had done enough to gain Neubauer's approval and a seat alongside Fangio in 1955. They won five of the six Grands Prix with more powerful W196s which came with the option of short and long wheelbases. Fangio won the championship for a fourth time. Mercedes then quit, their withdrawal prompted by tragedy at Le Mans when one of their cars crashed into the crowd.

THE CAR

When the W196 first appeared at Reims, the Mercedes not only had the very latest chassis and engine technology, but it was also clothed in all-enveloping bodywork for this very fast circuit. The triangulated spaceframe of small diameter tubes made up a chassis that was ahead of anything the Italian teams had to offer. The straight-eight engine, chosen for lightness, had desmodromic valves (negating the need for valve springs) and direct fuel injection – de riguer in F1 for many recent decades, but a novelty in 1954. The engine was canted over at 37 degrees from horizontal to achieve a low bonnet line and complement the sleek bodywork.

Engine	Mercedes-Benz 8-cylinder in-line
Size	2496 cc
Power	290 bhp
Weight	approx 700 kg (1543 lb)
Wheelbase	2050–2350 mm (81–92 in)

TEAM HISTORY

Mercedes has a formidable history in motor sport. From the pioneering years of Grand Prix racing in the 1900s to periods before and after World War II, the German cars have appeared spasmodically – but with devastating effect each time.

From winning races on the dusty roads between towns and cities in Europe at the start of the 20th century, to producing mechanical masterpieces in the 1930s, the Mercedes Grand Prix cars set a standard in perfection that ranged from technical excellence to meticulous team management.

When the Nazis came to power in January 1933, Grand Prix racing was seen as a powerful propaganda weapon. A substantial grant was offered to the German company producing the most successful racing car for 1934. Daimler-Benz AG (racing under the Mercedes-Benz brand name) and Auto Union accepted the challenge. In the end, the grant was shared between the two, such was the high standard of innovation that produced some of the most powerful Grand Prix cars ever seen.

The W25 became a consistent winner until 1937, when the introduction of the W125 continued the trend by dominating the European Championship (then the equivalent of today's F1 World Championship). Mercedes responded to a change of engine formula in 1938 by producing the W154, another sleek and powerful silver machine capable of winning the European Championship once more. The intervention of World War II in September 1939 brought racing to an end, the Mercedes-Benz *Rennabteilung* (racing department) reforming a decade later and eventually preparing to do battle in Grand Prix racing, this time with the W196.

THE DESIGNER

Born in London in 1906, Rudolph Uhlenhaut moved to Germany eight years later. He was technical director at Mercedes-Benz from 1937 and responsible for their Grand Prix cars until the outbreak of World War II. At the cessation of hostilities, Uhlenhaut designed the iconic 300 SL gull-wing road car and its racing derivative, the 300 SLR, while preparing the W196 for Grand Prix racing. A fine driver in his own right, Uhlenhaut could discover at first hand any weakness in the chassis or suspension design. Following an injury to a Mercedes driver at a previous race, Uhlenhaut was listed as reserve for the 1937 Donington Grand Prix.

FAMOUS DRIVERS

A wish to use German drivers meant Hans Herrmann and Karl Kling were called up but Mercedes knew they needed to make an exception for Juan Manuel Fangio. Having kept an eye on Stirling Moss in a privately entered Maserati in 1954, team manager Alfred Neubauer was sufficiently impressed to take the Englishman on board for the following year.

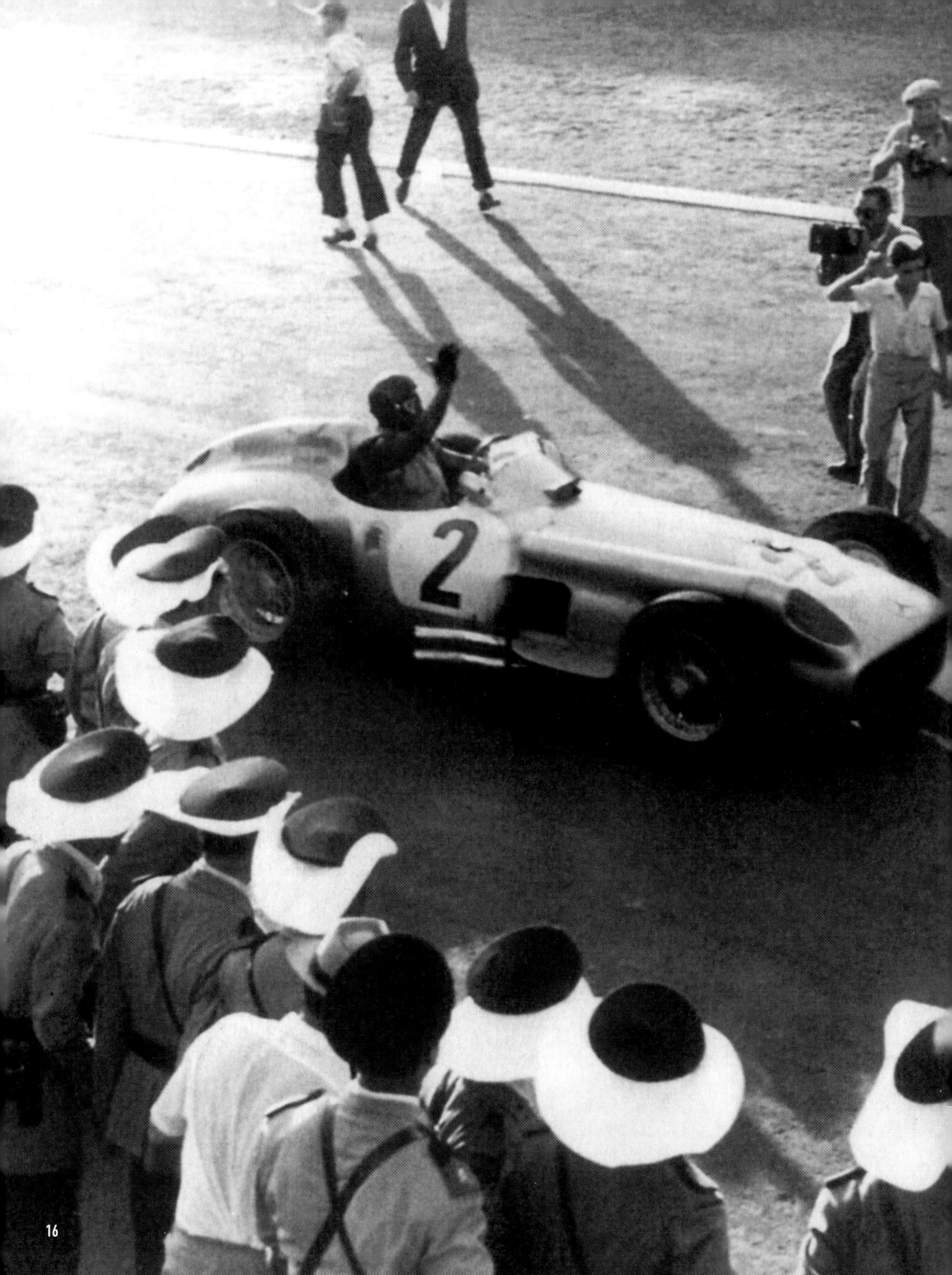

MEMORABLE RACE

The opening round of the 1955 World Championship was held in Fangio's home country, Argentina. More than 400,000 adoring fans were reported to have flocked to the Buenos Aires Autodromo to see one of their heroes start his Mercedes-Benz W196 from the front row, alongside a Ferrari (driven by José Froilán González, also for Argentina), a Maserati and a Lancia. With the temperature on that January afternoon reaching 36 °C, the emphasis during the 375 km (233 mile) race would be on survival as much as speed.

All but 2 of the 21 starters made the most of a rule permitting a car to be shared by more than one driver. Fangio chose to go it alone for the three hours it would take to complete 96 laps. It was excruciating. Apart from the heat surging through the cockpit from the front-mounted engine and radiator, Fangio had to contend with burns inflicted on his right leg by a chassis member being turned red hot by the outside exhaust pipes. As other drivers either retired exhausted in the pits or spun off, Fangio kept going. 'My body seemed to be on fire and my leg was burning so badly I could smell it.' said Fangio. 'To stop myself passing out, I tried to imagine I was sitting in a bath of ice.' Fangio won the race. He would carry the scars on his calf for the rest of his life.

After an extraordinary display of skill and stamina, Juan Manuel Fangio receives the plaudits from his fellow-countrymen at the end of the 1955 Argentine Grand Prix. Fangio's right leg was badly burned by heat from the exhaust pipes transferring through the chassis of his Mercedes-Benz W196 during three hours of racing.

Lancia D50

'The Lancia-Ferrari was a very pleasant car to drive there [the Nürburgring Nordschleife – where Fangio won with the D50 in 1956]. It was agile on corners and braked well.'

Juan Manuel Fangio

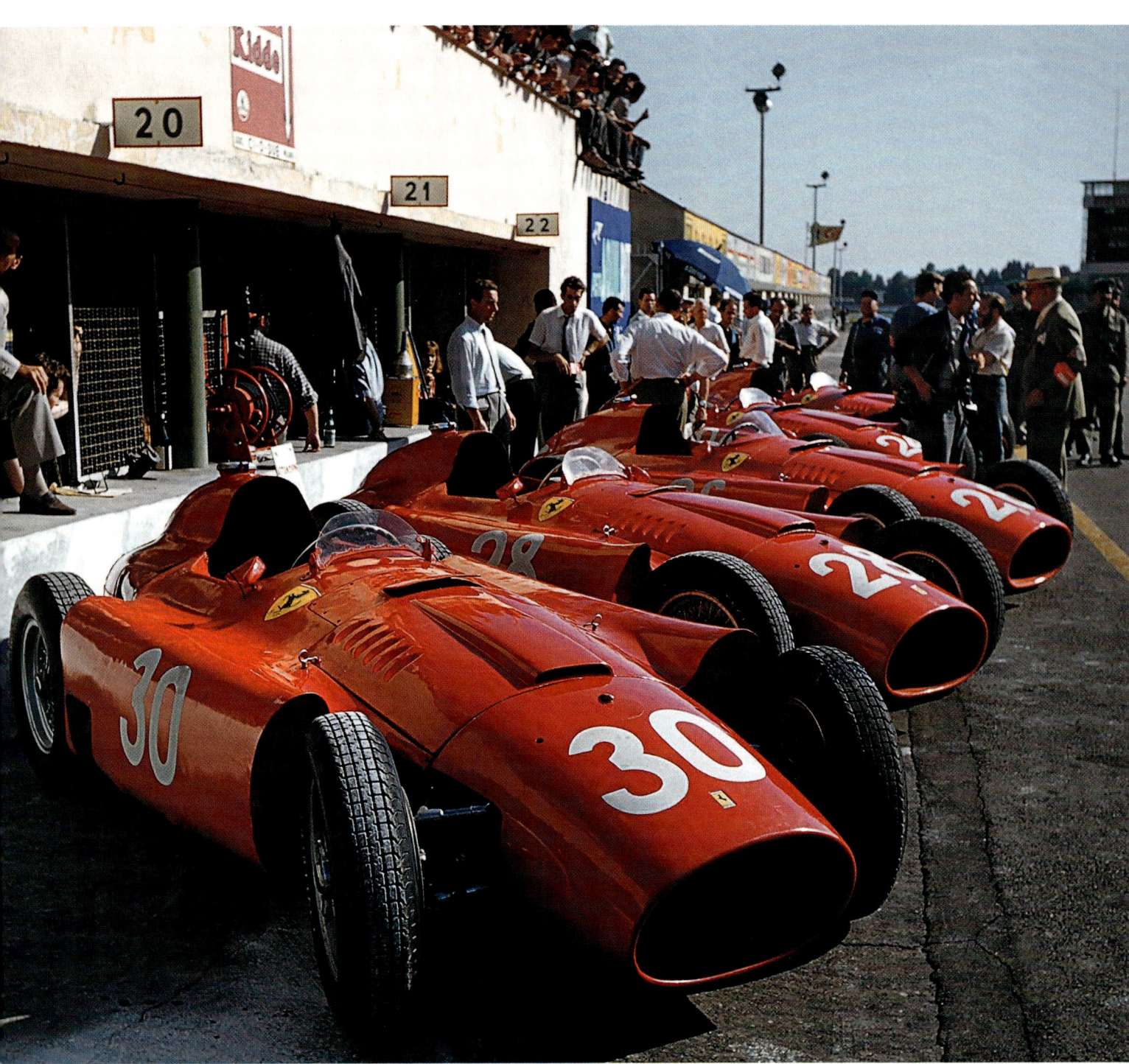

For a car that had limited success and a comparatively brief history, the Lancia D50 struck fear into its rivals as readily as it captured the imagination, due to its appearance. The red Italian car was comparatively short and stubby, its V8 engine contributing to the impression of menace. A long time in gestation, coupled with a troubled period for the Italian manufacturer, meant a change of the car's ownership and name. Now known as the Lancia-Ferrari D50, the car finally came on stream in 1956 to win five of the seven Grands Prix.

The attention to hidden mechanical detail was matched by an outward impression of efficiency and Italian flair thanks to a purpose-built transporter, top quality tool kits and smartly presented mechanics.

THE CAR

Rather than rely purely on engine power, the design brief was to make the D50 as agile and light as possible. To save both weight and space, the Lancia broke new ground by dispensing with a familiar tubular frame to carry the engine and making the V8 a structural chassis member with loads carried by the crankcase and cylinder heads.

Taking a further step from tradition, rather than running directly fore and aft, the engine was angled slightly to allow the prop shaft to pass to the left of the driver's seat rather than beneath it, letting the driver sit much lower than usual in the cockpit. To further concentrate the car's weight amidships and as low as possible, most of the fuel would be carried in distinctive pannier tanks, mounted between the wheels rather than within a massive single fuel tank in the car's tail. In a later development, the fuel would be largely returned to a tank in the rear with the panniers faired into the main bodywork, with all of the above contributing to the D50's squat appearance and nimble handling.

Engine	Lancia unsupercharged V8
Size	2489 cc
Power	275 bhp
Weight	650 kg (1433 lb)
Wheelbase	2280 mm (89.8 in)

A formidable sight. Five Lancia-Ferrari D50s lined up in the Monza pit lane in preparation for the 1956 Italian Grand Prix. Alfonso di Portago would drive #30, with the rest handled by Luigi Musso (#28), Peter Collins (#26), Eugenio Castellotti (#24) and Juan Manuel Fangio (#22). Fangio finished second in #26 to win the World Championship after Collins had handed over his car to the Argentine following a steering failure on #22.

TEAM HISTORY

Established in 1906 in Turin, Lancia & C. Fabbrica Automobili soon acquired a reputation for motor cars of quality and technical innovation. In 1952, Gianni Lancia (son of the founder, Vincenzo) launched an ambitious competitions programme, beginning with sports cars. Following success in major events such as the Mille Miglia and Targo Florio, Lancia turned his eye towards Grand Prix racing. The Lancia D50 was the result.

The original plan to take part in the 1954 season was blighted by delays, the Lancia D50 finally appearing at the final race of the season in Spain. Both cars retired but, with Alberto Ascari having led from pole for several laps, the D50 showed enough potential to be of concern to Mercedes-Benz, poised to carry all before them after a crushing debut in France a few months before.

Further technical and handling problems for Lancia during the first Grand Prix of 1955 in Argentina were soon forgotten as the D50 opened its account in two non-championship races. On each occasion, the winner's laurels had gone to Ascari, the double World Champion posing as big a threat in the eyes of Mercedes-Benz as the car he was driving.

Lancia had built its entire racing programme around the talented Italian. When Ascari was killed while testing a Ferrari sports car on 26 May 1955, Lancia, and the whole of Italy, was devastated. Coming on the back of mounting financial pressures for the car company, agreement was eventually reached to have Ferrari assume control of the race team, with the cars and equipment being moved lock, stock and barrel from Turin to Maranello.

Tyre problems during practice on the high-speed banked section of the Monza Autodrome meant the entry of four Lancia-Ferraris suffered a humiliating withdrawal before the Italian Grand Prix, the final race of the season. But they were ready for 1956.

Ferrari may have been helped by Mercedes-Benz quitting motor racing following the tragedy at Le Mans, but the Maserati 250F presented a formidable challenge, particularly in the hands of Stirling Moss. The Englishman would win at Monaco and Monza but victory for Fangio in Argentina, Britain and Germany (backed up by Britain's Peter Collins, who scored his maiden GP win in Belgium, followed by another in France) would ensure the D50 would carve its place in Formula 1 history. And not before time. The D50 – now known as a Ferrari 801 – would continue with moderate success into 1957, when the Maserati 250F would have its day.

THE DESIGNER

The Lancia D50 was designed by Vittorio Jano who, by the early 1950s, was a highly accomplished veteran engineer, responsible for the Lancia sports cars and now poised to return to single-seater design following his highly acclaimed work with Alfa Romeo. Jano relied on specialist engine designer, Ettore Zaccone Mina, to take care of the 2.5-litre unsupercharged V8 engine. When Ferrari took over the Lancia F1 project, Jano continued as a consultant.

FAMOUS DRIVERS

Alberto Ascari formed the lynchpin of the Lancia squad until his death in May 1955, with Juan Manual Fangio then assuming seniority the following year. Throughout, Lancia used the services of Eugenio Castellotti and Luigi Villoresi (Ascari's close friend and mentor), with Peter Collins and Luigi Musso joining the squad when Ferrari took control. Despite winning the championship, Ferrari was not a particularly happy ship in 1956 as the young Italian drivers fought among themselves, and Fangio did not enjoy the intrigues endemic to Ferrari. He did appreciate, however, the fact that Collins had handed over his car during the final race at Monza (thus ensuring Fangio of his fourth world title) despite Collins having an outside chance of winning the championship.

Juan Manuel Fangio won the World Championship in 1956 but was never entirely comfortable with the atmosphere within Ferrari.

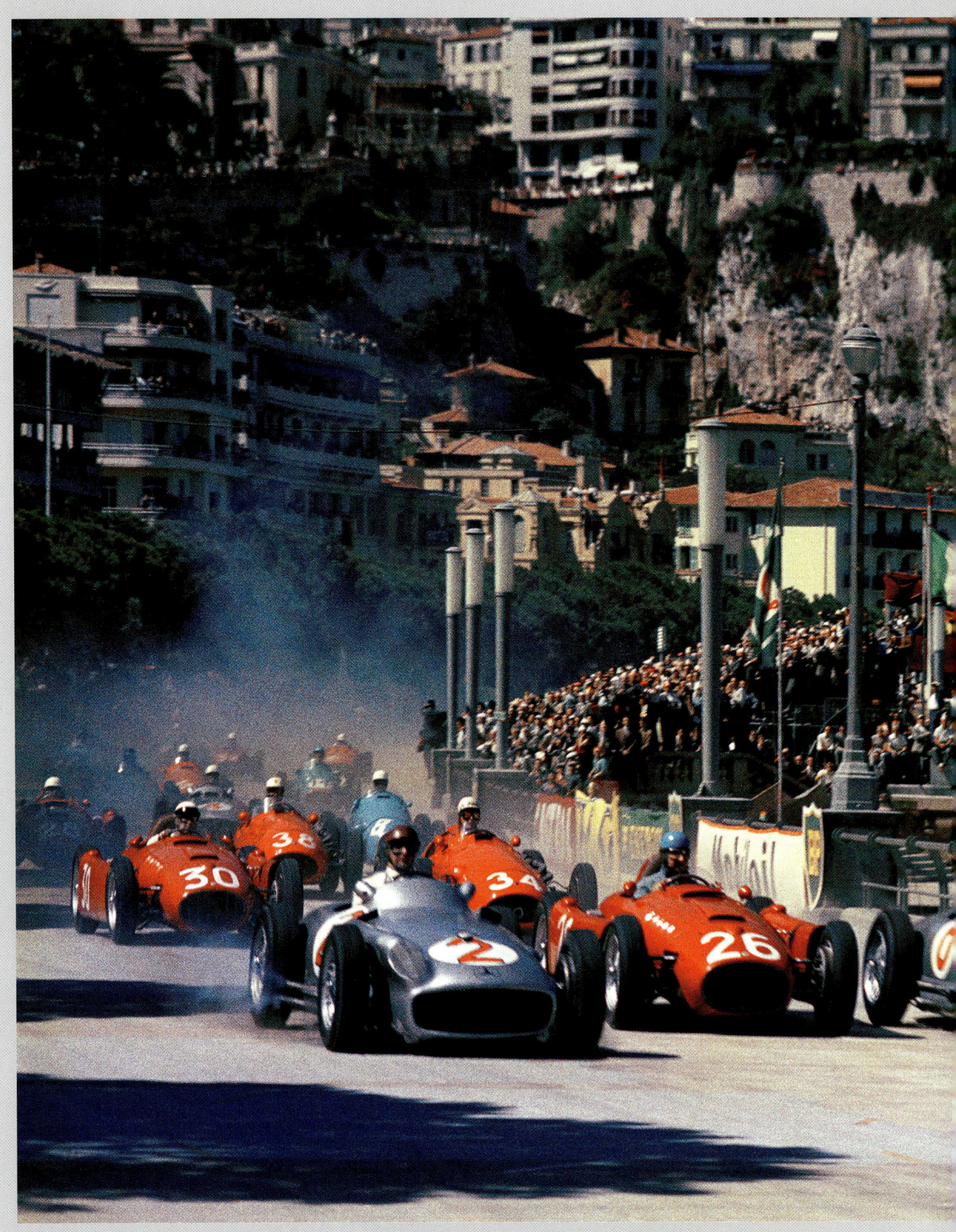

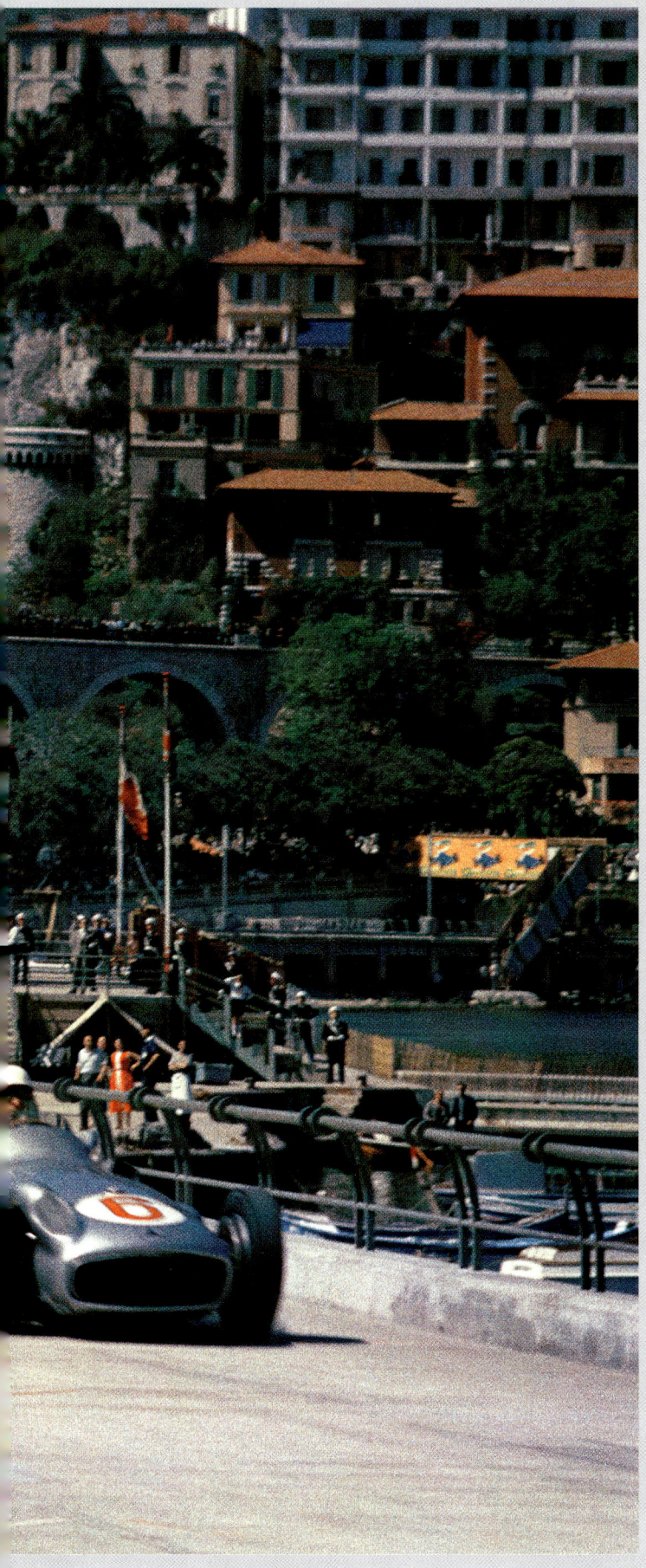

MEMORABLE RACE

Having claimed only five World Championship Grands Prix, the most memorable race is arguably one that the Lancia D50 failed to win.

The 1955 Monaco Grand Prix was the moment when Lancia arrived in force – the four gleaming D50s parked en échelon in the pits made a truly impressive sight. This race also marked the first appearance in Europe of the Mercedes-Benz W196, specially adapted for the tight street circuit. The silver cars, driven by Juan Manuel Fangio and Stirling Moss, dominated most of practice but Ascari literally got among them by starting his D50 from the middle of the three-car front row.

There was little Ascari could do in the race as the Mercedes pair pulled away. Even when Fangio retired with a blown engine, a Mercedes victory seemed assured as Moss was almost a lap ahead of Ascari, who had been busy fending off attention from his young team-mate until Castellotti hit a kerb and suffered a puncture. Then, in a matter of minutes, the complexion of the race changed completely.

As Moss completed his 81st lap, a cloud of smoke signalled big trouble thanks to engine oil spewing onto the hot exhaust. As the Mercedes mechanics descended on the car once Moss had reached the pits, Ascari was powering through the tunnel, unaware that he was about to take the lead. As he arrived at the chicane leading onto the harbour front, the Lancia hit a patch of oil. There was nothing he could do to prevent the car from smashing through the straw bales lining the track and plunging into the harbour in a massive cloud of steam and spray. It was with some relief that rescuers saw Ascari's familiar light-blue crash helmet bob to the surface. Apart from a cut to his nose, the driver was perfectly okay. The race was won by the Ferrari of Maurice Trintignant. Having escaped this potentially lethal moment, Ascari would be killed four days later at Monza. It has never been ascertained just why his Ferrari sports car left the road on a circuit he knew intimately.

Alberto Ascari (#26) is engulfed by the Mercedes-Benz W196s of Juan Manuel Fangio (#2) and Stirling Moss (#6) at the start of the 1955 Monaco Grand Prix. Ascari and his Lancia D50 would finish the race in the harbour. Ascari survived the spectacular incident, but was killed four days later when testing a Ferrari sports car at Monza.

Maserati 250F

'As soon as I got my hands on my 250F, I realised it was in a different class. Its handling was a joy; predictable and progressive.'

Sir Stirling Moss

Considered by motor sport enthusiasts worldwide to have been one of the most beautiful Formula 1 cars ever made – and one of the nicest to drive.

Designed and built by Maserati in Italy, the 250F was truly a production racing car – at least 25 were made between 1954 and the end of 1957, when the works team was withdrawn due to financial difficulties. The Maserati 250F remains the only car to run in the first and last races of the 2.5-litre era between 1954 and 1960.

The 250F may have claimed more than 40 victories in that period but the early models were not particularly reliable. Initially, rather than run a works team, Maserati put the 250F on general sale, making it popular among privateer drivers.

Stirling Moss was the most notable of these, the Englishman using a privately entered 250F to showcase his natural ability in 1954 by winning three non-championship races, finishing third in the Belgian Grand Prix and earning a drive with the Mercedes team the following season. By which time, Maserati had become the regular entrant of a works team, Juan Manuel Fangio winning in Argentina and Belgium in 1954, with Moss (Mercedes having withdrawn from racing) triumphing in Monaco and Italy in 1956.

Virtually every leading F1 driver of the period raced a 250F at some stage, such was the Maserati's popularity and strength in numbers. Fangio is best remembered, with the Argentine driver claiming his fifth and final World Championship after returning to the Maserati works team for 1957 and winning four Grands Prix, of which his last at the Nürburgring has been hailed as one of the greatest drives of all time.

Another of Fangio's memorable performances in 1957 had taken place in the French Grand Prix at Rouen-Les-Essarts. The 5.10 km (3.17-mile) road circuit consisted of a downhill section enabling Fangio to demonstrate his supreme control by sliding the red car at will through the fast curves. This combination of driver skill on a glorious circuit remains one of the most outstanding demonstrations of the Grand Prix art – with the aid of a compliant, near-perfect F1 car.

THE CAR

By 1957, the 250F had been developed and improved to become a sleek and comparatively simple racing car.

In their element. Juan Manuel Fangio, having given a thrilling display of power-sliding with his Maserati 250F through the downhill curves, negotiates the cobbled Nouveau Monde hairpin at Rouen-Les-Essarts while dominating the 1957 French Grand Prix.

The six-cylinder engine had adequate power which the drivers could manage easily thanks to the car's predictable handling. Slight but critical repositioning of the engine in the chassis allowed the driver to sit lower and the car to become more streamlined – the original 250F being one of the first single-seaters to feature a wrap-round windscreen in place of the traditional flat aero screen.

Engine	Maserati 6-cylinder in-line
Size	2493 cc
Power	270 bhp
Weight	630 kg (1389 lb)
Wheelbase	2280 mm (90 in)

TEAM HISTORY

Maserati has a long sporting history, stretching across three decades during the most significant period in Grand Prix racing. Three of five brothers were behind the formation of Officine Alfieri Maserati in 1926. The first Maserati racing car carried a trident motif, a symbol of their home town, Bologna. The firm won numerous Grands Prix until bought in 1937 by the Orsi family. Three years later, the company moved to Modena (later to become the home town of Ferrari), where it remains as the manufacturer of quality road cars.

Maserati produced several Grand Prix cars, which had mixed results but remained the mainstay of major motor sport as racing recovered from World War II. Development of the Maserati A6 and 4CLT in various guises brought modest results to match a performance that was outclassed by Ferrari in 1952 and 1953. But the step change to the 250F to meet the start of the 2.5-litre formula would become the best-known symbol of success for the Italian marque.

Following Fangio's championship in 1957, the 250F may have drifted into obsolescence, but the Maserati name continued to be represented on starting grids thanks to the efforts of privateers; Gino Munaron, for example, finishing third in the non-championship 1960 Buenos Aires Grand Prix.

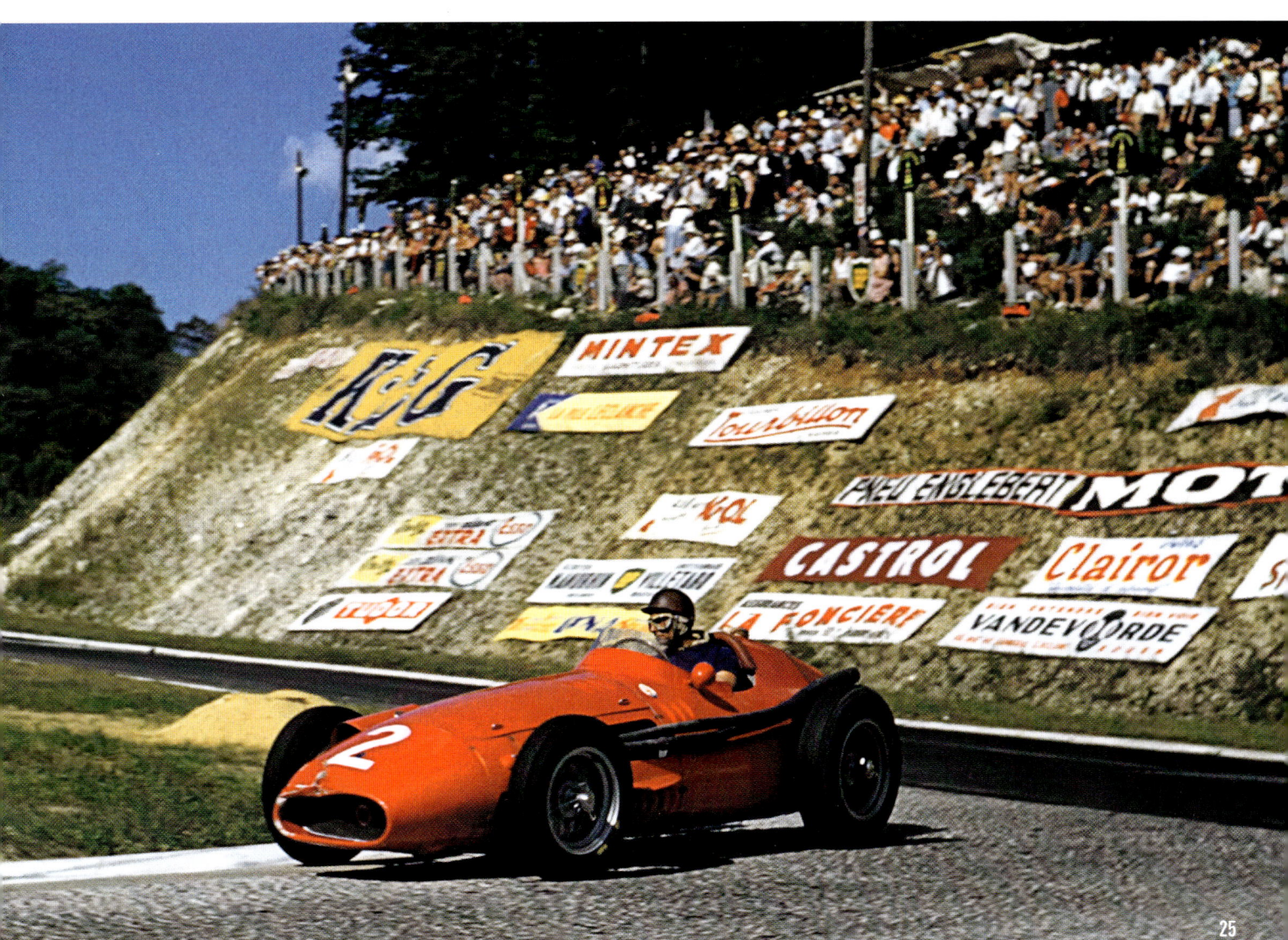

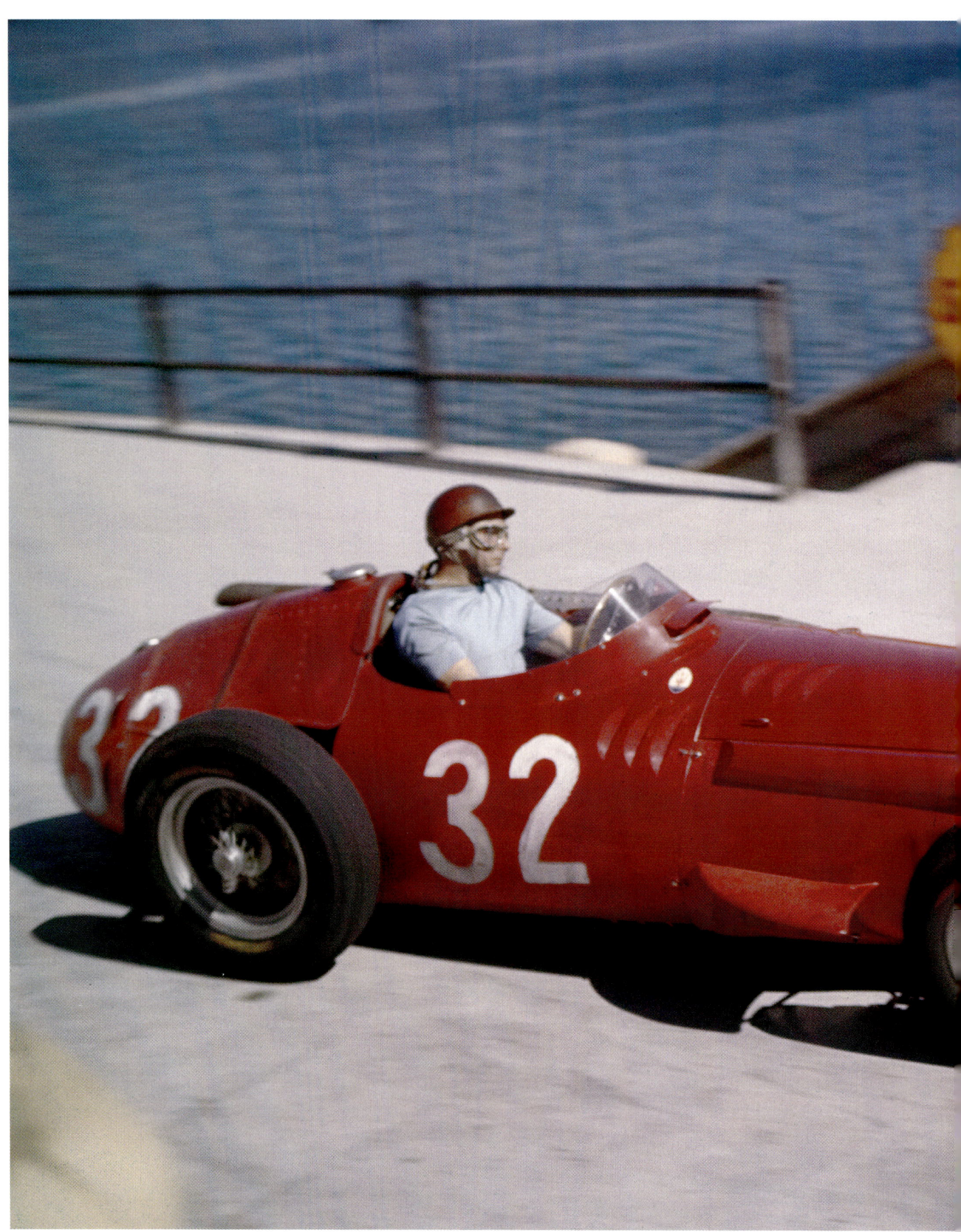

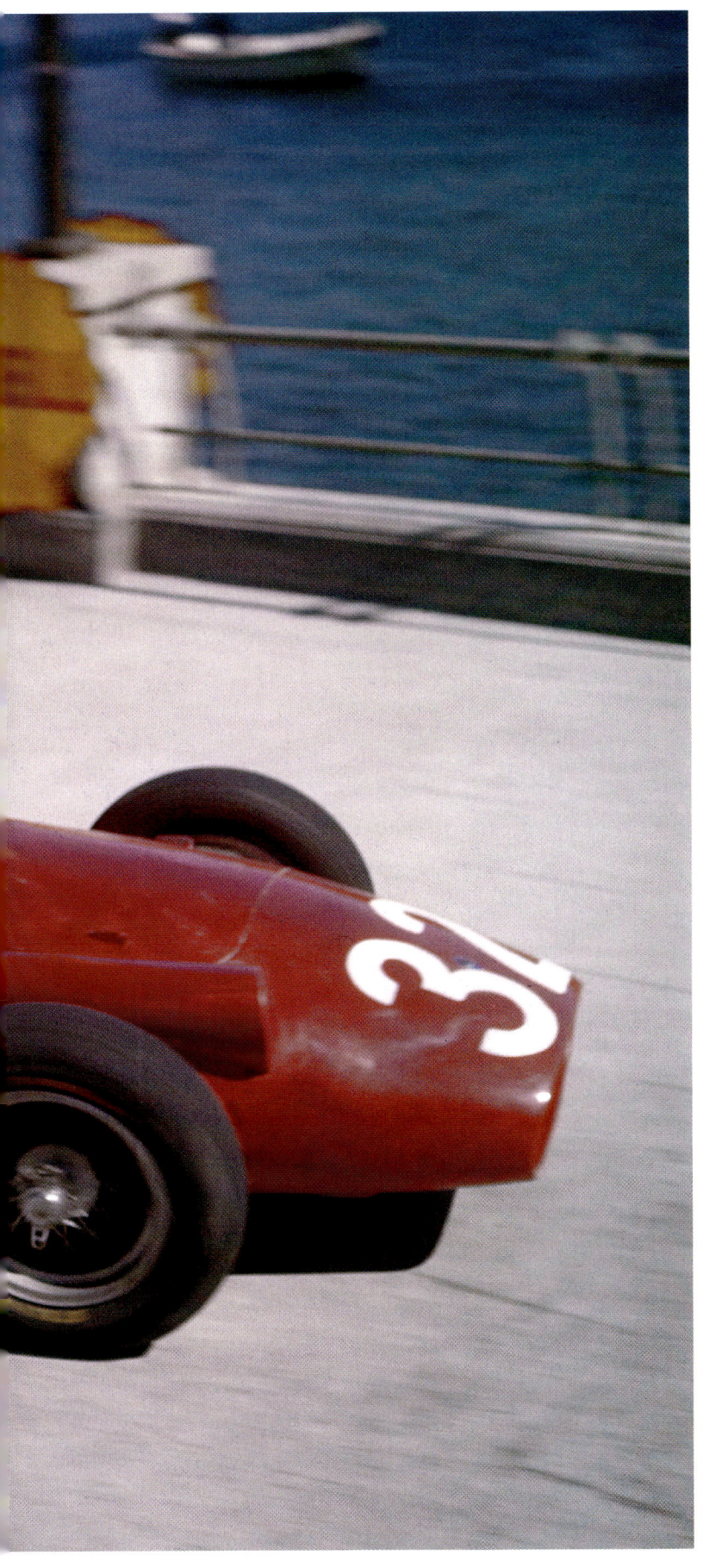

THE DESIGNER

The Maserati 250F was built by Vittorio Bellentani and Alberto Massimino, led by Gioacchino Colombo. Formerly an apprentice at Alfa Romeo, Colombo had designed engines for Ferrari before returning to Alfa Romeo and masterminding championship winning F1 cars for Giuseppe Farina and Juan Manuel Fangio. Colombo moved to Maserati in 1952 and created the 250F, arguably his most memorable design. Colombo left Maserati in November 1953, before the 250F prototype had run. His place was taken by Giulio Alfieri, the engineering graduate who had joined Maserati a couple of months before.

FAMOUS DRIVERS

Some of the greatest names in motor sport history have driven Maserati single-seater and sports/racing cars. José Froilán González and Alberto Ascari were among the top line post-war drivers to represent the Trident symbol, with Baron Emmanuel 'Tuolo' de Graffenried (winner of the 1949 British Grand Prix) being one of the many privateers to race a Maserati. Jean Behra, Luigi Musso and Harry Schell claimed podium finishes in the red cars, but it was Fangio who was head and shoulders above the rest.

The graceful lines of the Maserati 250F are evident as Juan Manuel Fangio heads for victory in the 1957 Monaco Grand Prix.

27

MEMORABLE RACE

Juan Manuel Fangio had won three Grands Prix in 1957 and few would bet against him claiming a fourth for Maserati in Germany. Held on the Nürburgring Nordschleife, this was Fangio territory. The 250F may not have been as powerful as the rival Ferrari, but the handling of the beautifully balanced Maserati was tailor-made for the daunting 22.8 km (14.2-mile) track, twisting and turning through the Eifel Mountains.

Sure enough, Fangio claimed pole by almost three seconds. Running with less than half a tank of fuel, he took off into an early lead ahead of the Ferraris of Mike Hawthorn and Peter Collins. When the Maserati stopped to refuel, the Ferraris swept by. At the end of the next lap, they were 45 seconds ahead. One lap later, the gap had increased slightly. Believing they had this race in the bag, Hawthorn and Collins eased off.

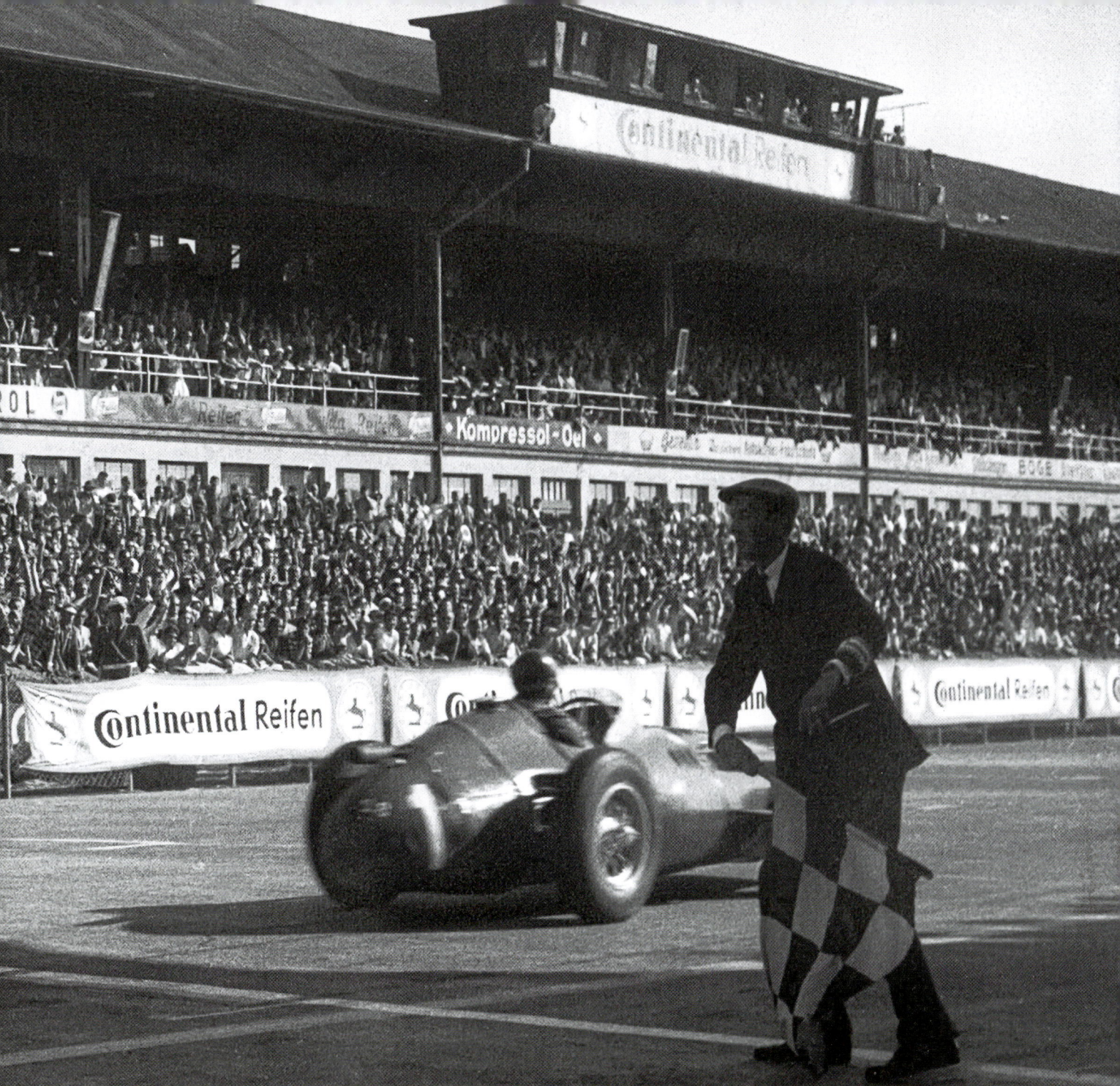

Fangio's 24th and final Grand Prix win – and, arguably, his finest. The Argentine driver becomes World Champion for the fifth time as he crosses the line following a stunning drive in his Maserati 250F in the 1957 German Grand Prix.

Meanwhile, Fangio had gone to work, slashing 15 seconds off the lap record. Hawthorn and Collins were stunned when their pit board showed the gap had shrunk to 35 seconds. They put the hammer down, and Fangio went quicker still. On the next lap, he went round the Nürburgring eight seconds faster than he had managed during practice. He would later admit it was a lap he would never forget – and one he had no wish to repeat.

With two laps to go, the Ferraris were in sight. Despite the best efforts of the English drivers, nothing was going to stop the mighty Fangio on this day. He won the race and, appropriately, the World Championship for the fifth time.

Vanwall VW4

'The Vanwall was more difficult to drive than I think was generally appreciated at the time. It was heavy, and not the sort of car you could throw around and really enjoy yourself, like the 250F Maserati. The Vanwall called for more precise driving.'

Tony Brooks

Vanwall marked the beginning of Britain's rise as a manufacturer of world-beating F1 cars. The VW4 established that claim by winning the 1957 British Grand Prix – the green car with its distinctive tear-drop shape was shared by Stirling Moss and Tony Brooks. The two Englishmen had combined to produce the first all-British win – car and drivers – in their home Grand Prix since 1923.

The Vanwall had looked the part. Even better on this heady July day at Aintree (the Grand Prix track running alongside and across the famous horse-racing course), the elegant F1 car had been the inspiration of Tony Vandervell, a staunch patriot whose main ambition had been to take on Ferrari and Maserati and 'beat those bloody red cars'.

Apart from a powerful intervention by Mercedes in 1954 and 1955, Italian teams had totally dominated the World Championship since its inception in 1950. Alfa Romeo, Ferrari and Maserati manufactured distinguished road cars. Vandervell's company, Thinwall Engineering, simply made automotive parts. If anything, that strengthened the industrialist's desire to demonstrate British craftsmanship and creativity on the world's race tracks.

The victory at Aintree in 1957 was followed by wins for Moss at Pescara and Monza – two very different tracks. The fact that they were both in Italy increased Vandervell's satisfaction no end. Now he knew Vanwall was ready to take a serious run at the championship in 1958 with the VW5, a refined version of its predecessor.

Moss won at Zandvoort in Holland, with Brooks taking his turn with majestic victories at Spa-Francorchamps in Belgium and the notorious Nürburgring Nordschleife in Germany. When Moss won on the streets of Porto in Portugal and Brooks repeated Vanwall's victory of the previous year at Monza, Moss went to the final round in Casablanca with an outside chance of taking the title. He did all he could, winning the Moroccan Grand Prix and setting the fastest lap (worth an extra point). But it was not enough to prevent Ferrari's Mike Hawthorn from becoming the first British World Champion by a single point.

Nonetheless, six victories, five pole positions and three fastest laps in 1958 had guaranteed the Vanwall's place as a classically elegant F1 car and ensured a worthy victory in the inaugural Formula 1 Constructors' Championship. Never in the history of Grand Prix racing had a British team been so successful.

THE CAR

Initially using Ferrari race cars as test beds for his ideas, the first Vanwall (an amalgam of Vandervell's surname and the company name) made a hesitant start in 1954. It was only when Vandervell tapped into the nascent talent of two young engineers that the performance matched the car's emerging graceful lines. Colin Chapman designed a light space frame chassis and Frank Costin produced the tear-drop body shape to accommodate the tall four-cylinder Vanwall engine mated to a five-speed gearbox. With the seat placed above the transmission, the driver had a lofty position, relieved in part by the car's aerodynamic profile. The exhaust system was faired into the bodywork, with a clever ducting system to keep the driver cool.

Engine	Vanwall V254 4-cylinder in-line.
Size	2490 cc
Power	285 bhp
Weight	640 kg (1410 lb)
Wheelbase	2282 mm (90.25 in)

The Vanwall's unique profile is shown as Stirling Moss takes part in practice for the 1957 British Grand Prix at Aintree.

TEAM HISTORY

Guy Anthony (Tony) Vandervell was a successful industrialist, passionate about Great Britain and motor racing in equal measure. Having supported the BRM (British Racing Motors) project to carry Britain into motor sport prominence in the early 1950s, Vandervell became frustrated by the delays and mismanagement. He felt there was no alternative but to go out on his own.

To discover more about operating a racing team, Vandervell bought a Ferrari and, never afraid to speak his mind, irritated Enzo Ferrari by pointing out the single seater's shortcomings. The car was known as a 'Thinwall Special' in deference to Thinwall engine bearings manufactured by his company, Vandervell Products.

Operating out of a factory in Acton, West London, Vandervell took a step further by designing his own car for the 1954 F1 World Championship. Vandervell also chose to produce his own engine based on a motor from Norton (the motorcycle company which Vandervell also owned). The Cooper Car Company was commissioned to build a chassis to take the four-cylinder engine, the car being entered as a Vanwall

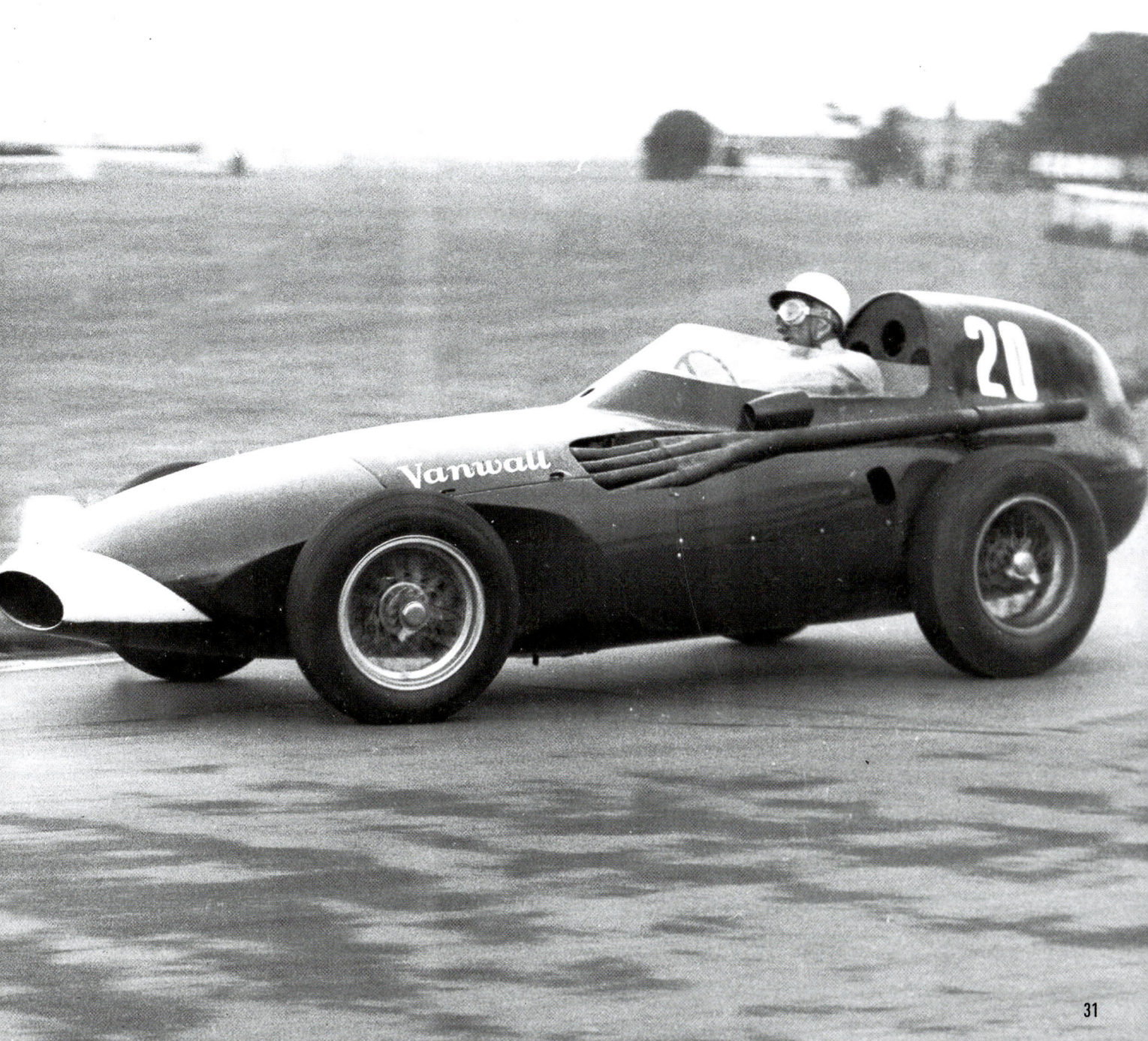

Special in the British Grand Prix. Driven by Peter Collins, the car failed to finish, a prelude to generally mediocre performances by Vanwall during the rest of 1954 and into the following season.

The astute Vandervell signed up a young engineer and an equally promising aerodynamicist, their combined efforts helping turn the team's fortunes around. Victory for Stirling Moss in a non-championship F1 race in 1956 would set in motion powerful performances over the next two seasons.

There were mixed emotions when Vanwall clinched the Constructors' Championship in Morocco at the end of 1958. A third Vanwall, driven by Stuart Lewis-Evans, had crashed and caught fire, with the young Welshman succumbing to his injuries a few days later. On 13 January 1959, Tony Vandervell announced the withdrawal of his team from Grand Prix racing. He cited ill-health, the strain of building up his own team having taken its toll. But there was no doubt that he had been deeply troubled by the death of Lewis-Evans, the only driver to come to serious harm in a Vanwall.

THE DESIGNER

The first Vanwall was created by Owen Maddock, Chief Designer with the Cooper Car Company between 1950 and 1963. For 1956, Tony Vandervell hired Colin Chapman (who we will meet several times in this book) to design the chassis and rear suspension to accompany the graceful work of Frank Costin, taken on board to adapt his aircraft aerodynamic knowledge for racing car use.

FAMOUS DRIVERS

More than a dozen different drivers, from Alan Brown to Piero Taruffi, raced Tony Vandervell's various F1 cars. Stirling Moss and Tony Brooks were the most prominent, sharing Vanwall's nine Grand Prix victories.

Their smiling faces showing the oily signature of combat, Tony Brooks (left) and Stirling Moss share the moment of victory for Vanwall at Aintree in 1957.

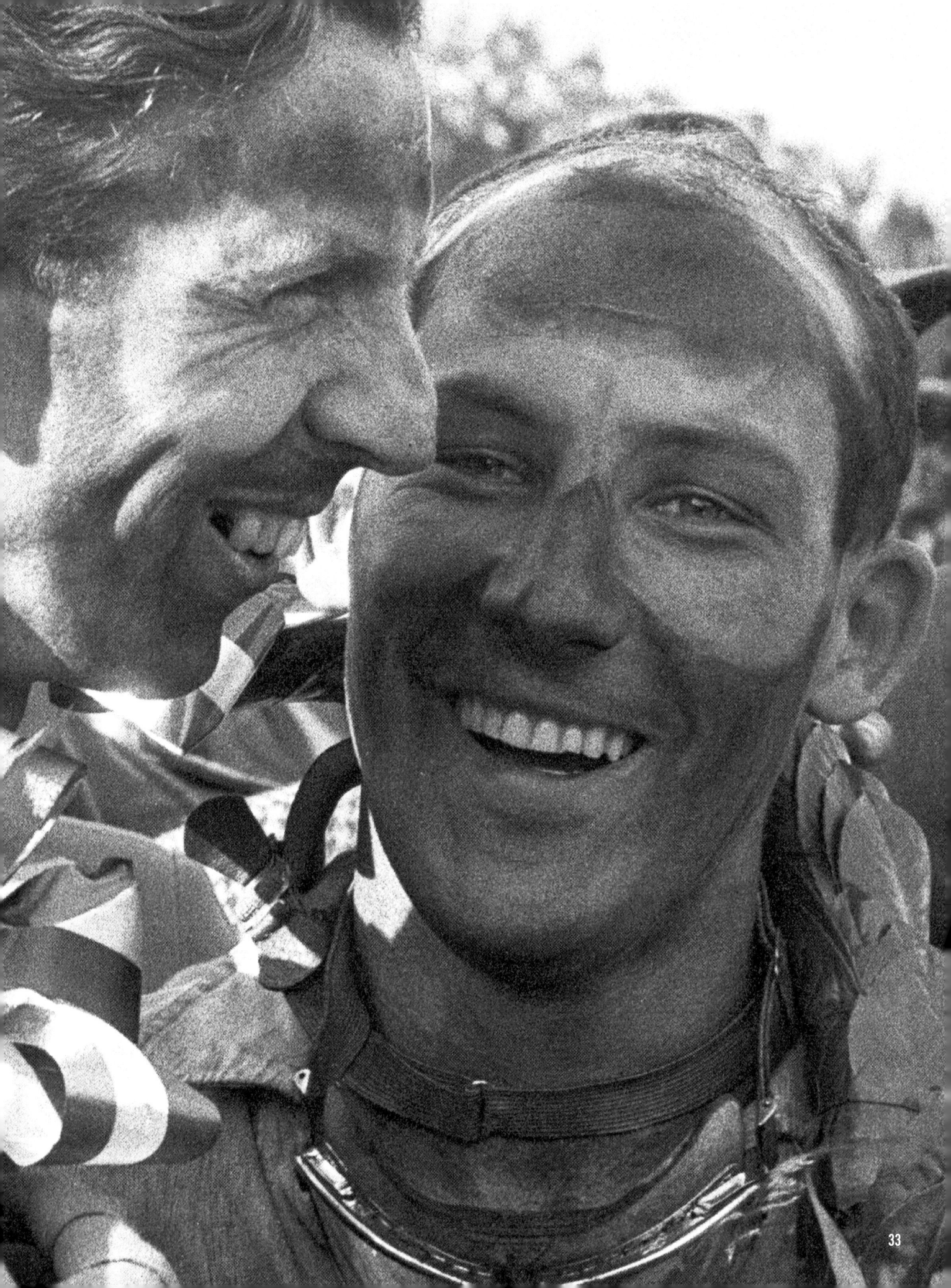

MEMORABLE RACE

The pressure on Vanwall to finally come good was immense. The British Grand Prix, scheduled for Aintree on 20 July 1957, boasted entries of four cars each from Maserati and Ferrari, but Britain expected the Vanwall team to do its bit.

Stirling Moss and Tony Brooks were not confident. Moss was recovering from a nasty sinus infection and Brooks had been in hospital, recuperating from a thigh injury incurred when he overturned his Aston Martin during the Le Mans 24-Hour race.

Moss, starting from pole position, led until a misfire prompted a pit stop. When the engine problem could not be cured, Brooks was called in to hand over his car to Moss – a previously agreed tactic that the unfit Brooks was happy to accept. Moss leapt onto the rear wheel, dropped into the high cockpit and was away, rejoining in ninth place. The race was on.

By lap 47 Moss was fourth, having dispensed with, among others, the Maserati of reigning World Champion, Juan Manuel Fangio, and the Ferrari of Peter Collins. Out front, Jean Behra broke the lap record as he maintained the lead inherited since Moss's pit stop. With Moss 45 seconds behind and as many laps remaining, the feisty Frenchman was looking good.

Then the complexion of the race changed in an instant. Behra's press-on pace took its toll as the Maserati's engine blew up. Mike Hawthorn, about to take the lead, picked up a puncture from the six-cylinder Maserati's hot metal debris. At the same time, Moss passed his team-mate, Stuart Lewis-Evans, to take the lead. Aintree erupted. There was even more emotion 20 laps later when Moss accelerated out of the final corner and thrust his right arm in the air as he received the chequered flag. It would be Vanwall's finest moment.

A memorable moment in July 1957 as Stirling Moss takes the chequered flag to give Vanwall an all-British victory for drivers and team in their home Grand Prix.

35

Ferrari Dino 246

'The noise was deafening; the two exhaust pipes finished either side of me, about a foot to the rear. I liked everything about the car; its balance in the faster corners, the brakes, the seating position, the free-revving engine. The gearbox was a joy; fast, and as smooth as silk.'

Tony Brooks

The Ferrari Dino 246 has various claims to fame. It was the first car to win a Grand Prix with a V6 engine and the last front-engine car to win a World Championship race. Along the way, Mike Hawthorn raced the Dino 246 in 1958 to become the first British World Champion.

The roots of the Dino 246 go back to 1957 when, known as the Dino 156, the Ferrari with its V6 engine was intended for a new 1.5-litre limit in Formula 2. Pressure to succeed in 1958 was compounded by Ferrari failing to score a single championship Grand Prix win the previous year – the first time this had happened since 1950.

The Dino 246 scored its first victory in the Glover Trophy at Goodwood on Easter Monday 1958. This was followed by two more non-championship wins at Syracuse in Sicily, and the International Trophy at Silverstone. Which was all well and good, but the writing was on the wall – in English.

In January, the first round of the World Championship had been won by Stirling Moss in a small (by comparison with the Ferrari) Cooper-Climax. Moss and the privately entered team may have fooled the opposition by running non-stop (and finishing with canvas exposed on the rear tyres), but the fact that the four-cylinder engine was mounted in the rear would prove to be a foretaste of F1's future.

In the meantime, Ferrari's immediate attention was focused on the rise of another British team, Vanwall. Pole position at Monaco and victories for the green car in The Netherlands and Belgium made it clear that the Dino 246 would have its work cut out.

Hawthorn scored the first Grand Prix win for the Ferrari at Reims, but the weekend was darkened by the death of Luigi Musso when the Italian's Ferrari flew off a fast curve on the road circuit. There would be further tragedy when Peter Collins was killed at Nürburgring Nordschleife, two weeks after he had won the British Grand Prix in his Dino 246.

Two more wins for Vanwall meant the 1958 championship would be decided at final round in Morocco, where second place was good enough for Hawthorn to become World Champion, despite having won just one Grand Prix.

The Dino 246 was revised for 1959. Tony Brooks scored typically classy wins and came very close to becoming World Champion. Development continued into 1960, by which time the Dino 246 was being outclassed, the sole (and final front-engine) victory coming at Monza – mainly because the race had been boycotted by the British teams.

THE CAR

The Dino 246 was, in effect, a scaled down and unsophisticated version of the previous Lancia-Ferrari, the principal difference being the engine. Enzo Ferrari's son Alfredo, known as 'Alfredino' or 'Dino', had favoured a V6 configuration – Ferrari Senior named the car in Dino's honour after his death in 1956 from muscular dystrophy and nephritis at the age of 24. Originally intended for the 1.5-litre Formula 2 regulations, the V6 was gradually enlarged to 2.4 litres (hence the title '246').

For 1959, the Dino 246 received suspension modifications, a five-speed gearbox, slightly increased wheelbase, the permanent introduction of disc brakes, revised bodywork with higher cockpit sides and a smoother, more elegant nose. Plus, of course, continual improvement to the V6 engine – which, as a necessary resort, was moved (much against the traditional ethos of Enzo Ferrari) to the rear of the car during 1960.

Engine	Ferrari V6
Size	2474 cc
Power	290 bhp
Weight	560 kg (1230 lb)
Wheelbase	2162 mm (85.1 in)

TEAM HISTORY

Enzo Ferrari raced in the 1920s and formed Scuderia Ferrari in 1929 to race Alfa Romeos on behalf of the Italian motor manufacturer. When the relationship deteriorated in 1938, Ferrari began building his own cars, entering the Mille Miglia sports car race. Ferrari resumed car manufacturing and racing at the end of World War II. Raising his sights, Enzo Ferrari produced his first Grand Prix car in 1948 and won the first of many World Championships in 1952. The Dino 246 would provide Ferrari with his fourth driver's title in 1958.

THE DESIGNER

Enzo Ferrari attributed the V6 engine to Dino, more, it is thought, in tribute to his departed son rather than through technical input, despite Dino's degree in engineering. It was quietly accepted that, at best, Vittorio Jano (see 'Lancia D50', page 18) had guided Dino's hand. The chassis was designed by Carlo Chiti, formerly with Alfa Romeo. The 32-year-old Italian had taken over from Andrea Fraschetti when the engineer was killed in August 1957 while testing a Formula 2 Ferrari at the Modena Autodrome.

FAMOUS DRIVERS

The era of the Dino 246 coincided with a period when Enzo Ferrari was at his most mischievous as he played one driver off against another. Having been one of Ferrari's favourites, especially at Monza in 1956 (see 'Lancia D50', page 18), Peter Collins fell from favour when, in Ferrari's eyes, the handsome Englishman was likely to lose his edge as a driver following his marriage to an American actress. Just before the 1958 French GP, Collins was demoted to F2 driver. Ferrari relented, but only after robust objections by Collins and his team-mate, Mike Hawthorn. In the same race Luigi Musso, the only Italian driver of note who had won a non-championship race for Ferrari earlier in the year, was killed. Musso felt excluded by his British team-mates and was chasing Hawthorn's leading car on the high-speed road course when the Dino 246 left the road at the 249 kph (155 mph) Courbe du Calvaire. Following the death of Collins in 1958, and Hawthorn's retirement soon afterwards, Tony Brooks moved from Vanwall and scored stylish wins in 1959 at Reims and on the banking of the super-fast Avus track in Berlin.

Mike Hawthorn (seen leading the 1958 Monaco Grand Prix in his Ferrari Dino 246) became the first Briton to win the World Championship.

MEMORABLE RACE

Avus was used just once to stage a World Championship Grand Prix – which was probably just as well since the track in a western suburb of Berlin had little to offer other than the need for extreme bravery on the part of the driver. The 8.3 km (5.2-mile) circuit consisted of two sides of a dual carriageway, the 282-kph (175-mph) straights linked at one end by a brick-built banked curve. The gravitational force on the 45-degree banking did its best to push drivers through the floors of their cars. Unlike the banking at Monza, however, Avus did not allow cars to find a natural line. It was necessary to physically steer to avoid being drawn to the top, where only a flat ledge lay between continuing and

The Ferrari Dino 246 of Tony Brooks leads the field off the fearsome brick-built banking at Avus during the 1959 German Grand Prix.

flying off the banking and into the paddock below. The F1 drivers went to the start knowing that a former Ferrari driver, Jean Behra, had been killed in a sports car race the previous day. In wet conditions, the Porsche had spun over the top, smashed into a building and flung Behra from the cockpit. The Grand Prix was run in two heats, Tony Brooks winning them both, with the Englishman learning to master the art of slipstreaming, and putting himself in contention for the championship.

Cooper T51

'Luckily, I knew a bit about motor cars and I was able to help Coopers considerably with development of the race car. We were able to prove to the world that a rear-engined car was the way to go in Grand Prix racing.'

Sir Jack Brabham

The Cooper T51 may have been small, but its effect on Formula 1 history was huge. In 1959, the British car became the first to win the F1 World Championship with the engine mounted behind the driver.

There were many benefits to be had from this fundamental change to F1 car design. By removing the need to have the propeller shaft run from the engine at the front to the transmission at the rear, the driver could sit lower and minimise even further a frontal area already reduced by the absence of the engine. The smoother shape reduced drag, while the driver enjoyed the benefit of no longer having waves of stifling heat coming from the front of the car.

A more compact gearbox and transmission at the rear would produce less torque and stress, and allow lighter support structures, all of which would benefit acceleration, permit smaller brakes and generally allow more nimble handling. It was a win-win all round.

The Cooper Car Company, manufacturers of racing cars for many categories, benefitted from a revision to the regulations for 1959. The 2.5-litre capacity limit remained but engines had to be fuelled by AvGas aviation spirit, which offered better consumption than the previous choice of methanol. In addition, the substantial reduction of Grand Prix race distances from 500 km/three hours to 300 km/two hours would mean smaller fuel tanks, enhancing even further the fuel economy created by the British-built Coventry-Climax four-cylinder engine.

Following company practice, Cooper made their cars available to private entrants. One such, Rob Walker Racing, had already scored Cooper's first two F1 victories with a T45 (the less powerful forerunner to the T51) the previous year, with Cooper finishing third in the newly constituted Constructors' Championship behind Vanwall and Ferrari.

For 1959, the works team was ready from the outset. Jack Brabham won the Monaco and British Grands Prix, and

had points placings elsewhere, putting the Australian in the running for the championship, which he won at the final round in the United States.

Just as important for Cooper, victories for Moss in the Walker entry in Portugal and Italy, meant the small team from Surbiton in Surrey won their first Constructors' Championship. Such a heady moment for John Cooper was heightened even further when the championship was clinched on Ferrari's doorstep at Monza, the team boss rejoicing by doing one of his celebrated somersaults – and landing flat on his back on the edge of the track! It would be the prelude to more moments of euphoria as Brabham and Cooper went on to do the double in 1960 – by which time the Cooper Car Company had been instrumental in changing the face of motor racing.

THE CAR

The Cooper T51 was a natural development of the T43 and T45, which had given Cooper their first F1 wins in 1958. The T51 continued the use of a spaceframe chassis, the engine being behind the driver, with the weight-saving advantages this inferred. Going against perceived knowledge, the tubular frames were curved, careful calculations allowing them to accept loads without compromising the rigidity of the frame. A further contribution to the Cooper's improved handling came from locating the fuel tanks on either side of the cockpit rather than at the rear.

The four-cylinder engine was commissioned from Coventry-Climax, a British company producing, among other items, fork lift trucks and fire pumps. The efficiency and lightness of their overhead camshaft engine had appealed to small independent race car manufacturers, who persuaded Coventry-Climax to think about engines for motor sport. The first Coventry-Climax race engine appeared in a sports car at the 1954 Le Mans 24-Hour race.

The main difficulty was sourcing a gearbox for F1 – Cooper modified a Citroen unit. Rob Walker Racing chose an Italian Colotti gearbox which, although purpose made, was more fragile.

Engine	Coventry-Climax 4-cylinder in-line
Size	2495 cc
Power	240 bhp
Weight	701 kg (1545 lb)
Wheelbase	2462 mm (104 in)

Jack Brabham swings his Cooper T51 through the infield at Aintree while leading every lap of the 1959 British Grand Prix.

TEAM HISTORY

At the end of World War II, motor sport enthusiasts were looking for cars to race. Charles Cooper, proprietor of a garage in Surbiton, Surrey, assisted his son John to cobble together a chassis linking, at either end, front suspension from a damaged Fiat 500 Topolino that happened to be in the garage. Since motorcycle engines were in plentiful supply, here was a cheap and simple powerplant with chain drive direct to the rear wheels, therefore placing the driver ahead of it. The combination was perfect for the popular and inexpensive 500cc Formula 3 class. The Cooper Car Company Limited was founded in 1948 in anticipation of demand for these simple little racers with their spindly wheels. Such was their domination that Formula 3 became affectionately known as 'Formula Cooper'. Expansion into sports cars and Formula 2 followed with cars that were reliable and competitive. The company's mounting ambition saw a move to Grand Prix racing when F2 became the world championship formula in 1952. The F2 Coopers were front-engined, powered by Bristol and Alta engines, with the rear-engine concept taking hold in 1957 when F2 cars were limited to 1.5-litre engines. Adapted from a sports car, the Cooper T41 formed the nucleus of what would become the championship winning T51 Grand Prix car.

THE DESIGNER

Owen Maddock studied engineering at Kingston Technical College and went to work for the nearby Cooper Car Company in 1948, the company being so small that Maddock was a Jack-of-All-Trades until, a few years later, finding himself in the role of Chief Designer. Having seen the company's growth through the little Cooper 500s with their motorcycle engines, Maddock was well-versed in the company's rear-engine ethos when the time came to take a serious run at Grand Prix racing. The Cooper T51 was the result of his work at the drawing board and close consultation with Jack Brabham, a capable engineer as well as driver.

FAMOUS DRIVERS

With the T51 being run successfully by private teams as well as the Cooper Car Company, the roster of drivers came close to 30 in number. The Grand Prix winners were Jack Brabham, Stirling Moss, Maurice Trintignant and Bruce McLaren, with Masten Gregory and Roy Salvadori taking podium finishes.

MEMORABLE RACE

Jack Brabham went to the final race of the 1959 season knowing that fourth place or higher in the United States Grand Prix would bring the Australian his first World Championship. That seemed assured when his rivals, Tony Brooks and Stirling Moss, ran into various problems. Moss had led until sidelined by gearbox trouble on his Cooper; Brooks was recovering from a time-consuming pit stop early in the race. Brabham was leading comfortably when, within sight of the chequered flag, his Cooper ran out of fuel and spluttered to a halt. With Brooks making up ground rapidly, Brabham knew he had to get his car across the line – unaided. The final 400 yards of the Sebring circuit were uphill. As Brabham pushed the Cooper all the way, he was overtaken by three cars, including the Ferrari of Brooks. Fortunately for Brabham, the remaining runners were more than a lap behind. An exhausted Brabham collapsed as he and the Cooper rolled across the line nearly five minutes later, but in the necessary fourth place. Cooper's day was made complete when Bruce McLaren scored his maiden victory to become the youngest Grand Prix winner at the age of 22.

With an official warning well-meaning helpers against assisting Jack Brabham, the exhausted Australian pushes his Cooper T51 towards the finishing line at Sebring to be classified fourth in the United States Grand Prix and claim the World Championship.

Ferrari Dino 156

'I liked the Nürburgring. The Ferrari 156 was perfect there. The car flew so beautifully, landed so beautifully. Lap by lap we went faster and faster. We got the lap record; the first time round there under nine minutes. Incredible.'

Phil Hill

One of the most striking F1 cars of all time, mainly thanks to its distinctive nostril radiator intakes, led to the Dino 156's unofficial title 'Sharknose'. The Ferrari's performance matched its looks, thanks in large part to a V6 engine, the next in line in the Dino hierarchy. The 156 won the 1961 F1 World Championship but, in keeping with Ferrari's often difficult reputation, the beginning and end of the Sharknose story would be tinged with controversy.

Enzo Ferrari had caught the competition – most notably the British – on the hop by being prepared and ready for a change in formula from 2.5 to 1.5 litres despite giving the illusion that might not be the case. By the time his rivals had stopped complaining about the reduction in engine size, the Ferrari team was into its stride to such an extent that the title boiled down to a battle between two of its drivers, Germany's Wolfgang von Trips and Phil Hill from the United States.

The potential pleasure of the moment would be shattered when von Trips, the heir-apparent, was killed during the final race at Monza. The repercussions of such a tragedy, particularly on home turf, would reverberate throughout the team, leading to the departure of several key figures. Meanwhile, the recovering competition would ensure the days of the Sharknose would not stretch into 1962. But it had looked and sounded glorious while it lasted.

THE CAR

This was the first Ferrari F1 car designed from scratch with an engine in the rear. Development of a small capacity version of the V6 had been taking place during the final three years of the 2.5-litre formula. A Ferrari 246 with a central engine had appeared during the 1960 Monaco Grand Prix and at a non-championship race (won by von Trips) on the Solitude road circuit in Germany. Over time, the suspension was altered and the transmission improved, with the 1.5-litre prototype making its first appearance in the Italian Grand Prix.

When the Sharknose made its entrance at a non-championship race at Syracuse in Sicily in April 1961, the red car was powered by the latest version of the 65-degree V6. Meanwhile, development was at an advanced stage with a 120-degree V6, which would be better suited as a central engine with a lower centre of gravity and easier installation in the tubular chassis. In addition, the wider vee would allow more room for experimental carburettor or fuel injection systems. Despite these advances in certain areas of engineering, Ferrari would become the last team in F1 to retain centre-lock wire wheels.

Engine	Ferrari V6
Size	1476 cc
Power	190 bhp
Weight	460 kg (209 lb)
Wheelbase	2300 mm (91 in)

TEAM HISTORY

There had been massive indignation among the British teams in December 1958 when motor sport's governing body announced that, from 1 January 1961, F1 would be for cars with a minimum weight of 500 kg, and a maximum engine capacity of 1.5 litres unsupercharged. The widespread feeling was that these underpowered cars would be slow and unspectacular, with teams such as Lotus, BRM and Cooper pushing for a so-called Intercontinental Formula for 3-litre cars to be adopted as the World Championship standard. As the British huffed and puffed, Enzo Ferrari made occasional encouraging noises about the Intercontinental Formula, knowing full well that work was continuing at pace on his 1.5-litre car. When the Sharknose was unveiled in March 1961, it was effectively game over. The British teams realised, too late, during the previous summer that the 1.5-litre formula was not going away and the crafty Enzo Ferrari was ahead of the game. A reduction of the minimum weight to 450 kg was seen as a patronising concession and did nothing to lesser the ire in British quarters.

THE DESIGNER

Carlo Chiti, having been responsible for the Dino 246, made the transition to the design of the Sharknose. In the process of evolving the engine, Chiti could see the benefits of producing a completely new 120-degree V6. Meanwhile, Enzo Ferrari had hired Mauro Forghieri, a bright young engineer whose father had worked at Maranello for many years. The original intention was for Forghieri to gain experience before pursuing his dream of working for a gas turbine company in the United States. Following a sudden and dramatic upheaval within his technical department at the end of 1961, Ferrari offered to put Forghieri in charge of all motor sport activity and testing. Although stunned by the offer at first, Forghieri accepted. He would become one of the sport's most significant designer/engineers and remain with Ferrari for more than 25 years.

FAMOUS DRIVERS

For 1961, Enzo Ferrari nominated Phil Hill, Wolfgang von Trips and Richie Ginther as his F1 drivers but, typically, did not designate a team leader. Von Trips and the two Americans effectively spent the season racing each other. Ferrari also supported Giancarlo Baghetti in a Sharknose run by an amalgamation of small Italian racing teams. Von Trips won in The Netherlands and Britain. Hill finished first in the Belgian Grand Prix and claimed pole position on the Nürburgring Nordschleife. On race day in Germany, the Ferraris were beaten – as they had been at Monaco – by the brilliance of Stirling Moss in a less-powerful Lotus. Hill would be the reluctant winner of the tragic final round at Monza.

Phil Hill relishes the handling of his Ferrari 156 Sharknose in 1961 as he tackles the Karussell on Germany's Nürburgring Nordschleife.

MEMORABLE RACE

The Federation Italiana Scuderie Automobilsche (FISA) was a group of racing teams with the combined aim of promoting a new generation of Italian drivers. Giancarlo Baghetti was entrusted with a Ferrari 156 for the debut of the Sharknose at Syracuse in Sicily. The 25-year-old Milanese driver not only won this race but also another non-championship Grand Prix at Naples. It may have been a very impressive start to Baghetti's F1 career, but he was expected to be no more than a supporting act when FISA was asked to bring this car along to the French Grand Prix at Reims. In any case, Baghetti's Sharknose would have the 65-degree V6, whereas the three works cars would have the latest 120-degree engine.

Sure enough, Ginther, Hill and von Trips ran line-astern at the front but, one by one, they ran into trouble, leaving

Despite his inexperience, Giancarlo Baghetti looks relaxed in the Ferrari 156 as he follows the Porsche of Dan Gurney during the 1961 French Grand Prix at Reims. The distinctive nose of the Sharknose shows signs of having been peppered by grit from the surface of the super-fast road circuit.

Baghetti to do battle with Jo Bonnier and Dan Gurney. The Porsche drivers used their combined experience to constantly slipstream and outfox the novice on the long, fast straights. When Bonnier ran into engine trouble with two laps to go, it was left to Gurney to deal with the young pretender. Gurney took the lead under braking for the final corner and positioned his Porsche in the middle of the road for the long blast to the finish line. Baghetti tucked into the silver car's slipstream, feinted to the left and then jinked right, timing the move to perfection as he pulled alongside Gurney and won the race by one tenth of a second. It would be the last time in his career that Giancarlo Baghetti would win a major international motor race.

BRM P57

'The BRM [P57] never really went well on tight circuits such as Monaco; it didn't like hairpins too much and didn't get its power down on the road as well as the Lotus. It was also pretty heavy compared to the rest. But at Zandvoort – where I won my first Grand Prix – the car went beautifully. I had absolutely no problems with it at all.'

Graham Hill OBE

BRM (British Racing Motors) had endured a difficult time in the 1950s, trying to become established as a serious Grand Prix contender. A single win with a front-engine car in 1959 had done little to soften the scepticism, added to which BRM, along with most British teams, had been late to the 1.5-litre party in 1961. The following season was seen to be make or break. Thanks to the P57, it was the former as BRM won the Drivers' and the Constructors' Championships in 1962.

Following the trend, the P57 was BRM's latest version of a rear-engine car, the lessons from previous models coming in time to provide a competitive mount for BRM's new V8. Having been with the team for two seasons, Graham Hill was ready to make the most of the neat P57 as he won in The Netherlands, Germany and Italy. The British driver went to the final round in South Africa leading on points and was assured of the race win and the title when the Lotus of his rival, Jim Clark, retired.

The P57 continued into the following season and BRM appeared to have the upper hand once more by winning a couple of non-championship races, with Hill taking his first victory at Monaco, the opening round of the 1963 championship. But not even the arrival of the P57's successor, the P61, would stop a rout by Jim Clark and his Lotus 25 during the rest of the season.

THE CAR

BRM made their first venture with a rear-engine car in 1960. The P48 – in effect, a converted front-engine car from the previous year – turned out to be no better than a test bed as it was chopped and changed, and ran with a variety of engines. It was little surprise when BRM finished at the bottom of the championship. The P57 was not only timely, but also attractive – apart from, in the early races, having four exhausts on either side of the car pointing skywards. When it was realised the pipes in this configuration were limiting performance (in addition to frequently falling off), a lower and sleeker system allowed BRM to extract the maximum from their excellent fuel-injected V8 engine. The brakes had also been improved, which was a relief for the drivers who had been relying on a single disc attached to the rear transmission of the earlier P48. The lower, lighter and slimmer P57 would claim four Grands Prix wins and two podium finishes.

Engine	BRM V8
Size	1498 cc
Power	188 bhp
Weight	635 kg (1400 lb)
Wheelbase	2286 mm (90 in)

TEAM HISTORY

In 1933, three motor racing enthusiasts formed ERA (English Racing Automobiles) with the intention of manufacturing single-seater racing cars capable of upholding British prestige abroad. They achieved their aim before World War II intervened. By the time hostilities ended in 1945, two of the founders, Raymond Mays and Peter Berthon, had developed more ambitious plans. They wanted to build a Grand Prix car; a state-of-the-art machine financed and built by, and racing for, Great Britain. When Mays approached home industry to raise finance, the response was positive. Within 12 months, he had raised £25,000; a considerable figure at the time but one that would soon be devalued by post-war inflation. With more than 100 firms involved, however, there could be no turning back.

It was agreed that the car would be known as the British Racing Motors, or BRM for short. As if Mays and Berthon did not have enough problems, they opted for a complicated and highly ambitious supercharged V16 engine. Meanwhile, British industry was struggling to find its feet and it took until May 1949 for all the parts to be delivered. When the BRM V16 was finally complete, it sounded glorious – but proved as difficult to drive as it was to run reliably. Public expectation, fanned by patriotic newspaper coverage, reached such a pitch that the car was entered for a race far sooner than Mays and Berthon would have wished. When the BRM attempted to start from the back of the grid at a non-championship event at Silverstone, it broke both driveshafts. The much-vaunted car quickly became the butt of music hall jokes. When BRM went into decline in 1952, Alfred Owen (MD of the Rubery Owen Group) took over the assets and liabilities and continued his support as BRM finally won a Grand Prix seven years later. A complete failure to prepare for the 1.5-litre formula in 1961 brought an ultimatum from Owen, as the threat of closure hung over the team from Lincolnshire. The arrival of the P57 turned everything around in 1962 as BRM went from the bottom to the top of the championship in a single season.

THE DESIGNER

Tony Rudd trained as an engineer with Rolls-Royce. The Englishman was seconded to BRM thanks to the engine and luxury car manufacturer making superchargers for the BRM V16. Rudd remained with the team, assuming full technical control in 1960 and was responsible for the BRM P57, largely at the insistence of the drivers who valued his organisational as well as design skills. The V8 engine was designed by Peter Berthon and Aubrey Woods, both having been with BRM since the formative days of the V16.

FAMOUS DRIVERS

Graham Hill and Richie Ginther drove for BRM in 1962, the American joining that year, Hill having been with the team since 1960. Ginther, an outstanding development driver, was a perfect fit and backed up Hill's four championship Grand Prix wins with third place in the French Grand Prix at Rouen, and recording a 1–2 finish for BRM in Italy.

As reigning World Champion, Graham Hill applies a touch of opposite lock in his BRM P57 as he presses on during the 1963 British Grand Prix, in which he started and finished third. By this stage, in their second season with the P57, BRM had applied an orange nose band which would become synonymous with the British team.

MEMORABLE RACE

Graham Hill cited the 1962 German Grand Prix as one of his best drives. It was certainly the most dramatic – starting with a huge accident during practice. The Nürburgring Nordschleife was difficult enough without the private entrant, Carel de Beaufort, agreeing to have a camera fitted to his Porsche. There was scant knowledge of the effect of pummelling dealt out by the track's many dips and bumps. When the camera fell off the Porsche on a fast, downhill section, Hill not only hit the camera but also damaged the BRM's oil tank, the contents spraying the rear wheels and sending the P57 into a ditch, where it tore off a rear wheel before coming to a halt halfway up a bank. Hill was bruised, but fit enough to take part with the spare BRM in the race. Bringing further menace to this daunting track, the rain was so bad that the race had to be delayed due to an earth bank having subsided on the track. With every driver starting on the same Dunlop rain tyre, Hill gave himself an advantage by removing the front and rear anti-roll bars to make the BRM more forgiving on the slippery surface. Hill took the lead at the end of the second lap and, for the rest of the race, fought an unremitting battle with the Lola of John Surtees and Dan Gurney's Porsche, the first three separated by 4.4 seconds. The rain never relented during a race that had lasted for two and a half hours.

The BRM P57s of Graham Hill (#11) and Richie Ginther (#12) struggle for grip at the start of the 1962 German Grand Prix at the Nürburgring Nordschleife. Hill would claim victory after a race-long battle in the rain with the Lola Mk4 of John Surtees (#14) and the pole position Porsche 804 of Dan Gurney (#7). Jim Clark, having qualified third between Hill and Surtees, is engulfed by the field after forgetting to switch on the fuel pump on his Lotus 25 (#5).

Lotus-Climax 25

'The 25 was virtually shaped around me. The design had me lying back to reduce frontal area. This was somewhat more accentuated than it had been in either the Lotus 21 or 24. Once I had mastered the new position, I wondered how I had ever driven a racing car any other way.'

Jim Clark OBE

When the Lotus 25 first appeared in 1962, rivals were immediately crestfallen. How on earth were they going to beat this car? It not only looked the part but, in the hands of Jim Clark, would go on to rewrite the Formula 1 record books in every department. It is not an exaggeration to say the Lotus 25 revolutionised racing.

Lotus cars had taken part in Grands Prix since 1958. Each model would be a clever development of its predecessor thanks to the inventive brilliance of Colin Chapman. But when he rolled out the 25, it was obvious the Lotus boss had taken a huge step forward with his fundamental design ethos of lighter, lower and faster. That was proved, almost from the word go, when Clark won pole position and set fastest lap on the car's first appearance at Monaco before going on to win the Lotus 25's third Grand Prix at Spa.

In 1963, Clark and the 25 really got going. The Scotsman started 20 F1 races, won 12 of them and set 11 fastest laps. He claimed seven pole positions in the ten World Championship Grands Prix, won seven and finished either second or third in two of the remaining three. It would not be uncommon for Clark to finish a minute or more ahead of the next man. More than once, he lapped the entire field. Even allowing for the driver's natural brilliance, there is no question that the car played its part. An affinity between Clark and Chapman allowed them to fine-tune the Lotus 25 and make the most of such superior and clever thinking from its designer.

THE CAR

By introducing a monocoque chassis, Chapman made the tried and trusted spaceframe construction obsolete overnight. The Lotus 25 was perfectly proportioned. The monocoque was effectively two pontoons carrying the fuel and linked by bulkheads front and rear, an undertray and a dash-panel frame. This 'bath tub' profile allowed Chapman to design his latest car around Clark, whose slight build suited a car that was sleek, compact and stunning to behold. The use of a stressed skin chassis brought lightness and previously unmatched rigidity. Power was provided by the latest Coventry-Climax engine, a V8 first seen in the Lotus 24.

The 1963 Dutch Grand Prix at Zandvoort typified the brilliance of the Jim Clark/Lotus 25 combination. The Scotsman led from pole position, lapped the entire field and set fastest lap.

Engine	Coventry-Climax V8
Size	1497 cc
Power	195 bhp
Weight	451 kg (995 lb)
Wheelbase	2286 mm (90 in)

TEAM HISTORY

Lotus Engineering was formed in 1952 by Colin Chapman, a bright 24-year-old who had started out by building trials cars in a rudimentary lock-up garage in North London. The first Lotus, the Mark 1, was based on an Austin 7 two-seat sports car. Chapman produced the first single-seater racing car carrying a Lotus badge in 1957. The Lotus 12, initially designed for Formula 2, was small with a low frontal area ahead of the Coventry-Climax four-cylinder engine. Modifications and an increase in engine capacity brought the step up to Formula 1 with a two-car entry for the 1959 Monaco Grand Prix. A Lotus 12, driven by Cliff Allison, finished sixth, several laps behind the winning Ferrari. When the Lotus 16 failed to bring an improvement in reliability and results in 1959, Chapman turned his attention to designing a car with the engine behind the driver.

The Lotus 18 may have had a more angular appearance than the all-conquering Cooper T51, but Stirling Moss put the Lotus to good use when he took pole position and won the 1960 Monaco Grand Prix in the dark-blue 18 entered by Rob Walker Racing, a result he repeated at Riverside in the United States. The works team did not score their first victory until the same race (this time at Watkins Glen) a year later – Innes Ireland's victory in a Lotus 21 being rewarded with dismissal to make way for Jim Clark to become number 1 driver. Clark's initial forays were with the Lotus 24, which was effectively a customer car and a stopgap until the arrival in May of the Lotus 25 at the opening round of the 1962 World Championship in The Netherlands.

THE DESIGNER

Colin Chapman studied structural engineering at University College London before completing national service with the RAF and joining the British Aluminium Company. The combination of experience with all three would provide a useful grounding in the manufacture of racing cars that were light and efficient. Chapman was taken on as a consultant by Tony Vandervell to assist with the redesign of the Vanwall F1 car for 1956. In October of that year, Chapman unveiled the Lotus 12, manufactured in outbuildings behind his father's pub in Hornsey, North London. The company, later to become Group Lotus, moved to a purpose-built factory at Cheshunt in Hertfordshire, from where Chapman indulged his passion by producing road and racing cars noted for ingenuity and style.

FAMOUS DRIVERS

Cliff Allison and Graham Hill were among the first to race for Lotus, the list of drivers expanding exponentially with the growth in sales of race cars to private entrants. Stirling Moss was the most successful of these, with the Englishman pulling off a memorable win with the Rob Walker Lotus 18 by defeating a trio of Ferrari 156 'Sharknoses' at Monaco in 1961. Innes Ireland may have provided the works team with their first victory in the US Grand Prix at the end of the same year, but it was Jim Clark who would be forever associated with Lotus, the 25 providing the springboard for this remarkable partnership.

Jim Clark was synonymous with early success at Lotus, his affinity with Colin Chapman allowing them to fine-tune the Lotus 25 into a winning car.

MEMORABLE RACE

It is one of the ironies of F1 folklore that Jim Clark hated Spa-Francorchamps and yet he won the Belgian Grand Prix four times. An even greater paradox is that one of his greatest drives came in appalling conditions when the 15-km (9.3-mile) road circuit was at its most treacherous. And he did much of it one-handed while holding the gear lever in place.

Clark's dislike had been spawned at an early stage. His first motor race abroad happened to be in a sports car at Spa on a weekend in 1958 when a fellow Scot, Archie Scott-Brown, was fatally injured in a fiery accident. When Clark made his F1 debut at the same circuit two years later, his antipathy was intensified by the loss of two British drivers (one of whom was a very good friend) and serious injury to another.

The arrival of the Lotus 25 in 1962 helped Clark expunge his fear of the place as he scored his first Grand Prix win. Twelve months later, he returned with the latest Lotus 25, but problems during practice meant eighth place on the grid. A perfect start put him into the lead as the pack rushed downhill to Eau Rouge, the first corner. After five laps, Clark was eight seconds in front. Problems for his nearest challengers extended that lead to more than a minute.

Then came rain, a perennial hazard in this part of the Ardennes. Conditions were so bad that lap times extended by more than two minutes. By this stage, Clark was having to contend with the Lotus jumping out of fifth gear – the last thing any driver needed on a high-speed circuit such as this. Clark had to hold the lever in place with his right hand while negotiating the daunting left-right Masta Kink, his left hand holding the wheel low, the better to apply opposite lock and deal with an inevitable 210-kph (130-mph) slide close by a stout stone building at the exit. Given the conditions at Spa and Clark's aversion to racing there, it was an exceptional performance. He won by almost five minutes.

After a brilliant start from the third row of the grid, Jim Clark leads the field through the first corner of the 1963 Belgian Grand Prix at Spa-Francorchamps. The Lotus 25 is ahead of Graham Hill's BRM P57 and the Brabham BT7 of Dan Gurney (#16).

Honda RA272

'I didn't get a perfect start [in the 1965 Mexican Grand Prix]. Dan Gurney and Jimmy Clark were the two qualifiers ahead of me. I had to slip the clutch to bring the revs back up. When I booted that throttle, the Honda went like a dragster. I went right between the two of them with a full head of steam. I never saw anything like it. When I exited Turn 2, there wasn't anybody in my mirrors.'

Richie Ginther

When Honda won a Grand Prix for the first time, their car, the RA272, was immediately obsolete. However, that did not detract from a timely sense of achievement just 18 months after the Honda Motor Company's F1 debut, and two years into the Japanese firm's production of trucks and cars.

The 1965 Mexican Grand Prix may have marked the end of the 1.5-litre formula, but it gave Honda an eleventh-hour chance to show their worth by leading every lap in Mexico City. Until then, progress in the previous ten races had been stumbling – if exceptionally noisy. The shrieking V12 had eventually become the most powerful F1 engine thanks, in part, to Honda's experience accumulated during years of impressive performances in international motorcycle racing.

Turning attention to competing on four wheels, Honda had gone straight to the top and produced their own Grand Prix car without significant input from any of the established F1 teams. The most striking feature of the first Honda F1 car, the RA271, was its engine – a transverse V12 mounted in a basic tube-frame chassis.

The RA271's successor, the RA272, was a more sophisticated monocoque car when Honda arrived, for the best part of a full season, with two cars in 1965. Advances in engine performance eventually began to show at the fast Spa-Francorchamps circuit, where Richie Ginther qualified fourth and finished sixth. The American driver briefly led the British and Dutch Grands Prix although mechanical problems continued to plague the industrious little team.

That changed at the final race in Mexico. Ginther qualified third and led every lap, and the second Honda of Ronnie Bucknum making the day complete by finishing fifth.

The chequered flag brought an end to the life of the 1.5-litre formula and, with it, the RA272. But Honda had absorbed valuable lessons in preparation for the arrival of the 3-litre formula in 1966.

THE CAR

The RA272's most noticeable feature, both visibly and aurally, was its 60-degree V12 engine mounted across the car in a tubular subframe attached to the back of the monocoque chassis. Showcasing Honda's history in motorcycle racing, the V12 went against convention with four valves per cylinder, needle roller bearings and revving to 12,000 rpm. The ensuing power reached the road through a six-speed gearbox.

Engine	Honda RA272E V12
Size	1495 cc
Power	240 bhp
Weight	498 kg (1098 lb)
Wheelbase	2300 mm (91 in)

TEAM HISTORY

Soichiro Honda was ambitious. Having established a company to make motorcycles in 1947, he saw motor racing as a perfect platform for his products. Not one to do things by half, Honda announced his intention to enter the Isle of Man TT – and win. In 1961, Honda dominated the 125cc and 250cc classes in the classic road event.

Turning his attention to cars and trucks, Honda could see the potential global leverage from success in Formula 1. The Honda R&D division bought a Cooper-Climax F1 car in 1961 with the intention of installing a Honda V12 engine in the back. When this presented too many potential problems, the pragmatic Honda decided to build the chassis as well.

The spaceframe RA271 ran in three exploratory Grand Prix outings in 1964. The first was at the Nürburgring, the most difficult track imaginable on which to make a debut in any class of racing, never mind F1. The choice of

driver seemed just as irrational when Honda nominated Ronnie Bucknum, a young American who had been successful in sports car racing on the West Coast, but who had never driven a single-seater anywhere, never mind on the fearsome Nordschleife. The choice was prompted by Honda's imminent launch of the 600 car in the USA. It was also true that, if Bucknum did well, then the RA271 would receive acclaim. If he struggled, the driver would be the scapegoat. In the event, Bucknum gave a good account of himself, starting from the back and, in wet conditions, moving into the midfield before the steering broke – fortunately without serious consequence. The remaining two races would be plagued with the anticipated teething troubles, all of which aided preparation for an eight-race assault in 1965.

THE DESIGNER

The Honda RA272 ('RA' standing for 'Racing Automobile') was the product of Honda's Research & Development department, headed by Yoshio Nakamura who, along with Shoichi Sano, took most of the credit for the design of both car and engine. Nakamura came from an aeronautical background, having designed fighter plane engines during the World War II. He joined Honda in 1958 and worked on engines for the Honda S360 road car. Fluent in English, Nakamura became project leader and managed Honda's F1 team from its inception.

FAMOUS DRIVERS

Ronnie Bucknum, a surveyor by profession, was chosen to make Honda's F1 debut. The second motor race Bucknum ever saw was the one he was in as the driver of a Porsche 356 Speedster, at a local sports car event at Pomona in California in 1956. Bucknum was capable enough to be offered drives by the American entrant and former international racer, Carroll Shelby. Bucknum was signed by Honda in March 1964 and remained with the F1 team until the end of the following year.

When Honda decided to up its game for 1965, Richie Ginther was signed as lead driver. The American had a solid reputation after two seasons with Ferrari (finishing second in the Monaco and Italian Grands Prix), and three years with BRM, which brought several podium finishes. Better than that, the wiry Californian was an excellent test and development driver – a perfect combination for Honda at this early stage of their F1 venture. It was on Ginther's suggestion that the RA272 was fitted with a manual fuel/air mixture control for the Mexican Grand Prix and turned up to full rich. It would pay huge dividends in a race run at altitude.

Honda designed their own chassis and mounted the V12 engine across the rear of the RA272.

MEMORABLE RACE

The final race for the Honda RA272 was always going to be significant. Not only was this the last-chance saloon for a shoot-out in the 1.5-litre formula, the car and all its intense development during the preceding 12 months would become redundant overnight.

Honda made the most of an opportunity to test between 6 a.m. and 9 a.m. each day before official practice started. There was much to fine tune on a complex fuel injection system, Mexico City being 2,134 metres (7,000 feet) above sea level. Once sorted, the Honda not only proved quick during practice but also underlined the team's potential when Bucknum and Ginther, as had become the norm, swapped cars – and continued to set fast times. They qualified third and tenth, Ginther ahead of Bucknum.

Within the first few hundred metres, it was game over for the competition as Ginther stormed into the lead and pulled away. The V12s did not miss a beat, Bucknum scoring his first (and only) championship points by finishing fifth, albeit a lap down on his victorious team-mate. It was the only Grand Prix in 1965 not to have been won by either a British-powered car or British driver, and the first Grand Prix win for both Honda and Goodyear tyres.

Richie Ginther was the perfect choice for Honda's first full season of F1 racing in 1965. Ginther had not only gained experience with Ferrari and BRM but the American was also an excellent test and development driver. Assiduous work by Ginther and the team produced a powerful car ideally suited to run at altitude and score an impressive win in the final race of the season in Mexico City.

Brabham-Repco BT19/BT20

'That 3-litre Repco was so simple to drive: very smooth and progressive. And the BT20 was so easy to drive in that race [1967 Monaco GP, won by Hulme]. It was unbelievable; as if on remote control; computerised. You could slow the thing up simply by throwing it sideways at the corner.'

Denny Hulme OBE

Rather than bristle with innovation to greet the dawn of the 3-litre era in 1966, the uncomplicated Brabham BT19 (and its slightly modified successor, the BT20) was the model of pragmatism and simplicity. While rivals struggled with technically challenging cars and engines to suit the new formula, Jack Brabham produced a relatively straightforward package, got on with the job by winning four Grands Prix and claimed his third World Championship before the season was done.

Everything about the operation was mix and match. Pondering how to handle the change from 1.5 to 3 litres, Brabham got into conversation with Repco, an Australian tuning company he knew and respected. Together, they worked on the idea of modifying an Oldsmobile V8 and installing it in the back of a BT19 – which had originally been designed for something else. With additional clever and fundamentally sound chassis engineering from Ron Tauranac (the 'T' in Brabham 'BT' prefix), the Brabham BT19 was ready for the new season while others dithered and delayed. At the end of the third round of the championship in France, Jack Brabham had become the first to win a Grand Prix in a car bearing his own name. It would be the start of an Indian summer for the 40-year-old Australian.

THE CAR

Despite the advent of the monocoque (courtesy of Colin Chapman and the Lotus 25), Ron Tauranac continued to have faith in a multi-tubular space-frame chassis. The Brabham BT19, created to accept a flat-16 Coventry-Climax engine, was sitting idle following the failure of the 1.5-litre engine to appear. With time running out before the advent of the 3-litre formula, the BT19 was considered suitable for modifications to receive a V8, following Jack Brabham's late negotiations with Replacement Pty Limited, a company in Melbourne operating under the 'Repco'

Denny Hulme powers his Brabham BT20 out of Station Harpin on the way to winning the 1967 Monaco Grand Prix.

62

Parts brand name. Repco had seen an opportunity when a General Motors project with an Oldsmobile V8 had been abandoned, leaving aluminium blocks in plentiful supply and avoiding the need to design a totally new competition engine from scratch. This astute little engineering company was about to create a Grand Prix winner from the ruins of an automotive giant's commercial disaster.

The BT19 may have been initially seen as a stop gap but Jack Brabham would use it to win six times (including non-championship races) before switching to the BT20 which, with one or two small improvements to the spaceframe and suspension, was virtually identical to its predecessor. In each case, use of modified uprights from the humble Triumph Herald road car was symptomatic of the Brabham design ethos.

Engine	Repco RB 620 V8
Size	2996 cc
Power	326 bhp
Weight	500 kg (1102 lb)
Wheelbase	2311 mm (91 in)

TEAM HISTORY

When Jack Brabham was winning his second World Championship with Cooper in 1960, he formed Motor Racing Developments (MRD) with Ron Tauranac, which was soon to become the world's largest manufacturer of customer racing cars. With an eye to building and racing his own F1 car, Brabham left Cooper in 1962 and entered the German Grand Prix with the Brabham BT3. A broken throttle linkage may have brought retirement at the Nürburgring, but Brabham finished fourth in the final two races of the season in the United States and South Africa. Expanding to a two-car team and winning a couple of non-championship races in 1963, the Brabham team then claimed their first Grand Prix victory when Dan Gurney won the 1964 French Grand Prix at Rouen, followed by a win in the final race of the Grand Prix season in Mexico. The BT3 had been painted in overall turquoise blue before adopting a green and gold colour scheme that would become the Brabham team trademark.

THE DESIGNER

Ever the resourceful engineer, Jack Brabham may have had a hand in the concept of the Brabham BT19 and BT20, but fine detail of the design and structure was carried out by Ron Tauranac. Born in England, Ron emigrated with his parents to Australia where, with his brother Austin, he built a hill climb car, known as a RALT (an amalgam of the initials Ron and Austin Lewis Tauranac). Having met Jack Brabham in Australia, Ron was tempted to move to England and work for Jack before eventually beginning their successful partnership on different fronts.

FAMOUS DRIVERS

Dan Gurney was the first works Brabham F1 driver until the American went off to form his own team in 1966. His place was taken by Denis 'Denny' Hulme, the New Zealander having already raced for Brabham in Formula Junior and Formula 3, before becoming the Brabham team's third F1 driver in 1965. After supporting Jack throughout 1966, Hulme won his first Grand Prix at Monaco the following year and went on to become World Champion that year.

Jack Brabham. The first man to win the World Championship in a car bearing his own name.

MEMORABLE RACE

Having won the 1966 French and British Grands Prix, Jack Brabham went to the Netherlands reasonably confident of a hat-trick, particularly when he took pole with Denny Hulme alongside. Despite – or, perhaps, because of – this run of success, Jack had become bemused by increasing comments about his age and the fact that he had turned 40. In a typically taciturn response, Brabham donned a false beard and limped to the starting grid using a jack handle as a walking stick. A different sense of fun was about to infuse the next two hours.

Sitting on the outside of the three-car front row, Jim Clark knew the start would be his best chance of getting among the Brabhams with his less-powerful 2-litre Lotus-Climax. Which is exactly what he did, the Scotsman getting ahead of Hulme and tucking in behind Brabham on the short run to the first corner. It took Hulme four laps to demote the Lotus but Clark, driving at the top of his considerable form, continued to harry the Brabhams.

There followed a classy display of teamwork as Hulme defended his team leader by taking the inside line into corners and foiling Clark's only chance to overtake. This continued until lap 17, when Hulme's car developed ignition trouble, leaving Brabham to fend off the Lotus through Zandvoort's twists and turns. The canny Clark knew the lapping of backmarkers might present an opportunity. Sure enough, during a particularly hectic encounter working through a number of cars, he got ahead of Brabham. Using his considerable racing repertoire and experience, Jack tried everything, to no avail. It was set to be a fight to the finish, only for the Lotus to suffer an engine cooling problem which forced Clark into the pits after 75 laps. Brabham won the Dutch Grand Prix for a second time. But the 'Old Man' really had to work for this one.

Jim Clark (#6) has slotted his Lotus 33 inbetween Jack Brabham's leading BT19 and the second Brabham BT19 of Denny Hulme as the field leaves Tarzan on the first lap of the 1966 Dutch Grand Prix at Zandvoort. Judging by his set expression, Brabham knows he has a fight on his hands.

Eagle-Weslake AAR-103

'My fuel pressure was running so low during the race [1967 Belgian Grand Prix], that I thought I wasn't going to make it, but I won by 63 seconds. Spa was no fluke. We were running as fast as Lotus on the straights, if not faster.'

Dan Gurney

The Eagle-Weslake AAR-103 vies with the Maserati 250F for the title of 'Most Beautiful Formula 1 Car', albeit with a fraction of the Italian car's success. Nonetheless, there was considerable affection for the Eagle – and just as much for its driver, Dan Gurney – during the American team's brief sojourn in Grand Prix racing from 1966 to 1968.

A former Grand Prix winner with Porsche and Brabham, Gurney saw the advent of the 3-litre formula as a good opportunity to enter his own car in F1. Whereas Jack Brabham had been ready for the new era with his Brabham BT19, Gurney and his team, Anglo American Racers, was not alone in failing to have a suitable engine up and running for the first few races. When the purpose-built Weslake V12 finally did arrive, a multitude of problems would hamper progress.

But when the blue car, with its stylish finish and distinctive beak-like nose, finally came on song almost a year later, it did so in an appropriate place – Gurney winning the 1967 Belgian Grand Prix on the majestic Spa-Francorchamps circuit. The Eagle would not come close again to achieving such a popular victory, with the team gradually losing momentum during 1968.

THE CAR

The Formula 1 car was a modified version of the Eagle originally conceived to take part in the Indianapolis 500. The F1 Eagle had a full monocoque chassis made of a thinner gauge aluminium (which did not reduce the weight sufficiently) and designed to accept an engine built by Weslake & Co. The small British company in Rye, Sussex, had been founded by Harry Weslake, an expert in cylinder head design. The V12 was notable for having four valves per cylinder, set at a narrow angle that allowed a single slim cover to enclose both camshafts on each bank. These top-end design features would become commonplace a decade later. But the underlying potential flaw of the moment was that Weslake had never designed an entire engine, never mind a highly-stressed power unit for a F1 car.

Engine	Weslake V12
Size	2997 cc
Power	390 bhp
Weight	541 kg (1192 lb)
Wheelbase	2451 mm (96.5 in)

TEAM HISTORY

Dan Gurney and fellow American Carroll Shelby (both winners at Le Mans) formed All American Racers (AAR) with the intention of winning the Indianapolis 500. Being a lover of road racing, and having had seven years of F1 experience, Gurney was also keen to fly the Stars and Stripes in Grand Prix racing. Shelby was not involved when Gurney established a base next door to Weslake in Sussex and adopted the 'Anglo American Racers' title for his Formula 1 team. When it became clear Weslake's V12 would not be ready for the start of the 1966 season, Gurney bought a couple of Coventry-Climax FPF engines as a stopgap. Despite the 2.75-litre four-cylinder units being underpowered on the fast straights of Reims, Gurney scored AAR's first championship points by finishing fifth in the French Grand Prix. Suspension modifications, allied to Gurney's technical input and driving skill, improved the Eagle's performance to such an extent that he qualified third on the twists and turns of Brands Hatch and was holding second place in the British Grand Prix when a piston failed.

The Weslake engine finally appeared at the Italian Grand Prix, Gurney's race lasting for only 17 laps until problems with the fuel system and oil temperature intervened. This was hardly a surprise considering the new engine had not run in the chassis until the moment Gurney ventured down the Monza pit lane. There would be different difficulties with the V12 during the final two races of 1966. Accompanying a weight-saving programme by AAR involving magnesium chassis skins and the use of titanium, Weslake had a revised and lighter V12 ready for the following season. In March, Gurney held off the Ferrari of Lorenzo Bandini to win a non-championship race at Brands Hatch and went on to qualify on the front row at Zandvoort, only to be let down

by a repeat of the metering unit trouble that had caused retirement from a top-three position in Monaco.

At Spa, however, it all came right, Gurney setting the fastest lap on his way to a fine victory. It would be the height of AAR's achievement. Gurney was leading by almost a minute on the Nürburgring Nordschleife when a driveshaft coupling broke. Then a succession of engine failures would lead to an eventual parting of the ways with Weslake, resulting in Gurney setting up his own engine shop in Kent. A shortfall in horsepower and finance fostered a gradual loss of impetus, and Anglo American Racers was wound up at the end of 1968.

THE DESIGNER

All American Racers hired Len Terry to design their first Indy car, the Englishman's credentials having been enhanced by victory at Indianapolis for a Terry-inspired Lotus 38. Not surprisingly, the first Eagle bore a strong resemblance to the Lotus, albeit with the distinctive nose that would become an Eagle hallmark. When tasked with providing a F1 car, Terry adapted the Indy Eagle for road racing, reducing weight and fuel capacity but maintaining its unique profile. The Weslake V12 engine was designed by Aubrey Woods, the former BRM engineer who had worked with Gurney when he drove for the British F1 team in 1960.

FAMOUS DRIVERS

Dan Gurney would naturally be the lead and, frequently, the sole driver with Anglo American Racers. When running two cars, Gurney was joined by Richie Ginther with occasional appearances by Bruce McLaren, Ludovico Scarfiotti, Phil Hill and Bob Bondurant.

The beautiful lines and finish on the Eagle are evident as Dan Gurney hustles his pride and joy through the fast sweeps of Spa-Francorchamps during the 1967 Belgian Grand Prix.

69

MEMORABLE RACE

The 3-litre formula finally stretched its legs and came to life in the 1967 Belgian Grand Prix. F1 racing during the previous 12 months had stumbled along as engine manufacturers got their heads around the new formula, forcing most teams to compromise. Two weeks before the Belgian race, the Ford-Cosworth engine had been unveiled at Zandvoort, where it had won. The fast roads of Spa-Francorchamps would allow Lotus to show what the Cosworth DFV could really do. By a happy coincidence, BRM's complex H16 engine had finally come on song, along with AAR's Weslake V12. By the end of qualifying, Gurney split the Lotus pair of Jim Clark and Graham Hill, with a Ferrari V12, a Maserati V12 and Jackie Stewart's BRM not far behind. Clark's average speed on his pole position lap for the 15-km (9.3-mile) lap had been 243 kph (151 mph), which included negotiating the tight hairpin at La Source.

Gurney made a poor start and completed the first lap in fifth place, his cause helped only slightly by Hill having been delayed by a flat battery. By the end of the second lap, the Eagle was into third place and chasing Stewart in the BRM and Clark's leading Lotus. It made an imposing sight and sound as a V8 led a H16 and a V12. But would they last?

Clark was forced to retire when the Ford-Cosworth developed a misfire. Stewart's H16 may have been going surprisingly well but, on this occasion, it was the BRM's gear linkage that would give trouble, Stewart being forced to hold the car in gear. Gurney closed in, setting a lap record at 239.55 kph (148.85 mph), taking the lead with eight laps to go, becoming the first American in 46 years to win a Grand Prix in an American car. A week before, Gurney had shared the winning Ford at Le Mans. Those seven days in June 1967 would mark the pinnacle of his career, helped along the way by a classy, if capricious, Formula 1 car.

Dan Gurney prepares to leave the downhill pit lane at Spa-Francorchamps during practice for the 1967 Belgian Grand Prix. Partially hidden behind the hatted team manager, Bill Dunne, Jo Ramirez looks on. The Mexican mechanic would later become a stalwart of the McLaren F1 team. Goodyear's tyre technician, Bert Baldwin, approaches on the left.

Lotus-Ford 49

'The Lotus 49 has probably more power in relation to its weight than any pure road racing car [as opposed to the IndyCar, which he had been racing for Lotus] so, naturally, it's going to take a bit of getting used to. With that amount of power and the light weight, things happen bloody quickly!'

Jim Clark OBE

The Lotus-Ford 49 was one of the few cars in which the engine and the chassis had an equal share in moving forward technology and the means of going racing. It not only provided a significant pivot in F1 history but it also looked the part. It won 12 Grands Prix over four consecutive seasons. The 49 may not have been truly evolutionary by comparison with cars yet to come from Lotus, but combined with the Ford-Cosworth DFV, it would play a substantial part within the F1 narrative.

The Lotus 49 was conceived by Colin Chapman as an uncomplicated car to take an engine that was something of an unknown quantity. That chassis design philosophy would nevertheless expand a theory about how the DFV should be mounted in the car, with the combination producing a machine capable of transmitting the V8's substantial power to the track.

Making its debut in the 1967 Dutch Grand Prix, the 49 was a winner straight away and would have had a greater say in the championship had the Lotus been sorted and introduced earlier in the season. It did the job in 1968, a year when Team Lotus was rocked by the death of Jim Clark in a Formula 2 race. Graham Hill rose magnificently to the task to clinch the championship at the final round, by which time the Ford-Cosworth DFV had been made available to rivals, most notably Ken Tyrrell's Matra International team.

Jackie Stewart had given Hill a close run in 1968, but the Scotsman cleaned up in 1969 with the Tyrrell Matra-DFV. The Lotus 49 won twice that year, including Jochen Rindt scoring his maiden victory in the United States Grand Prix. The Austrian would give the Lotus 49 its final Grand Prix win in typically colourful style at Monaco in May 1970. The Ford-Cosworth DFV, meanwhile, was far from finished, as will be shown in the following chapters of this book.

Dazzling debut. Jim Clark, leading the Brabham BT20 of Denny Hulme, laid down a significant marker by winning the first race for the Lotus 49 and its Ford-Cosworth engine in the 1967 Dutch Grand Prix.

THE CAR

As the 3-litre era beckoned, Colin Chapman was more concerned about finding a competitive engine than creating a car to carry it. The Lotus boss approached Walter Hayes and asked if the Director of Public Affairs at Ford of Britain would be interested in funding a Grand Prix engine. Hayes, seeing an involvement with front line motor sport as a

useful means of polishing Ford's rather dowdy image at the time, managed to persuade the Ford directors to commit a minimum of £100,000 towards an engine that would be designed by Cosworth Engineering, a small engineering company in Northampton.

The resulting Ford-Cosworth DFV (standing for Double Four Valve) followed the simple and effective trend set by Jack Brabham's Repco V8 in 1966 rather than going down the more complex multi-cylinder route favoured by Ferrari, BRM, Eagle-Weslake and Maserati (engine suppliers to Cooper). It was agreed that Lotus would have exclusive use of the DFV in 1967 before the V8 became available to any team approved by Ford and willing to pay the £7,500 asking price.

Believing that his car should be relatively simple and not distract his team from sorting Cosworth's engine, Chapman defined the dimensions of the 49 by those of the V8 in the rear. The result was a slim monocoque with the engine bolted to a bulkhead behind the cockpit, while serving a load-bearing role. The rear suspension was effectively bolted to the back of the V8, contributing to a car with timeless, economical lines.

The cars raced in 1967 carried the familiar Lotus colours of British Racing Green with a central yellow band. That changed completely – and controversially – when the advent of commercial funding in F1 led to the Lotus 49 resembling a mobile cigarette packet in deference to title sponsorship from John Player and their Gold Leaf brand. The car itself remained competitive and would continue to do so while undergoing development through Lotus 49B and 49C derivations, and adapting to the noticeable advent of wings and emphasis on aerodynamics. The Lotus 49 would win numerous F1 races in the hands of privateers around the world.

Engine	Ford-Cosworth DFV V8
Size	2995 cc
Power	410–430 bhp
Weight	501–540 kg (1105–1190 lb)
Wheelbase	2413–2489 mm (95–98 in)

TEAM HISTORY

On the back of Jim Clark's championship year in 1963, Lotus developed the ground-breaking 25 and introduced the Lotus 33 in time for Clark to win a second title in 1965. The following season was fallow by comparison, as Lotus made do while waiting for the Ford-Cosworth DFV. As an interim solution in 1966, the Lotus 43 was produced to accept a BRM H16. Somewhat miraculously, Clark managed to win the United States Grand Prix, the only victory for this heavy and complex engine. The Lotus 49 and the DFV could not come quick enough.

THE DESIGNER

The Lotus 49 was driven by Colin Chapman in every sense. A skilful and quick driver in his own right, Chapman tried the Lotus 49 for himself on the company's test track at Hethel in Norfolk before its first race in The Netherlands. For the first time, Chapman was able to enjoy working hand-in-hand with an engine manufacturer rather than having to compromise and mould his design around an existing engine. The detail work was carried out by Maurice Phillippe, a former aircraft engineer who had worked for Ford and joined Lotus at the end of 1965.

Cosworth Engineering had been founded when two former Lotus engineers – Mike Costin ('Cos') and Keith Duckworth ('worth') – joined forces with the intention of tuning and building racing engines. Costin oversaw production and day-to-day running of the company, while Duckworth was the more creative of the two. When approached by Chapman, Duckworth and Costin estimated £100,000 would be needed to design and build a 3-litre Formula 1 engine from scratch, neither man having been responsible for the creation of an entire engine until now. Chapman's subsequent blandishments would lead to one the best investments ever made by the Ford Motor Company.

FAMOUS DRIVERS

Jim Clark continued to be the subject of Chapman's justifiable admiration and trust – which made Graham Hill's decision to leave BRM and join Lotus in 1967 seem all the more courageous and self-confident. It would work well for the wrong reasons when Clark was killed in April 1968 – Hill's indomitable spirit helping hold the team together as he won the championship that year. Jackie Oliver (Clark's immediate replacement) finished on the podium in Mexico. Ever the deal maker, Chapman was not averse to selling his F1 cars to private entrants. In 1968, Rob Walker took delivery of the seventh Lotus 49 to have been made. The Swiss driver Jo Siffert used it to score an unexpected win in the British Grand Prix, when both works 49s retired while leading. Jochen Rindt joined Hill at Lotus in 1969 and claimed two wins in the 49.

The indomitable Graham Hill helped hold the Lotus team together after the death of Jim Clark in April 1968. A few weeks later, Hill celebrates a timely win with the Lotus 49 in the Spanish Grand Prix at Jarama.

MEMORABLE RACE

Jochen Rindt was never afraid to show his emotions, both in and out of the car. At Monaco in 1970, while awaiting the arrival of the Lotus 72, Rindt seemed disinterested in competing with the Lotus 49, then in its fourth season. He qualified eighth and ran unobtrusively in the midfield, as if wishing the race to be over sooner rather than later. One by one, those ahead either made mistakes or retired. With 19 laps to go, Rindt found himself in second place, albeit some distance behind the leader, Jack Brabham. Suddenly, the streets came alive as Rindt hurled the Lotus into outrageous angles, smashing the lap record time and again, his fastest lap being almost a second beneath the pole position time. With one corner to go, and the Lotus closing, Brabham made an error of judgment and slid into the straw bales, handing Rindt one of the most dramatic victories in the history of the event – not to mention the Lotus 49.

Jochen Rindt hurls his Lotus 49C into Mirabeau during an epic chase which would lead to the Austrian snatching the lead of the 1970 Monaco Grand Prix at the final corner.

77

McLaren-Ford M7A

'It took Denny and I a while to get used to the characteristics of the Ford DFV. With just the slightest bit of oil down [on the track surface], it was possible to get wheelspin all round the circuit [Brands Hatch]. If it's wet or oily, the extreme power, which tends to come in all at once at around 6,500 rpm, is quite an embarrassment.'

Bruce McLaren

The M7A, with its distinctive orange colour scheme, announced the arrival of McLaren as a serious force in Formula 1. Bruce McLaren had spent two years making occasional appearances in Grands Prix with various cars that had either been conceived with something else in mind, or were hamstrung from the start by engines that were not fit for purpose. The availability of the Ford-Cosworth DFV in 1968 changed all that. Bruce and his small team were able to get down to designing a Formula 1 car around a V8 that had been proven beyond doubt by Lotus in 1967. The McLaren-Ford M7A was McLaren's answer to the Lotus 49.

Made ready in time for the 1968 season in Europe, McLaren entered two cars for the non-championship races at Brands Hatch and Silverstone. Bruce won the first and his new team-mate, Denny Hulme, claimed the second. It was an impressive start by any standard, and the team from Colnbrook in Surrey looked forward to the forthcoming Grands Prix in Spain and Monaco. At Jarama, Hulme finished second with McLaren retiring with an oil leak, and at Monaco, Hulme finished fifth with McLaren making a rare mistake, crashing at the exit of the tunnel.

Bruce would more than make up for the disappointment a fortnight later in Belgium when he gave McLaren what would be the first of many Grand Prix victories in the following decades. Hulme would win at Monza and lead McLaren's first 1–2 finish at St Jovite in Canada to put himself in the mix for a three-way fight for a championship that would eventually go to Graham Hill and Lotus.

In all, the McLaren M7A made 29 race starts in 1968, finishing on the podium ten times. Bruce McLaren Motor Racing would be runner-up in the Constructors' Championship, a feat that would not be matched until the arrival of the McLaren-Ford M23.

THE CAR

The M7A had a three-quarter length, open-topped bath tub style monocoque chassis. Like the Lotus 49, McLaren used the Ford-Cosworth DFV as a stressed member, four bolts securing the V8 to a bulkhead behind the driver's seat. The rear of the engine had pick-ups for radius arms that were part of a suspension system designed with the input of Bruce McLaren. The sleek glass-fibre bodywork featured ducts on the upper surface of the nose to speed the exit of hot air from the radiator – a feature introduced by Bruce on his CanAm sports cars. One-off modified M7B and M7C versions added little to the McLaren record in 1969.

The CanAm cars were a distinctive orange-yellow, and McLaren chose the same papaya shade for the latest M7A. The team had previously been unable to settle on a trade mark scheme, having gone from British Racing Green to black and silver, white and blue (a financially driven choice for the benefit of the makers of the movie 'Grand Prix'), followed by red with pale stripes. Teddy Mayer, Bruce's management partner, reckoned papaya would show up strongly on television as well as providing a threatening image in rivals' mirrors. He would be proved correct on both counts.

Engine	Ford-Cosworth DFV V8
Size	2995 cc
Power	410 bhp
Weight	540 kg (1190 lb)
Wheelbase	2388 mm (94 in)

Bruce McLaren Motor Racing was a winner from the start with the M7A at two non-championship races in 1968, a papaya orange colour scheme becoming the team's trademark. Bruce McLaren deals with a wet track at Rouen during the French Grand Prix.

TEAM HISTORY

Bruce McLaren studied engineering at college in Auckland, New Zealand. His motor sport career began with a humble Austin 7 two-seater sports car and progressed to a Cooper single-seater. Bruce was good enough to win a Driver to Europe scholarship in 1958, with the Cooper Car Company in Surrey being his first port of call. Through his equal enthusiasm for driving and engineering, McLaren made enough of an impression to be offered an F1 drive by Cooper – the relationship paying dividends in the United States at the end of the following season when Bruce, at the age of 22, became the youngest winner of a Grand Prix.

As Cooper's star began to fade, McLaren felt he had no option but to start his own team in September 1963. The first car was based on a Cooper two-seater with an American V8 engine shoehorned into the back. This concept would be massively refined in the coming years as McLaren built cars from scratch for CanAm, a lucrative series of races in North America for powerful sportscars. By dominating that championship and selling customer McLarens off the back of it, McLaren was able to turn his thoughts to a serious run at Formula 1, with the arrival of the 3-litre formula in 1966 an appropriate moment to do it.

The first F1 McLaren, the M2B, was powered initially by a derivative of a Ford V8 Indianapolis engine, and then by an equally underpowered Serenissima – the Italian V8 holding together long enough to give McLaren their first world championship point with a distant sixth place in the British Grand Prix. As a stopgap while waiting for a BRM V12 engine for 1967, McLaren raced the M4B, an uprated version of a neat F2 car. The M5A was made ready for the BRM engine, Bruce leading a very wet Canadian Grand Prix until electrical trouble intervened. The M7A with its Ford-Cosworth DFV was eagerly anticipated.

THE DESIGNER

Robin Herd landed his first job in motor racing when McLaren made the Oxford graduate (with a double first in physics and engineering) their Chief Designer. Herd was responsible for the early McLarens. He had completed the layout of M7A before moving elsewhere, his place being taken by Gordon Coppuck who, like Herd, had served an apprenticeship with the National Gas Turbine Establishment. Coppuck did most of the detail work, with Bruce McLaren becoming heavily involved with the concept.

FAMOUS DRIVERS

Denny Hulme left Brabham at the end of 1967 to join his fellow Kiwi at McLaren. For the final three races of their first season together, McLaren and Hulme were joined by Dan Gurney in a third M7A as the American wound down his team, All American Racers.

MEMORABLE RACE

The Belgian Grand Prix was the fourth round of the 1968 World Championship and, in truth, not a race McLaren expected to win. That sense of doubt would last until the dying seconds of the race at Spa-Francorchamps. The orange cars had qualified fifth and sixth, Hulme ahead of McLaren, as Bruce settled into a brand new M7A after badly damaging his car during the previous race at Monaco.

The lap chart shows Bruce in 11th place at the end of the first lap with little chance of getting among a fierce three-way battle at the front. McLaren had only gained two places as the race reached quarter distance. The picture began to change as the leaders ran into trouble, Hulme amongst them, having moved into second place, only to retire with a broken driveshaft.

Hard-pressed by the BRM of Pedro Rodríguez, McLaren found himself in second place with five laps to go. Jackie Stewart, meanwhile, was 30 seconds down the road in a seemingly unassailable lead. At the start of the final lap, Stewart's Matra-Ford dived into the pits for a precautionary splash of fuel. McLaren, continuing to fend off Rodríguez, failed to notice and the McLaren pit crew did not have enough time to signal the good news. Not even when Bruce crossed the line three-and-a-half minutes later did he realise the chequered flag was for him. His car was so new, there had not been time to fix either his name or the McLaren logo to the bodywork to show the world that Bruce had joined Jack Brabham as a winner in a car of his own creation.

An unexpected win for Bruce McLaren and the M7A at Spa-Francorchamps in Belgium in June 1968.

Matra-Ford MS80

'One of [Jackie] Stewart's qualities was that he gave good feedback to the engineers. It's often overlooked how vital that is. That was one of our strengths in 1969. The MS80 was the MS10 corrected, and we'd had the right information about everything that needed fixing.'

Bernard Boyer

Described by Jackie Stewart as one of the best racing cars he had ever driven, the Matra MS80 had a brief but successful existence. The French-built car with a Ford-Cosworth DFV engine won five of the eleven rounds of the 1969 F1 championship to give Stewart his first world title.

The light blue MS80 was run by Ken Tyrrell under the title Equipe Matra International – a sign of pragmatic Anglo-French collaboration as Matra, an aerospace company, recognised the specialist knowledge of Tyrrell and his small racing team operating out of a former woodyard in Surrey.

The relationship had begun with a Formula 2 Matra in 1967. Stewart appreciated how Matra's aerospace construction methods paid dividends in a rigid chassis that handled with precision. Although producing their own car, the MS11, powered by their V12 engine, Matra were astute enough to hedge their bets and have Tyrrell install the newly available Ford-Cosworth V8 in the back of a different chassis for the 1968 season. The first product of the partnership, the MS10 (MS standing for Matra Sports), won three Grands Prix and came close to giving Stewart the championship.

Using lessons learned, the MS80 would become the most successful Matra during the French firm's six seasons in F1. Only two such cars were built, the life of the MS80 cut short by a change in the technical regulations for 1970 that would rule out an essential part of Matra's novel method of chassis construction. In any case, politics would end the successful affiliation, a take-over of Matra by Chrysler precluding Tyrrell's preference for Ford power. The relationship had been short, but very sweet.

THE CAR

After a difficult start with their V12 car, Matra chose to focus on the MS80 for Tyrrell in 1969. A bulbous appearance was created by concentrating the fuel load around a low centre of gravity – a visible departure from the accepted norm of carrying fuel comparatively high in a cigar-shaped chassis.

However, the main advantage of the MS80 was hidden from view.

As had been the case with all their single-seaters, Matra had lined the box sections on either side of the cockpit with polymer resin, thus providing a seal that enabled fuel to be carried without the use of rubber bag tanks. This would allow the installation of bulkheads within the box sections to increase the car's tortional stiffness. The process was expensive and complicated but worth the effort, judging by Stewart's glowing comments on the car's handling. It was a measure of Matra's commitment that they had gone to all this trouble in the knowledge that the car would be made redundant at the end of the year when bag tanks would become compulsory and impossible to fit within the sides of the MS80.

It was important, therefore, that this car should work from the outset, which it did, with Stewart dominating the Race of Champions at Brands Hatch in March 1969. Bruce McLaren, watching from the trackside after his car had broken down, was staggered by the ability of the MS80 to ride the bumps and put down the power from the latest version of the Ford-Cosworth DFV – a problem he had been only too familiar with in 1968 (see 'McLaren-Ford M7A', page 78).

Matra and Tyrrell experimented with a four-wheel-drive version (known as the MS84), Stewart feeling it would have an advantage in a wet race – of which there had been quite a few during 1968. A single MS84 (using a spaceframe rather than a monocoque) was built, raced occasionally and scoring a point by finishing sixth in the hands of Johnny Servoz-Gavin in the Canadian Grand Prix.

Engine	Ford-Cosworth DFV V8
Size	2995 cc
Power:	430 bhp
Weight	559 kg (1232 lb)
Wheelbase	2400 mm (94.5 in)

Jackie Stewart, on his winning way with the Matra MS80 during the 1969 French Grand Prix at Clermont-Ferrand.

TEAM HISTORY

Matra (an acronym for Mechanique Aviation Traction) was a French conglomerate, founded in 1945 and associated with, among other things, defence, aerospace and transport. Matra Automobiles was created during the 1960s following the acquisition of René Bonnet, a small company manufacturing sports cars in limited numbers. Marcel Chassagny, the founder of Matra, appreciated the importance of motor sport and appointed Jean-Luc Legardère as director of a new division, to be known as Matra Sports. Their first racing car, the MS1, was designed in 1965 with Formula 3 in mind. Legardère, a successful businessman and a prominent figure in French horse racing, was not afraid to cast aside nationalistic instincts and chose a British F3 engine because it was the most successful. He would apply the same logic when tempting Ken Tyrrell, a staunch patriot, to come on board with a French company, which the Englishman, in truth, knew little about. The liaison would work extremely well for both sides.

THE DESIGNER

The MS80 – along with every racing car produced by Matra – was designed by Bernard Boyer, a largely unsung engineer who had formerly competed in Formula 3 and taken part in the Le Mans 24 Hour race. Boyer, who joined Matra in 1966, was known to use his talent as an engineer/driver to test his creations. When Matra withdrew from racing in 1973, the Frenchman worked on missile development. Gerard Ducarouge would also play a significant role in the design of the MS10 and MS80.

FAMOUS DRIVERS

Matra's campaign with the MS80 was focused almost entirely on Jackie Stewart. Jean-Pierre Beltoise, who had raced Matra's MS11 with their V12 in 1968, was transferred to the Tyrrell team when Matra shelved their F1 car for 1969. Johnny Servoz-Gavin, who had stood in for the injured Stewart at Monaco in 1968, raced the Matra MS84 at the final three Grands Prix of 1969.

MEMORABLE RACE

Having won four of the previous five races in 1969, Jackie Stewart arrived at Silverstone for the British Grand Prix with a comfortable lead in the championship. Jochen Rindt had zero points mainly due to reliability problems with the ageing Lotus 49. For one lap, however, the red, white and gold car remained impressively quick in the hands of the extrovert Austrian, as he proved by putting it on pole, alongside Stewart.

During qualifying, Stewart had heavily shunted his Matra against the sleepers on the outside of Woodcote when a piece of dislodged concrete kerb punctured a rear tyre. Having saved Stewart from injury, the aluminium chassis was nevertheless beyond immediate repair. The Tyrrell mechanics set about transferring Stewart's pedals and settings to the sister MS80 entered for Jean-Pierre Beltoise, the Frenchman being obliged to race the spare four-wheel drive MS84.

The Union Flag had barely fallen as Rindt and Stewart tyre-smoked off the line as one. By the end of the first of 84 laps, they were already three seconds to the good and into a breathtaking race of their own. The official lap chart shows that Rindt led laps 1–5, Stewart was in charge until lap 16, with Rindt taking over for the next 46. But that merely indicates who was first across the timing line and does not begin to describe what went on in between.

The lap record, broken third time round, was repeatedly pulverised as the leaders cleverly used their respective

Friends and foes: Jackie Stewart's Matra MS80 leads the Lotus 49B of his Swiss neighbour and friend, Jochen Rindt, during an epic battle that lasted for over an hour during the 1969 British Grand Prix at Silverstone.

slipstreams to pass and re-pass, usually on the same lap. On lap 16, they came across Beltoise, struggling with the MS84. Rushing down Hangar Straight, Stewart's leading Matra went one side of the Frenchman, Rindt the other, with the Lotus emerging in front. Not long after half distance, they caught a five-car battle for fifth place, the leaders slicing through with no loss of momentum whatsoever. Spectators never knew which car would appear first. This happened every 82 seconds, lap after lap.

An attempt by Rindt to break free extended the lead to three seconds; the most it would be during this relentless dispute. Stewart responded – as Rindt knew he would –

with another new lap record and eventually closed to within one second.

They had been at it for an hour and 18 minutes when, with 22 laps to go, Rindt dived into the pits. An end plate on the rear wing had been fouling his left-rear Firestone, such was the lurid angle of the Lotus through the predominant right-handers.

Stewart won by a clear lap, a bland statistic that masks a motor race of truly epic proportions.

March-Ford 701

'On a bumpy circuit like Brands Hatch, I wouldn't say the March 701 was difficult to drive; it was impossible. But I did come close to winning the Belgian Grand Prix. I sometimes wonder how I managed that...'

Chris Amon MBE

The background story was more extraordinary than the car itself, with the March 701 being devoid of revolutionary thinking in favour of simplicity and balancing the fledgling company's books. March had been formed in 1969 by Max Mosley (a lawyer and former amateur racing driver), Alan Rees (a competent F2 driver), Graham Coaker (an engineer, experienced in racing car production) and Robin Herd (a nascent design wizard with a double first from Oxford). The March name was an amalgam of their initials.

This quartet of assorted temperament and talent had astounded the motor sport world by announcing not only their intention to diversify into various racing categories but also to run a Grand Prix team and make their Formula 1 cars available to whoever wished to buy them. Surprisingly, it seemed a self-fulfilling prophesy when prospective F1 purchasers stepped forward – headed by Tyrrell Racing Organisation, the reigning World Champions.

In truth, Tyrrell had little option. The sudden demise of the powerful relationship with Matra (see 'Matra-Ford MS80', page 82), left Ken Tyrrell and Jackie Stewart with an engine (the Ford-Cosworth DFV), but no car to put it in. Naturally, Brabham, Lotus and McLaren were not keen to supply a chassis to a team and driver that, in all probability, would give them a hard time. The arrival of March presented the only solution.

Having Tyrrell on board was a massive feather in the March cap and gilded the news that their two works cars would be supported by STP, the American oil company also choosing to buy a 701 for Mario Andretti, the reigning USAC (United States Auto Club, now more commonly known as IndyCar) Champion. This was in addition to a small British team entering a 701 for Ronnie Peterson, a young Swedish driver with exciting prospects.

The March cup was overflowing, only for the frothy content of goodwill and optimism to gradually evaporate as the 1970 season progressed. But not before another extraordinary turn of events – the March 701 won a Grand Prix.

The initial sense of disbelief had continued at the first round of the championship when Stewart put his March on pole for the South African Grand Prix, with the works 701 of Chris Amon setting an identical time not long after. Amon's March would be eliminated in a collision but Stewart might have won had he not experienced tyre trouble after leading for 19 laps.

This promise was backed up when Amon and Stewart each won a non-championship race before the Tyrrell driver went on to lead every lap of the Spanish Grand Prix. That month-long sequence would be the peak of achievement for the 701 – and, arguably, March's subsequent F1 effort across more than 200 F1 races.

THE CAR

The March 701 was essentially a simple, easy-to-build and maintain car with a conventional straight-sided aluminium bath tub monocoque. The Ford-Cosworth DFV engine – another obvious choice given its availability and performance – was bolted onto the back of the monocoque in what had become the accepted manner. There was equally orthodox suspension front and rear. The only departure from the norm was an interesting one and a sign of the assistant designer's growing interest in aerodynamics. Wing-shaped tanks had been added to each side of the chassis, the better to spread the fuel load for longer races and generate a modicum of downforce at the same time.

Engine	Ford-Cosworth DFV V8
Size	2995 cc
Power	430 bhp
Weight	581 kg (1280 lb)
Wheelbase	2362 mm (93 in)

TEAM HISTORY

Having met when studying at Oxford, Max Mosley and Robin Herd were reunited in 1968 – Mosley while attempting to be a Formula 2 driver; Herd having been infinitely more successful as designer of racing cars for the fledgling McLaren team. Viewing the sparse F1 grids of 15 starters – sometimes fewer – with one or two dubious cars at the back, Herd and Mosley reckoned they could do a better job and make a profit.

March was formed in 1969 with the combined forces of these two, plus Alan Rees and Graham Coaker, as each man invested £2,500 (approximately £50,000 today). The first March, a Formula 3 car, was built in Coaker's garden shed and showed a reasonable turn of speed at its first race the following September. Acquisition of premises on an industrial estate in Bicester, Oxfordshire, coincided with the launch of a business plan to fund a Grand Prix team by building and selling cars for Formula Ford, Formula 3, Formula 2, and CanAm, the lucrative sports car series in North America. Even more implausibly, it seemed, March would also offer F1 cars for sale. Six 701s were built in six months. A single Grand Prix win with the 701 would flatter an enthusiastic but over-ambitious group that had taken on too much, too soon.

THE DESIGNER

At the age of 30, Robin Herd had already gained a reputation as a highly promising engineer when he became a founding partner of March. With a double first in physics and engineering, Herd had worked as a design engineer on the Concorde supersonic aircraft project before joining McLaren and designing, among other projects, the sports cars that had dominated the CanAm series. When at March, Herd was assisted by Peter Wright, who came up with the idea of the wing-shaped auxiliary fuel tanks, a precursor to Wright's ground-effect underwing side pods on the Lotus 78 and the trailblazing 79.

FAMOUS DRIVERS

The March Engineering entry consisted of Chris Amon and Jo Siffert. At Tyrrell, Jackie Stewart was supported by Johnny Servoz-Gavin early in the season, and later by François Cevert. The STP 701 was driven by Mario Andretti. Ronnie Peterson made his F1 debut in a March 701 entered by the British team, Antique Automobiles Racing. Hubert Hahne failed to qualify a privately entered 701 for his home Grand Prix in Germany.

Chris Amon finished second in the 1970 French Grand Prix at Clermont-Ferrand, a result more to do with driver skill on the difficult 16-km (10-mile) Charade Circuit than the quality of the March 701.

MEMORABLE RACE

The Spanish round of the 1970 Formula 1 World Championship was memorable for all the wrong reasons – apart from the March 701's first (and only) Grand Prix victory. The second round of the championship was riven with disputes and discontent from beginning to end. Argument about who could and could not race at Jarama ended with ugly scenes as four drivers who had not qualified were allowed on the grid, and then ordered to leave. Jo Siffert did not take kindly to officials attempting to drag him from the cockpit of his March 701.

At the other end of the grid, Jackie Stewart's March shared the front row with Denny Hulme's McLaren and the pole position Brabham of Jack Brabham. Stewart took an immediate lead but, seconds later, the race descended into chaos. Brake failure on the approach to a hairpin sent Jackie Oliver's BRM into the Ferrari of Jacky Ickx, catching the red car amidships, piercing a fuel tank and causing an immediate inferno. Apart from minor burns, both drivers escaped unhurt, but hopelessly inadequate fire-fighting facilities left both cars ablaze on the edge of the track while the race continued, drivers having to deal with a surface smothered in water, cement dust and foam.

Stewart was challenged briefly by Brabham before the Australian spun at the scene of the accident. Brabham's recovery was helped by only six other cars running as the race reached half distance. Then engine failure caused Brabham to join the retirement list, leaving Stewart to cruise home, a lap clear of the remaining four. A win was a win, which March were only too pleased to accept.

Jackie Stewart carefully picks his way through the chaos at Jarama in 1970 as marshals attempt to deal with the burning Ferrari (foreground) of Jacky Ickx and Jackie Oliver's BRM. Unfathomably by today's standards, the race was not stopped, Stewart going on to score the only Grand Prix victory for the March 701.

89

Lotus-Ford 72

'This car is so good, a trained monkey could win in it.'

Jochen Rindt (when congratulated on his win with the Lotus 72 in the 1970 German Grand Prix at Hockenheim)

Similar to the Lotus 49, its successor, the 72, remained competitive for longer than expected. Seeking an advantage over his rivals – particularly as most of the leading teams were using the same Ford-Cosworth V8 – Colin Chapman took a long look at the chassis and its suspension, and how the car might work best with Firestone tyres.

He came up with a distinctive wedge shape by moving the cooling from the front of the car to its sides. A few major bugs with the brakes and handling needed ironing out following its introduction in April 1970 but once sorted, the Lotus 72 flew, particularly in the hands of Jochen Rindt. After winning five Grands Prix (one with the Lotus 49), the Austrian looked invincible. But a fatal accident (due to a mechanical failure) during qualifying for the Italian Grand Prix would plunge Lotus into despair. Stepping up to the plate, Emerson Fittipaldi, in only his fourth F1 race, won the United States Grand Prix, thus helping ensure Lotus claimed the Constructors' Championship, and Rindt became the first posthumous World Champion.

Lotus struggled in 1971, failing to win (as a works team) a Grand Prix in a season for the first time since 1960. Fittipaldi suffered more than he admitted about the effects of a bad road accident and the 72 had undergone several developments, with Chapman not helping by occasionally diverting his attention to the Lotus 56 turbine car.

It was all-change in 1972. The Gold Leaf colours became a black and gold scheme, accompanied by a request – largely ignored by old school members of the media – for the 72 to be known as a John Player Special in deference to the latest marketing strategy of the team's title sponsor, Imperial Tobacco. Fittipaldi won five races and became, at the time, the youngest F1 World Champion. He was also in the running in 1973, making the most of continual improvements to a car good enough to give Lotus a second consecutive Constructors' Championship.

The aging 72 was supposed to be replaced by the Lotus 76 in 1974 but, when the new car failed miserably, the 72 was wheeled out again and, remarkably, won three Grands Prix in the energetic hands of Ronnie Peterson. In 1975, it was asking too much of the five-year-old car to perform to previous levels, and Lotus finished seventh in the

The sleek lines of the wedge-shape Lotus 72 shown to full effect as Jochen Rindt claims pole for the 1970 British Grand Prix at Brands Hatch.

championship, with a mere nine points. It was an indifferent end to a distinguished career, the Lotus 72 having won 20 championship races to make it, at that time, the most successful Grand Prix car of all time.

THE CAR

Apart from his usual guiding principle of making a Formula 1 car as light as possible, Colin Chapman sought aerodynamic efficiency with the 72 by creating a low, wedge-shaped car with the radiators mounted amidships, torsion bar suspension and inboard brakes. Suspension loads were minimised and the absence of heat from wheel-hub mounted brakes also helped integration with the development of soft compounds by Firestone. The Lotus 72 would be constantly revised during the following seasons, most notably with a change from Firestone to Goodyear tyres and the need to have additional regulatory protection for the fuel tanks. A plethora of rear wing profiles would come and go to match the latest regulations and the constant search for additional downforce. At various stages, the developments would be categorised with 72B, 72C, 72D and 72E type numbers, the 'E' being the most successful with eight wins.

Engine	Ford-Cosworth DFV V8
Size	2995 cc
Power	430–465 bhp
Weight	528–576 kg (1165–1270 lb)
Wheelbase	2540–2667 mm (100–105 in)

TEAM HISTORY

How to follow the Lotus 49? A decision to try four-wheel-drive in F1 had led to a blind alley with the Lotus 63, a car that did not find favour with the drivers. Chapman's determination to succeed with the 63 led to the sale of the remaining Lotus 49s and the embarrassment of having to ask for them back because Rindt refused point blank to drive the 63 entered for the 1969 British Grand Prix. Rindt would give the Lotus 63 its best result by finishing second in the non-championship Gold Cup meeting at Oulton Park in August 1969, by which time Chapman was thinking about a specification that would ultimately lead to the Lotus 72.

THE DESIGNER

Colin Chapman and Maurice Phillippe had thrashed out the Lotus 72 concept between them with Chapman, as usual, envisaging the fundamental philosophy. Phillippe left Lotus in 1972. Martin Waide, who had been in the drawing office, took over design detail for a short period, pending the arrival as Chief Designer in 1973 of Ralph Bellamy, formerly with McLaren and Brabham.

FAMOUS DRIVERS

Given the car's lengthy history, many drivers found themselves behind the wheel of a Lotus 72. Jochen Rindt and John Miles did most of the work in 1970, with Emerson Fittipaldi taking over after the death of Rindt. Graham Hill drove a Lotus 72 for the private entrant, Rob Walker. For the first time, Lotus ran two 'non-British' drivers when Fittipaldi was joined by Reine Wisell, the Swedish driver replacing Miles at the end of 1970 following the Englishman's abrupt departure in the wake of Rindt's fatal accident. Dave Walker (former British F3 Champion with Lotus) joined the F1 team in 1972, Ronnie Peterson partnered Fittipaldi in 1973, with Jacky Ickx replacing the Brazilian when he moved to McLaren for 1974. There were occasional appearances in the works Lotus 72 for John Watson, Jim Crawford and Brian Henton.

The appearance of the Lotus 72 was changed by a switch of livery to black and gold. Emerson Fittipaldi on his way to third place at Monaco in 1972, and the World Championship.

MEMORABLE RACE

Pictured on the podium at Brands Hatch in July 1970, Jochen Rindt was wearing the winner's laurels and a puzzled expression suggesting surprise at being there. Coming through the final corner of the British Grand Prix, Rindt had been a few seconds behind Jack Brabham and convinced he was runner-up. Seconds later, Rindt overtook the leader as the Brabham-Ford, out of fuel, coasted towards the finish line.

It had been a race of cat and mouse. Rindt had started from pole and led from laps 7 to 65 before Brabham, always in close attendance, seized on a mistake by the Austrian and pulled away. Rindt was the first to admit Brabham deserved to win. And yet here was the Austrian, celebrating his third victory in succession with the Lotus 72. But not for long.

The scrutineers disqualified the Lotus because its rear wing was 15 mm (0.5 inches) above the regulation height. The Lotus crew, aware that the height might be marginal, had surreptitiously pressed down on the wing while the car was carried on a trailer during a victory lap immediately after the race. But this manual downforce proved to be insufficient for the official measuring tape.

Thinking on his feet, Chapman requested the car to be measured again in the scrutineering bay in the paddock, and not in the pit lane, where the initial check had been carried out. The scrutineering bay may have had the only flat surface within the undulating venue, but it was also located through a tunnel and some distance from the pit lane. Peter Warr, the Lotus team manager, recalled what happened next. 'Suddenly,' said Warr, 'several mechanics were needed to get the car through the tunnel! They happened to be pushing on the rear wing. The scrutineers now had different readings to those obtained in the pits. The wing supports were bent and it took two hours to convince them this was how the car had started the race.' The win was confirmed.

Jochen Rindt appears non-plussed on the Brands Hatch podium. The surprise winner of the 1970 British Grand Prix holds the trophy in front of his wife, Nina, and Colin Chapman. The Lotus boss would soon have to think quickly on his feet as the scrutineers attempted to disqualify the Lotus 72 on a technicality.

Tyrrell-Ford 003

'Compared to the Matra MS80, Tyrrell 003 was nervous car; you really had to drive it. But once you understood the need to be smooth, you could extract tremendous performance from 003.'

Sir Jackie Stewart

The Tyrrell Formula 1 car – of which 003 was the third to be built – was born out of necessity. The last thing Ken Tyrrell wanted was the responsibility of producing his own car. He was much happier when, as with the championship-winning Matra MS80, the design, manufacture and development was handled by someone else. That left the Tyrrell Racing Organisation (now known as Elf Team Tyrrell) to get on with running an efficient race team supporting its star driver, Jackie Stewart.

The advent of politics and a struggle with the March 701 had changed everything. The unavoidable ending of the relationship with Matra and the need to buy a Formula 1

car from March for 1970 had made Tyrrell and Stewart realise they had no influence over their future for as long as it was at the behest of another racing car manufacturer. The seeds for the first Tyrrell F1 car had been sown through circumstance.

Tyrrell 001 was built in complete secrecy; a task made easier by the team's location in a former woodyard in the depths of Surrey, and the design being carried out by an engineer relatively unknown in the F1 world. The royal blue car made its surprise debut in a non-championship race in August 1970 and, a couple of weeks later, took part in the Canadian Grand Prix, leading for 31 laps on the demanding Mont Tremblant-St Jovite circuit until a stub axle broke. Stewart then led for 82 laps at Watkins Glen before teething trouble intervened once more. But a point had been made. The Tyrrell (powered by the ubiquitous Ford DFV) was potentially quick.

Tyrrell 002, with a 101.6-mm (four-inch) longer wheelbase to accommodate François Cevert, was finalised and plans were laid for an improved third car to be made ready as early as possible in 1971. Stewart took Tyrrell 003 to victory first time out in the Spanish Grand Prix, following this up with five more wins. The Scotsman clinched his second World Championship and, with it, the first Constructor's Championship for a team of no more than 19 people – including Ken Tyrrell and his wife, Norah.

THE CAR

Ken Tyrrell wanted a relatively simple car that would not require much development to make it competitive while, at the same time, getting as close to the minimum weight limit as possible. Having Tyrrell 001 weigh in considerably lighter than the March 701 was a good start.

The chassis, with a distinctive bulbous shape, was a bath tub monocoque, the Ford-Cosworth DFV rigidly mounted to a bulkhead behind the cockpit and forming a fully stressed part of the chassis in what had become the orthodox manner.

The initial design included a unique blade-like nose cowl with a shark-mouth air intake beneath. This would later make way for a rounded, full-width nose which would become a distinctive feature of 003. At the same time, Tyrrell had introduced an air box above the driver's head to feed the V8. Others, such as Lotus with the 72, had made half-hearted attempts, the difference being that the Tyrrell airbox was properly sealed, right down to the engine's air intakes. Wary at first of its unattractive, drag-inducing shape, the drivers soon appreciated the benefits of the airbox when the DFV pulled an additional 200 to 300 rpm when exiting corners.

Engine	Ford-Cosworth DFV V8
Size	2993 cc
Power	440 bhp
Weight	567 kg (1250 lb)
Wheelbase	2431 mm (95.7 in)

Jackie Stewart, carrying number 1 assigned to the reigning World Champion, takes Tyrrell 003 to second place in the 1972 British Grand Prix at Brands Hatch.

TEAM HISTORY

Ken Tyrrell knew nothing about motor racing until a chance visit to Silverstone in 1951. Initial visions of becoming a racer gave way, with typically blunt reasoning, to the thought that he would be better off as an entrant making the most of a more gifted driver. Tyrrell gradually built up a racing team operating out of the same yard used by a lumber business established by Ken and his brother. Ken would soon be recognised as a talent spotter, particularly when he signed Jackie Stewart to drive for his Formula 3 team and won the British championship in 1964. An association with Matra began with Formula 2, and the liaison with the French aerospace company eventually led to Formula 1 with the Matra MS10 in 1968 and the championship-winning MS80 the following year.

THE DESIGNER

Ken Tyrrell had met Derek Gardner during Matra's experimentation with the four-wheel-drive MS84 in 1969. Gardner, a quiet and studious engineer who specialised in transmissions, had previous experience with racing thanks to Lotus attempting to incorporate four-wheel-drive in their IndyCar. When formulating plans to build his F1 car, Tyrrell chose Gardner because of his engineering background and low profile, even though the Englishman had no experience of designing a complete race car from scratch. To maintain secrecy, Gardner worked on Tyrrell 001 from a converted bedroom, with Stewart trying the wooden mock-up for size during a furtive visit to the garage of Gardner's home in Leamington Spa. Gardner eventually moved into a Portakabin in Tyrrell's yard, the car taking shape in an adjacent wooden shed that, in its own curious way, would become as famous as Ferrari's race shop in Maranello as a centre of Formula 1 excellence.

FAMOUS DRIVERS

Although he had won two Grands Prix with BRM, Jackie Stewart would establish his reputation as one of the world's great drivers during six seasons with Tyrrell, through to his retirement at the end of 1973. The Scotsman was partnered throughout the period of Tyrrell F1 cars by François Cevert, the Frenchman poised to take over as number 1 driver when he was killed during practice for the final race of 1973 at Watkins Glen.

Jackie Stewart (right) and François Cevert celebrate finishing first and second for Tyrrell in the 1973 Belgian Grand Prix at Zolder.

100

MEMORABLE RACE

A fortnight before the 1971 Monaco Grand Prix, extensive damage had been done to Tyrrell 003 when the throttle stuck open and sent Stewart head-long into a grass bank during a non-championship race at Silverstone. Working round the clock, the Tyrrell mechanics had stripped and rebuilt the chassis in time for first practice at Monaco. The recovery seemed complete when Stewart claimed pole but, as soon as he set off on the single warm-up lap before going to the grid, he sensed a problem.

The front brakes were locking more than they should. A quick investigation by the mechanics discovered that a joint on the brake balance bar at the base of the brake pedal had unwound. There was no time to fix it. Stewart would have to tackle this race with virtually no rear brakes – a big ask on any circuit, never mind this one.

There was little clue to a problem on the leading car as Stewart's deft footwork rarely allowed the front wheels to lock and emit tell-tale puffs of blue smoke. For the first part of the race, Stewart was helped by the Ferraris, Matras and BRMs gradually disappearing for various reasons. When his pit board indicated that Ronnie Peterson's March had moved into second place just before half distance, Stewart realised he may have a problem. He responded instantly to the young Swede's every move, Stewart stretching his lead to 26 seconds and focusing on nursing the Tyrrell home.

The intense concentration required during nearly two hours of relentless effort took its toll when Stewart was sick in his helmet. But he was there to take the chequered flag, and then grab a welcome drink as he headed towards the Royal Box. As he cleaned himself up with the aid of his flameproof balaclava, Stewart looked exhausted, his shoulder-length hair lank with sweat. Soon, he was almost lost inside a vast garland. The winner's cup was thoroughly well deserved.

With his Tyrrell 003 sporting the original blade-like nose, Jackie Stewart heads for a brilliantly executed victory in the 1971 Monaco Grand Prix while coping with virtually no rear brakes.

McLaren-Ford M23

'The M23 was not as sophisticated as the Lotus 72, but it was very driveable. We tried long wheelbase, short wheelbase; the car was very adaptable for different circuits. It was a strong car, well-engineered and reliable. McLaren was not a big team, but they had a huge desire to win.'

Emerson Fittipaldi

Emerson Fittipaldi won the 1974 World Championship in a McLaren M23. Given that the Brazilian had claimed his first world title with Lotus in 1972, the only surprise was that the McLaren was almost two years old. And it wasn't done yet – in the most impressive example of racing car longevity in the history of Formula 1, James Hunt would use a McLaren M23 to become champion at the end of an intense battle with Niki Lauda in 1976.

Naturally, the M23 had undergone development over the years but such durability of a fundamental design was remarkable by any standards – particularly those of today. Continuing into a new season with what is essentially a 12-month-old car would be seen by current F1 teams as a permanent pass for the back of the grid.

In 1973, the design protocol was very different and, in McLaren's case, extremely successful. First time out, Denny Hulme put his M23 on pole position and would have won the South African Grand Prix had it not been for a puncture. Through the rest of the season, a McLaren M23 would regularly qualify on or near the front of the grid, Hulme winning in Sweden while Peter Revson finished first in the British and Canadian Grands Prix. When the American driver left McLaren at the end of 1973, Hulme was joined by Fittipaldi as they brought four more wins for the M23 and Fittipaldi's second championship.

The M23 was largely unchanged going into 1975, the accompanying reliability giving McLaren 20 finishes from 28 starts – but not enough wins (three) to improve on third in the Constructors' Championship, with Fittipaldi finishing runner-up to Niki Lauda. The Ferrari driver would be in the championship reckoning once again in 1976, this time battling James Hunt, signed by McLaren after Fittipaldi's eleventh-hour departure to run a Brazilian F1 team with his brother. Following production delays with a new car, the M26, McLaren relied once again on the M23. With various modifications to the suspension and gearbox, the four-year-old car proved fast enough to give Hunt the championship by a single point.

McLaren produced 13 in total, the M23 winning 20 Grands Prix, two Drivers' World titles and one Constructors' Championship to make it the most prominent F1 car of its era.

THE CAR

As was the way at McLaren Racing, the designer, drivers, mechanics and team managers gathered in the small workshop in Colnbrook to discuss how best to tackle the latest requirements going into 1973. Faced with a regulation change calling for deformable structures to give added protection to the sides of the car, Chief Designer Gordon Coppuck chose to integrate the crush-proof areas into the chassis rather than follow the popular trend of simply bolting them on to an existing design. The result was an inherently rigid car that did not carry the weight penalty of add-on crush structures. Coppuck used his experience in designing McLaren's M16 IndyCar to opt for a wedge-shape chassis with side radiators. The Ford-Cosworth DFV and transmission were secured to the rear bulkhead of the aluminium chassis, as it had been with the previous F1 car, the M19. Proven rising rate front suspension was incorporated, with the entire chassis and engine covered in a single piece of bodywork. Over succeeding seasons, the suspension geometry and airbox shapes would be altered, and a six-speed gearbox introduced in 1976. Apart from small detail modifications, particularly to cope with a change in tyre diameter, the M23 remained essentially the same.

Engine	Ford-Cosworth DFV V8
Size	2993 cc
Power	460–465 bhp
Weight	601–619 kg (1325–1365 lb)
Wheelbase	2565–2718 mm (101–107 in)

Going into its fourth season, the M23 remained a force to be reckoned with when James Hunt joined McLaren in 1976. The Englishman won six Grands Prix and claimed the championship by a single point from Ferrari's Niki Lauda.

TEAM HISTORY

Knocked sideways by the death of Bruce McLaren in an accident during testing on 2 June 1970, the small team of loyal mechanics held it together under the leadership of Teddy Mayer and won the CanAm sportscar championship for a fourth time. Formula 1 proved less successful, McLaren failing to win a Grand Prix for two seasons until 1972, when they pulled out of CanAm to focus on F1. Denny Hulme won in South Africa, and seven further podium finishes were shared between the New Zealander and Peter Revson, helping to pull McLaren back to third in the Constructors' Championship. McLaren would not be lower than third during the next four years thanks to the arrival of the M23.

THE DESIGNER

Gordon Coppuck had been responsible for the successful McLaren IndyCar and CanAm cars in the early 1970s. When Ralph Bellamy, creator of the McLaren M19 (predecessor of the M23), left the team at the end of 1971, Coppuck took sole charge of the design office and set to work on the car required by the change in F1 regulations for 1973. The Englishman would remain with McLaren until a change of ownership in 1980.

FAMOUS DRIVERS

Following the loss of Bruce McLaren in 1970, Denny Hulme became the indefatigable mainstay of McLaren Racing. In 1973 he was partnered on the F1 team by Peter Revson. A third M23 was driven in the German Grand Prix by Jacky Ickx and, for four races, by Jody Scheckter. Emerson Fittipaldi joined Hulme in 1974 in cars sponsored by Marlboro. A third M23 in the colours of Yardley was entered for Mike Hailwood until the former motorcycle champion was injured during the German Grand Prix. Hailwood's place was taken by David Hobbs, and then Jochen Mass. Following Hulme's retirement at the end of 1973, Mass completed a full season alongside Fittipaldi until the Brazilian departed and made way for James Hunt in 1976. M23s were also driven by Gilles Villeneuve (making his F1 debut with the works team in the 1977 British Grand Prix) and Nelson Piquet (ex-works car entered by BS Fabrications in 1978).

Emerson Fittipaldi (#5) and Denny Hulme wait in the pits for the start of practice at Anderstorp in Sweden in 1974. Hulme would win one race with the McLaren M23 that year, while Fittipaldi claimed three championship Grands Prix and the world title.

106

MEMORABLE RACE

McLaren came to the 1973 British Grand Prix in a confident mood. Denny Hulme had claimed pole position in South Africa and won in Sweden, and Peter Revson was poised, the team felt, to score his first win. At the previous race in France, McLaren had given Jody Scheckter his F1 debut. The bullish young South African had been disputing the lead (no less) when he tangled with Emerson Fittipaldi's Lotus. Nonetheless, this had been enough to warrant the entry of a third M23 at Silverstone. McLaren were to get more than they bargained for.

Hulme and Revson qualified on the front row, alongside the pole position Lotus 72 of Ronnie Peterson. Scheckter was sixth fastest. Hulme warned the new boy to take it easy during the hurly-burly of the opening minutes. Towards the end of the first lap, Scheckter overtook his mentor to move into fourth place. Coming through Woodcote, Scheckter put a rear wheel on the dirt at the exit of the long 241-kph (150-mph) right-hander. In an instant, the white McLaren was sideways, with no hope of recovery.

Scheckter's momentum took him towards the pit wall. The resulting impact with the breeze blocks sent the McLaren back across the track as the remaining 20 or so drivers hammered through Woodcote at full bore. Amazingly, no one hit the McLaren amidships. But nine cars collided in high-speed avoidance, the entire Surtees team of three cars being wiped out. Apart from a broken ankle, no one was injured. And even more miraculously, considering cars were full of fuel, there was no fire. That would be reserved for angry rivals, seeking out Scheckter. Hulme and Revson looked on bemused as Phil Kerr, the McLaren team manager, spirited Scheckter to comparative safety in the team truck.

At the restart, Hulme and Revson allowed the race to settle down before moving into the top three, Revson ahead of Hulme. Just before half distance, Revson took the lead from Peterson and held on to score his first Grand Prix win. Hulme finished third and just managed to hold off James Hunt in a privately entered March. Few, least of all Hunt, would have believed that three years hence he would use the latest version of the car he had just followed to win the World Championship.

Peter Revson, leading the McLaren M23 of his team-mate, Denny Hulme, heads for his first Grand Prix victory at the end of a dramatic race for the Yardley-sponsored McLarens at Silverstone in 1973.

Ferrari 312T

'The Ferrari flat-12 engine had only a marginal power advantage over the Cosworth DFV. Where the 312T really scored was with the chassis. It was perfect; totally neutral and progressive. It was a permanent monument to Mauro Forghieri's skill; a real gem of a car.'

Niki Lauda

The late Sixties and early Seventies had not been kind to Ferrari, as the resulting key changes in the technical and management departments coincided with the arrival of Niki Lauda in 1974. Their first season together produced two wins but, in truth, a realistic chance of claiming the championship was lost through a combination of driver inexperience and tactical blunders by the team. Lessons learned would not be squandered.

The next car, the 312T, would contribute a great deal to championships for Lauda and Ferrari as the Austrian won five Grands Prix. In 1976, Lauda was set to capitalise on a revised car, the 312T2, but the season would be remembered for his extraordinary recovery after a fiery crash during the German Grand Prix and a battle to the wire with James Hunt, with the championship going to the McLaren driver by a single point. Continuing with the 312T theme in

1977, Lauda would underline his exceptional fortitude by winning a second championship with Ferrari before moving on to Brabham. Ferrari would suffer a comparative dip in competitiveness until the arrival of the 312T4 in 1979.

THE CAR

Ferrari had introduced their latest version of a flat-12 engine in 1970 for both Formula 1 and the World Sportscar Championship. Whereas the sleek little 312P sports prototypes would win the title in 1972, the F1 effort struggled with a variety of cars and designers. Mauro Forghieri was recalled to the racing department and immediately set about making better use of the flat-12 within the 312B3, a new car developed largely with the input of Niki Lauda. When Lauda (and team-mate Clay Regazzoni) complained about constant understeer with the 312B3, Forghieri packaged as much of the 1975 car as possible between the front and rear wheels. To assist with the mission of reducing the car's so-called polar moment of inertia, the gearbox was placed across the car instead of in the traditional longitudinal position. The latest Ferrari, known as the 312T ('T' for *trasversale*), was more nervous than its predecessor, but the drivers felt they could push harder and explore the limits of its handling. An evolutionary 312T2 was introduced for 1976 and 1977.

Engine	Ferrari flat-12
Size	2992 cc
Power	500 bhp
Weight	575–584 kg (1268–1287 lb)
Wheelbase	2517–2560 mm (99.1–100.8 in)

TEAM HISTORY

Ferrari had been through a difficult time, culminating in a lowly sixth place in the 1973 Constructors' Championship. But important moves were afoot. Enzo Ferrari had switched his team's focus solely to Formula 1 by abandoning plans to continue sports car racing. He had signed Niki Lauda, yet to prove himself, but a driver with nous and a direct manner. His first contact with the 'Old Man' came when Lauda drove the 1973 Ferrari on the team's test track at Fiorano and told the irascible icon that his car was rubbish! Which was true, but not necessarily what Mr Ferrari wished to hear.

When challenged to improve it, Lauda went to work with the team's technical director Mauro Forghieri and, within a week, lowered the Fiorano lap record by almost a second. This would not only cement the Austrian's relationship with the team but the lessons learned would also confirm Forghieri's thinking for Ferrari's 1974 car, the 312B3. Fiorano became Lauda's second home in the winter months as he continually tested developments, most of which turned the 312B3 into a potential race winner.

Fiat had taken a 50 per cent stake in Ferrari in 1969. A restructuring of the racing department led to Luca di Montezemolo, a member of the Agnelli dynasty that controlled Fiat, assuming a liaison role between the board of Fiat and the team. The suave lawyer knew exactly how to handle Enzo Ferrari and get things done – an asset Lauda appreciated and used to his advantage. It would be the beginning of an eventful, if comparatively brief, liaison in which the Ferrari 312T would play a significant part.

Clay Regazzoni was a perfect team-mate for Niki Lauda, the amiable but fast Swiss driver using his Ferrari 312T to take a popular win in the 1975 Italian Grand Prix at Monza. Third place in the same race was enough for Lauda to become World Champion for the first time.

THE DESIGNER

Ferrari was in such disarray following a poor season in 1972 that Mauro Forghieri, technical director since 1961, was branded by Enzo Ferrari as the scapegoat and exiled to some mundane department in the road car division. The result was the virtual collapse of the racing team. When 1973 turned out to be even worse than before, Forghieri was recalled and set to work immediately, the Italian masterminding a technical comeback that would include the 312T.

FAMOUS DRIVERS

Niki Lauda will be forever associated with Ferrari's return to form in 1974 and the success during the next three years. His team-mate for the first three seasons was Clay Regazzoni, supposedly the number 1 driver initially because of his previous experience with the team, but happy to receive the benefit of Lauda's input and, at times, necessarily blunt brand of leadership. The laid-back Swiss won three Grands Prix to twelve for Lauda during their time together, Regazzoni being replaced by Carlos Reutemann in 1977.

Niki Lauda's sometimes blunt brand of leadership had a major influence on the resurgence of Ferrari with the 312T.

Ferrari mechanics greet Niki Lauda as he nurses his 312T2 across the line to win the 1977 South African Grand Prix. Moments later, the 12-cylinder engine expired in a cloud of smoke.

MEMORABLE RACE

Both Niki Lauda and Ferrari were under pressure at the start of the 1977 season. Having lost the Drivers' Championship the previous year, question marks continued to hang over Lauda's recovery – both mental and physical – following the crash that had almost killed him during the 1976 German Grand Prix. Carlos Reutemann had won for Ferrari in Brazil but the 1977 season started badly for Lauda. A subsequent spell of relentless testing at Fiorano indicated that Lauda was ready to make up for lost ground at the next race in South Africa. When he took the lead from James Hunt and exercised his smooth but fast style to pull away, it was clear that Lauda had the Ferrari 312T2 working exactly as he liked. His 13th Grand Prix win seemed to be guaranteed, barring misfortune.

After about 30 of the race's 73 laps, the Ferrari began to understeer for no apparent reason. Gradually, Lauda was hauled in by the Wolf-Ford of Jody Scheckter, the South African being urged on by the home crowd. By driving tactically – holding Scheckter up enough through the final corner and then using the Ferrari's marginally superior acceleration on the long straight to prevent the Wolf from overtaking on the approach to the first corner – Lauda was able to hang onto the lead and gradually pull away as he adjusted his driving to the persistent understeer.

Then another problem arose. In the final laps, a flashing oil pressure light accompanied the rising water temperature gauge, indicating an overheating engine. Once again, Lauda had no idea why this should be. Nursing the ill-handling car and its fragile engine, Lauda managed to keep Scheckter at bay without revealing the extent of his problems. Seconds after crossing the line, Lauda's engine expired dramatically in a cloud of smoke and steam.

Unknown to Lauda, he had run over part of another car that had been involved in an accident. The errant piece, hidden from Lauda's view by the crest of a hill, had damaged the front wing (causing the understeer) and lodged itself in the water radiator. The 12-cylinder Ferrari engine had only four of its usual twelve litres of water left in the system at the finish. Lauda was fortunate to have got that far.

Tyrrell-Ford P34

'For some reason, we went well in Sweden. The layout at Anderstorp proved one of the P34's advantages was straight-line speed. It also scored on its turning-in speed to corners after braking. If the circuit was flat and you were braking in a straight line, it was okay. But anywhere else, as soon as you turned in, one wheel lifted up.'

Jody Scheckter

When the media was invited to the launch of the latest Tyrrell F1 car in September 1975, there was surprise over such an early reveal. Why would a team with a championship winning record wish to make the competition aware of their plans so far in advance of the following season? Such a question gradually became irrelevant as the wraps were slowly removed, starting at the back of the car.

Everything seemed normal initially: rear wing; high airbox; Ford-Cosworth DFV engine; standard cockpit. It was only when the covers revealed the front of the car that those in the room let out a collective gasp, followed by complete silence for a few seconds.

Instead of two front wheels, the Tyrrell had four. If a rival had wished to follow suit, it would have taken time and trouble to arrange the manufacture of the tiny wheels and brakes, never mind specifying purpose-made tyres. And that was assuming another team would automatically wish to go down this highly unconventional route. There had never been a Formula 1 car with six wheels. Rather than following their familiar type numbers – in theory, this should have been Tyrrell 008 – Tyrrell had designated the car 'Project 34' (shortened to P34); in itself, an indication of the car's pioneering aspect.

The P34 proved to be faster than its four-wheel predecessor during winter testing, which was hardly a surprise since the Tyrrell 007 was becoming long in the tooth. A more valid indicator would come not long after the P34 made its Grand Prix debut four races into the 1976 season. A retirement for the single-car entry in Spain was followed by fourth place in Belgium and a very impressive second and third with two cars at Monaco. Any lingering doubts about the efficacy of the six-wheeler would be blown away completely when the blue cars finished first and second at Anderstorp in Sweden.

It was an extraordinary achievement. And a singular one. As the remaining nine races unfolded, the Tyrrells slipped down the scale of significance. The P34s would occasionally lead and finish in the top three, but never again experience the domination hammered home in Sweden. Reliability problems would intervene, niggling failures aggravating regular difficulty with consistent braking on the four front wheels.

Undaunted, Tyrrell persisted, the P34 for 1977 appearing with sleeker bodywork and producing such competitive times during winter testing that Ken Tyrrell, not a gambling man, laid a £500 bet on one of his drivers winning the championship. It would turn out to be money wasted, as was the effort put into a car that would suffer from a lack of tyre development, Goodyear, understandably, focused on most customers running front wheels of a conventional size. The six-wheel project was abandoned at the end of the season.

THE CAR

The P34 was initially conceived as (quoting the designer) 'a concept for research purposes, which might or might not have racing applications'. The project had been prompted by most leading F1 teams having the same tyres, the same gearbox and, more significantly, the same engine. Running with four small wheels was a means of seeking a so-called 'unfair advantage' through reducing the aerodynamic lift created by standard front wheels. It was pointed out by Tyrrell that the apparent advantage of a hugely reduced frontal area would be negated by the large rear wheels. Nonetheless, initial tests suggested the six-wheel principle might indeed have a racing application that was worth pursuing.

The biggest surprise had been such a distinctively different car remaining secret during its construction. People from outside the team – machinists, fabricators, sheet metal workers – had been involved in producing the necessary specialist parts and yet no one in the wider industry had the faintest clue until the launch.

The brakes would turn out to the biggest concern as drivers found difficulty in preventing at least one of the four front wheels from locking. The rear tyres supplied by Goodyear throughout 1976 and 1977 were state of the art, but the

front tyres were metaphorically going nowhere. Narrowing and then extending the P34's front track would make no difference. The inability to get the front tyres to match the rest of the car would ultimately cause its downfall.

Engine	Ford-Cosworth DFV V8
Size	2993 cc
Power	460–465 bhp
Weight	601–619 kg (1325–1365 lb)
Wheelbase	2565–2718 mm (101–107 in)

TEAM HISTORY

The Tyrrell team had experienced a difficult time following the death of François Cevert during practice for the final race of the season in 1973. The Frenchman, coached and groomed by Jackie Stewart, had been more than ready to take the retiring champion's place. At the eleventh hour, Tyrrell had to prepare for the coming season with Jody Scheckter and Patrick Depailler, two novice drivers who found difficulty getting to grips with the fast but nervous cars that Stewart and Cevert had learned to master so well. That problem would be answered in 1974 by the arrival of the Tyrrell 007 – two podium finishes being followed by an extraordinary 1–2 in Sweden. The improvement in form was such that Scheckter had an outside chance of winning a championship that would eventually go to Emerson Fittipaldi. Meanwhile, the Tyrrell technical director was thinking about increasing his drivers' chances in 1976 by reducing the size of the front wheels.

THE DESIGNER

The rise of Derek Gardner's reputation had scarcely faltered since his arrival as a virtual unknown to design a Grand Prix car capable of winning the championship in its first full season. It was the same story with Tyrrell 005, the slab-sided iteration of Tyrrell 001 being capable of winning another championship in 1973. Tyrrell 007, which would win a few races during the next two seasons, was conventional compared to what came next. The struggle to make the P34 six-wheeler a success would ultimately lead to Gardner accepting a job in transmissions, the specialist field from which the quiet Englishman had come to make such a short but lasting impression in F1.

FAMOUS DRIVERS

Jody Scheckter and Patrick Depailler, having been with Tyrrell since 1974, had the questionable honour of racing F1's first six-wheeler in 1976. Scheckter's struggle with a car he never really liked led to an offer from the fledgling Wolf team, Depailler being joined in 1977 by Ronnie Peterson, an eight-time Grand Prix winner. Despite his sometimes spectacular efforts, the Swede could not coax a victory out of the P34 in its latest and final iteration before he left at the end of the year. Depailler would have to wait until 1978 before scoring his first Grand Prix victory with the Tyrrell 008.

Patrick Depailler gives the Tyrrell P34 its debut in the 1976 Spanish Grand Prix at Jarama. A lack of development with the four small tyres would eventually lead to the demise of the first six-wheel F1 car.

MEMORABLE RACE

The Scandinavian Raceway at Anderstorp was completely flat. The 4.4-km (2.5-mile) track was based around the runaway of the local airport and comprised a series of right-angled corners and hairpins. It was not a particularly inspiring venue but, for reasons that were never clear, the track had suited Tyrrell in 1974, when Scheckter and Depailler finished first and second. Any questions about the P34 being competitive two years later were answered when Scheckter put the six-wheeler on pole. Mario Andretti led for several laps before the Lotus-Ford suffered

Never a fan of the Tyrrell P34, Jody Scheckter nonetheless was happy to lead home an extraordinary 1–2 finish for the six-wheeler in the 1976 Swedish Grand Prix at Anderstorp.

an engine failure. Scheckter assumed a comfortable lead, with Depailler ready to give Tyrrell an historic 1–2 for a six-wheel F1 car. Scheckter's only problem had come during practice when a hub failed and one of the little front wheels fell off. Scheckter was surprised to find he was able to return to the pits on five wheels with no problem at all – so much so, when he arrived, no one on the team noticed the missing wheel and assumed he had stopped for routine adjustments.

Wolf-Ford WR1

'On short circuits, the Wolf was very nice. We did a lot of testing. I sent a telex to Ferrari at the beginning of the 1977 season and asked if we could use his Fiorano test track. Mr. Ferrari agreed! That helped us a lot.'

Jody Scheckter

The team was new; the car was new. Together, they won their first race. Debuts don't come much better than that in any form of motor racing, never mind the competitive world of Formula 1.

Walter Wolf, a Slovenian-born Canadian, had made enough money to satisfy his passion for fast cars. When introduced to Grand Prix racing, that enthusiasm became a deeply competitive zeal. Wolf bought his way into an ailing F1 team before deciding that the best way forward was to start from scratch and build his own car. He had learned enough to employ the best people in their respective specialist fields. Wolf tempted Jody Scheckter to leave Tyrrell. The South African, although disaffected with the P34 six-wheeler, was prepared to take a chance on Harvey Postlethwaite, an enthusiastic designer chosen by Wolf and already responsible for a Grand Prix winner with Hesketh in 1975. If Scheckter thought he might be on a winner once he saw the elegant Wolf WR1, that champagne moment would come sooner than anyone expected.

The first race of 1977 in Argentina looked like being no more than a reasonable shakedown for Wolf when Scheckter qualified in the middle of the grid. Biding his time and learning about how he and the car were coping with torrid conditions, Scheckter began to move up the order, helped by cars ahead either having mechanical problems or their drivers succumbing to the heat. With six laps remaining, Scheckter was as surprised as anyone to find himself in front and heading for a dream debut.

Luck may have played its part in Argentina, but there was no question about the quality of a high-profile victory in the Monaco Grand Prix, led all the way by Scheckter. A third win, this time in Wolf's home race at Mosport, was helped by the leading Lotus blowing its engine with two laps to go,

The striking appearance of the Wolf WR1 was matched by Jody Scheckter's driving and, remarkably, a win first time out.

but this result went some way to compensating for a certain win having been denied by a puncture on the streets of Long Beach, California.

Scheckter was runner-up to Ferrari's Niki Lauda in the championship. Walter Wolf Racing claimed fourth (out of 12) in the Constructors' Championship – a remarkable feat for a single-car entry. But that was as good as it would get. The WR5, a more complex car for the following season, simply didn't work. Scheckter went to Ferrari for 1979 and Wolf lost interest, eventually selling his team.

THE CAR

The striking appearance of the Wolf WR1 was due to curving bodywork in dark blue and gold. The monocoque chassis and suspension were conventional as Harvey Postlethwaite focused on reliability for the new team. The Englishman's design ethos was a success, judging by the fact that none of Scheckter's seven retirements were related to the chassis. With just one exception in the season's 17 Grands Prix, Scheckter would finish in the top three if the Wolf was still running at the finish. The Ford-Cosworth DFV was the obvious, and arguably the only, choice for a team that was swiftly put together.

Engine	Ford-Cosworth DFV V8
Size	2993 cc
Power	475 bhp
Weight	585 kg (1290 lb)
Wheelbase	2490–2615 mm (98–103 in)

TEAM HISTORY

Born in Slovenia, Walter Wolf's humble upbringing prompted the search for a better life in Canada. Aged 19 and penniless, Wolf kept himself warm in cinemas and learned his English from watching cowboy movies. An astute mind and the ability to hustle would eventually earn a small fortune through setting up and equipping offshore oil rigs.

Having enough money to finally indulge himself, Wolf pursued a passion for fast cars. Introduced to Frank Williams, Wolf accepted an invitation to attend a non-championship F1 race at Silverstone in 1975. Wolf was so enthused, he offered to pay for two engine rebuilds desperately needed by Williams' team. Wolf's fervour accelerated to such an extent during subsequent Grand Prix visits that he formed visions of owning his own F1 team and doing a better job than Williams. When Wolf offered to settle Frank's debts – estimated at £140,000 – in return for a 60 per cent interest in the team, Williams refused.

Wolf turned his attention to Hesketh Racing. Despite a glory day earlier in 1975 when James Hunt won the Dutch Grand Prix, this small team faced liquidation. Hunt was snapped up by McLaren, and Wolf accepted the offer of Hesketh's assets (including a new car of unknown potential) for £450,000. Having zero F1 experience, Wolf asked Williams to join him, which Frank did for a year before going off to do his own thing.

Wolf, meanwhile, appeared to be stuck in a cul-de-sac at the end of a disastrous season with the uncompetitive Wolf-Williams FW05. But the one thing he did have was membership of the Formula One Constructors' Association (FOCA) thanks to Jacques Laffite taking Frank's FW04 to a fortunate second place in the 1975 German Grand Prix. Wolf would never have enjoyed the associated perks and subsidised travel had he worked solely with what remained of Hesketh.

Wolf also recognised that money spent wisely could lay the foundations for a team capable of doing the job necessary to get him out of the blind alley. Having chosen Harvey Postlethwaite as designer, Wolf then persuaded the efficient and authoritarian Peter Warr to leave Lotus and become team manager. This was enough to facilitate another key part of Wolf's plan, as he coaxed Jody Scheckter to take a chance with what was effectively a new team, now known as Walter Wolf Racing.

THE DESIGNER

Having studied mechanical engineering and graduated with a BSc and then a doctorate, Harvey Postlethwaite gained experience with March, working on their Formula 3 and Formula 2 cars in 1970. When Hesketh Racing decided to go F1 racing with a March, Postlethwaite joined the privately run team and later accepted the challenge of designing their first F1 car. The highlight was a fine victory for James Hunt's Hesketh-Ford in the 1975 Dutch Grand Prix; the low point coming not long after when Lord Alexander Hesketh could no longer afford to run his team and sold out to Wolf-Williams. Postlethwaite remained with the team during a difficult season in 1976 and was perfectly poised to take on the role of technical director when Walter Wolf decided to go it alone.

FAMOUS DRIVERS

Jody Scheckter was the sole entry for Walter Wolf Racing in 1977, staying for two seasons before joining Ferrari. Wolf entered a second car for two races at the end of the 1978 season, the American driver, Bobby Rahal, retiring his WR1 from the Canadian Grand Prix after finishing 12th in a WR5 in his home race the previous week.

MEMORABLE RACE

Wolf could not have timed it better. By winning the 1977 Monaco Grand Prix, apart from the obvious pleasure of scoring their second win in six races, the result marked the 100th victory for the Ford-Cosworth DFV – a substantial milestone for the engine manufacturer considering Cosworth had first raced the V8 just 10 years before, almost to the day. Wolf could only benefit from the accompanying media attention, which was fully deserved. Jody Scheckter had led all 76 laps, snatching the lead at the start from John Watson's pole position Brabham-Alfa Romeo. Watson, who had been half a second faster during qualifying, pushed Scheckter for more than 40 laps, the nose of the red car almost touching the Wolf's gearbox until broken transmission ended Watson's race. Scheckter then came under pressure from Niki Lauda, the Wolf and the Ferrari covered by less than a second as they crossed the line. Scheckter accepted his trophy from Prince Rainier and then received an escort from Monaco's Chief of Police to the Wolf motor home. Over a glass of champagne, the Police Chief granted Scheckter, a Monaco resident, one year's immunity from parking tickets. All in all, a good day's work!

Jody Scheckter holds a lead he would never lose during the 1977 Monaco Grand Prix. The Wolf driver is followed into Loews Hairpin by John Watson's pole position Brabham-Alfa Romeo BT45B, the Ferrari 312T2 of Niki Lauda and the Brabham BT45B of Hans-Joachim Stuck.

Lotus-Ford 79

'When I raced the 79 for the first time [in a Grand Prix, following development to the car on the basis of lessons learned in a non-championship race], the back end of the car was unreal. It seemed like here was the perfect race car, with grip at the front, grip at the back, incredible traction.'

Mario Andretti

The Lotus 79 revolutionised racing car design. Previously, Colin Chapman had introduced the monocoque chassis with his Lotus 25, followed by a wedge-shape for the Lotus 72. The Lotus 79 (and its development predecessor, the Lotus 78) went a giant step further by using the entire car to utilise the passage of air over it – but, primarily, through the sides and underneath – to maximise the aerodynamics. The principle of so-called 'ground effect' had arrived. Not only was the Lotus 79 beautiful to behold, the performance was just as stunning. Mario Andretti was virtually unchallenged on his way to the 1978 World Championship.

THE CAR

The Lotus 72 had introduced radiators to the sides of the car. Now Colin Chapman thought about harnessing the air on its way into and around the cooling system by effectively trapping and utilising the airflow in box-like structures known as sidepods. A seal (initially a row of bristles, later to become a sliding skirt) between the bottom edge of the sidepod and the road would help contain and direct the passage of air around an inverted wing. The design was such that a venturi effect would create a vacuum, the accompanying suction pulling the car onto the track, loading the tyres and providing previously unknown levels of grip. Although winning races in 1977, the Lotus 78 needed refinement. The Lotus 79 produced even more ground effect thanks to modifications within the sidepods that included the removal of a fuel cell in each pod, the fuel now contained in a large single tank behind the driver. In 1978, the Lotus 79 claimed ten pole positions, winning six of the sixteen Grands Prix to give Lotus the championships for driver and team. The following year was an anti-climax by comparison as rivals copied and developed the ground effect philosophy, the Lotus 79 being relied on for another season while vainly waiting for the Lotus 80 to make its mark.

Engine	Ford-Cosworth DFV V8
Size	2993 cc
Power	475 bhp
Weight	575 kg (1268 lb)
Wheelbase	2743 mm (108 in)

TEAM HISTORY

As the Lotus 72 finally became uncompetitive and the Lotus 76 failed miserably, the team from Norfolk slumped to seventh in the 1975 championship with a mere nine points – a tenth of their tally in the glory days from two years before. The F1 team remained the domain of Colin Chapman, who continued to be motivated by the challenge of seeking out an advantage no one else had considered. Thinking out of the box once more, Colin Chapman charged his expanded design team with exploring his latest idea of doing much more with the car's aerodynamics, other than simply using front and rear wings. The resulting sleek shape of the Lotus 79 was enhanced by the simple black and gold John Player colour scheme of the team's title sponsor, Imperial Tobacco. As ever, the Lotus was powered by a Ford-Cosworth DFV V8.

Mario Andretti made the most of the Lotus 79 and the ground effect generated in the sidepods of the sleek car with its black and gold livery.

THE DESIGNER

Colin Chapman continued to be an energetic driving force and the creative genius who made strategic decisions while remaining involved in his team's day-to-day racing activity. The Lotus boss was not afraid to tap into the knowledge of others with specialist skills. Faced with race results far below his required standard, Chapman gathered a group of engineers, headed by Tony Rudd, formerly with BRM (see 'BRM P57', page 48). Rudd was joined by Ralph Bellamy (formerly with Brabham and McLaren) and, significantly in terms of his input to the ground effect phenomenon, Peter Wright, who had previously worked with Rudd at BRM before being associated with March and their 701 F1 car. Once the fundamentals had been agreed, Bellamy drew the car while Wright developed the aerodynamics. Martin Ogilvie, having worked on the Lotus 72, was responsible for the suspension and other details on the 79.

FAMOUS DRIVERS

Mario Andretti had previously driven for Lotus, the American famously winning pole position on his F1 debut with a Lotus 49 in the 1968 United States Grand Prix at Watkins Glen. After driving in F1 variously for March, Ferrari and the American Parnelli team, Andretti signed for Lotus in 1976. His perseverance and an excellent working relationship with Chapman began to pay off when he won the final race of that year in a Lotus 77, a prelude to four wins in the following season with the Lotus 78. With the all-conquering Lotus 79, Andretti would claim six wins, seven pole positions and three fastest laps (to add to a win and pole with the Lotus 78 early in the season).

In 1978, Andretti was partnered with Ronnie Peterson, the Swedish driver playing the dutiful role of number 2 driver. Andretti and the team were devastated when Peterson died of injuries received during a first-lap accident in the Italian Grand Prix, the race that confirmed Andretti as World Champion. Peterson had won two races that season (one in a Lotus 78), his place being taken by Jean-Pierre Jarier, who put the Lotus 79 on pole for the Canadian Grand Prix, and would have won in Montreal but for a loss of oil pressure. Carlos Reutemann drove a Lotus 79 throughout the 1979 Grand Prix season. Andretti had a couple of unsuccessful races with a Lotus 80 that represented Chapman's surprisingly fruitless attempt to advance the benefit of ground effect. Chapman sold a 79 to Hector Rebaque, the Mexican private entrant racing the Lotus until commissioning and running his own car for the final three Grands Prix.

A poignant moment as Mario Andretti (left) and Ronnie Peterson pose with a Lotus 79 on race morning at Monza in 1978. Later that day, Andretti would clinch the championship and Peterson would become involved in a multi-car collision, the Swede succumbing to his injuries in the early hours of the following morning.

MEMORABLE RACE

When Mario Andretti won in Germany in August 1978, it was his fifth win of the season. With five races remaining and an 18-point lead (worth two clear wins), the championship was looking good. Then it all went wrong two weeks later in Austria. Andretti spun off on the first lap and the race was won by Ronnie Peterson, Andretti's team-mate and closest rival. There was an informal agreement that, all things being equal, Andretti should have championship priority. Peterson was a man of his word but, if there was a repeat of the Austrian result, the title fight would be blown wide open.

And Peterson had let it be known that he would be leaving Lotus for McLaren at the end of the year. Mario trusted Ronnie implicitly. But he knew, given half a legitimate chance, Peterson would grab it. Andretti was noticeably edgy and more pensive when they arrived in The Netherlands for the next race at Zandvoort.

Peterson had taken pole position in Austria, but Andretti made sure he was on pole in The Netherlands. The Lotus 79 worked so well in the race at Zandvoort that the black and gold cars pulled away from the rest, Peterson shadowing his team-mate's every move. Andretti, anxious to finish this race, was only going as fast as he felt he needed, but with 20 laps remaining, that became a luxury he no longer had.

A weak spot on the Lotus 79 had been the exhaust pipes running too hot within the enclosed confines of the sidepods. When part of the exhaust broke, the surrounding bodywork began to burn and cost Andretti downforce. It was particularly noticeable at the exit of the fast right-hander leading onto the main straight. Once or twice, Peterson would dart from Andretti's slipstream as they reached the braking area at the end of the straight. But the status quo remained until the 75 laps had been completed. As it would turn out, this was Andretti's last of 12 victories in Formula 1.

Ronnie Peterson (#6) keeps Mario Andretti close company as the Lotus duo accelerate from the first corner of the 1978 Dutch Grand Prix. The following Brabham-Alfa Romeo BT46 of Niki Lauda and Carlos Reutemann's Ferrari 312T3 would soon be left far behind.

Brabham-Alfa Romeo BT46B

'It was the easiest win I ever had. You could do anything with that car. Going into a corner with a normal car, you'd usually back off to kill the understeer. With the Brabham, you just booted it even harder. The thing just sat down on the track, you were through the corner and away. Incredible car!'

Niki Lauda

This was one of the most inventive examples of rule bending in the history of Formula 1. Since a flat-12 Alfa Romeo engine in the back of the Brabham ruled out an effective ground effect system, which was pioneered by the Lotus 78 and Lotus 79, Brabham's designer, Gordon Murray, investigated a loophole in the regulations. Brabham incorporated a large fan on the back of the car, the prime purpose – according to Murray – being to cool a water radiator. The fact that the fan also drew air from a sealed engine compartment and sucked the car towards the ground was incidental.

Rivals did not see it that way – particularly when Brabham turned up at the 1978 Swedish Grand Prix with two of the so-called 'Fan Cars' and literally blew the opposition away. Niki Lauda, driving the winning BT46B, said he had never experienced such phenomenal grip while cornering.

Opponents claimed the creation of suction made the fan a 'moveable aerodynamic device', which was not allowed by the regulations particularly, it was argued, as this was the fan's primary purpose. Cooling the engine was secondary. Murray countered this argument by saying, if the fan was disconnected, the engine would overheat.

The BT46B was never declared illegal, but politics would come into play. Bernie Ecclestone owned Brabham but the shrewd entrepreneur was also in the process of trying to unite the Formula 1 teams in a fight with the sport's governing body for control of F1's commercial earnings. Wishing to keep everyone on side, the pragmatic Ecclestone chose to withdraw the BT46B from future races, much to Murray's disgust. The fan car's existence had been brief, brilliant, and deeply divisive.

THE CAR

Recognising the significance of Colin Chapman's championship-winning exploitation of ground effect with the Lotus 79, Brabham's Gordon Murray knew he had to circumvent an inbuilt disadvantage thanks to a contract with Alfa Romeo for the supply of engines. The basic shape of the wide flat-12 meant the heads of the engine would protrude into the sidepod areas where the clean passage of air was essential for the creation of ground effect. When an initial idea to use surface heat exchangers mounted on the flanks of the BT46 failed to work efficiently, Murray schemed a 'B' version that was even more extreme.

The BT46B carried a large horizontal water radiator above the engine. Flexible skirts touching the road, and seals around the slots for suspension and driveshafts, made the engine bay as airtight as possible. A purpose-built vertical fan, attached to the rear and driven off the gearbox, would extract the under-chassis airflow from around the engine and gearbox. The creation of a low pressure area caused a downward force on the car, pulling the rear of the Brabham closer to the track. The fan was large enough to be covered by a domestic dustbin lid when the engine was switched off. While Murray continued to maintain that the primary objective of the fan was to cool the radiator, rivals pointed to the extraordinary sight of the rear of the car rising and falling in the pit lane as the driver blipped the throttle and the revolutions of the fan rose and fell. Following the fan car's withdrawal, a hurriedly revised version of the BT46, with radiators mounted behind the front wheels, was raced for the rest of the season.

Carrying the number 1 as reigning World Champion, Niki Lauda switched from Ferrari to Brabham for 1978. A single race with the BT46B 'Fan Car' would give the Austrian the easiest of his 25 career Grand Prix victories.

Engine	Alfa Romeo 115-12 flat-12
Size	2993 cc
Power	520 bhp
Weight	629 kg (1386 lb)
Wheelbase	2590 mm (102 in)

TEAM HISTORY

At the end of 1970, Jack Brabham retired from driving and sold his share in the company to the businessman and driver manager, Bernie Ecclestone. Unhappy with Ecclestone's methods, Brabham's former partner, Ron Tauranac, sold up and followed Brabham to Australia. Ecclestone initiated a company strategy that would abandon the production of customer race cars and focus entirely on Formula 1. A significant aspect of the reorganisation was the promotion of Gordon Murray from the drawing office to Chief Designer, thus releasing a free spirit driven by revolutionary ideas. Murray's first creations, the BT42 and the BT44, returned the Brabham name to the fore as the Ford-Cosworth-powered cars won in 1974 and 1975. The switch to Alfa Romeo engines was less successful, the win with the BT46B fan car in Sweden in 1978 breaking an absence of almost three years from the top of the podium.

THE DESIGNER

Gordon Murray was born in South Africa in 1946. While studying mechanical engineering in Natal, Murray built and competed with his own car, the IGM (Ian Gordon Murray), in national racing. Moving to England in 1969, Murray was offered a job at Brabham by Ron Tauranac and stayed on with the team in Surrey following its acquisition by Bernie Ecclestone. Taking a chance on the young engineer's bold and innovative approach, Ecclestone gave Murray carte blanche in 1973. Murray worked closely with David North, an aerospace engineer with the British Aircraft Cooperation before joining Brabham in 1976.

FAMOUS DRIVERS

Niki Lauda left Ferrari as World Champion at the end of 1977 to join Brabham. The Austrian was partnered by John Watson, the Ulsterman having been with the team since the beginning of 1977.

MEMORABLE RACE

The Swedish Grand Prix was the eighth round of the 1978 F1 World Championship. Mario Andretti had won the previous two races to extend his championship lead as the Lotus 79 got into its superior stride. Lotus, more than most rivals, were not amused when Brabham arrived at Anderstorp and revealed two new cars with a novel interpretation of the regulations.

Fears that suction created by a fan at the back of the BT46B would give superior cornering power were not confirmed initially, as the Brabham appeared to be slow. It was a typical ruse inspired by the team's owner Bernie Ecclestone. Rather than reveal their hand straight away, the BT46B had been running with more fuel on board than was necessary. Andretti, meanwhile, set a time fast enough to win his fourth pole position of the season. But midway through the third and final practice session (grid positions being decided on times recorded throughout practice), Brabham removed the excessive fuel. John Watson lapped more than a second faster than he had gone before and claimed a place alongside Andretti, albeit seventh tenths of a second slower than the Lotus. Niki Lauda had catapulted up the grid to third. It was one thing to be fast over one lap of the flat 4.4-km (2.5-mile) track; quite another for a completely new and virtually untested car to keep this up for 282 km (175 miles). Nonetheless, Lotus were worried.

Some of that concern disappeared when Watson fluffed his start and ran wide at the first corner while trying to make amends. Lauda accepted the gift of second place and latched onto Andretti's tail, the black car and the cherry-red Brabham leaving the rest far behind. Lauda was content to maintain the pressure, waiting for Andretti to make a mistake. It was only a small error when it came on lap 39, but it was enough to let Lauda through and immediately pull away. Not long after, Andretti's vain chase was ended by engine failure. Lauda won by more than half a minute; a landmark victory for the BT46B on what was both its debut and final appearance.

The Brabham BT46B, with its rear-mounted fan, was one of the most inventive and controversial examples of rule-bending in the history of Formula 1. The 'Fan Car' was never declared illegal.

Ferrari 312T4

'As a driver, I was never interested in the Ferrari legend. I joined them for one reason – I wanted to win the world title and Ferrari offered me the most realistic chance of achieving that ambition. But to be honest, I never adjusted the car as much as other drivers would. I tended to drive around the problems. The only thing that mattered to me was the stopwatch. Saying that, in 1979 I wasn't driving sideways all the time with the 312T4. I was doing it right, I suppose!'

Jody Scheckter

Initially mocked by sections of the media as looking like a motor mower, the Ferrari 312T4 turned out to be a cut above the rest. Jody Scheckter proved the wisdom of a move from Wolf by using the box-like Ferrari to become the 1979 World Champion, with the South African and his teammate, Gilles Villeneuve, winning 6 of the 13 Grands Prix entered by the 312T4.

It was a very satisfactory result for the latest version of an engine in its tenth season, even though, from a design point of view, the shape of the flat-12 suddenly presented a significant handicap. If Ferrari wished to incorporate the ground effect performance advantage introduced so successfully by the Lotus 79, the best compromise would be to produce a narrow chassis and clothe it with a wide and exceptionally flat body, which gave the Ferrari 312T4 its distinctive shape. Relentless testing on Ferrari's track at Fiorano helped build in reliability that would pay point-scoring dividends with what was not necessarily the fastest car. In 26 starts in World Championship Grands Prix, the Ferrari 312T4 would only retire four times, two of which were tyre failures.

Five 312T4s were built and raced. One of them, chassis 040, was used by Scheckter to win in Belgium, Monaco and Italy, and was later acquired by the South African to add to his collection. Sold at auction in May 2024, the same 312T4 raised €7.6 million – not bad for a lawn mower.

THE CAR

Along with everyone else in the F1 pit lane, Ferrari had been forced to react to the highly successful exploitation of the ground effect phenomenon by Lotus in 1978. Whereas Brabham had commissioned a V12 (ultimately unreliable because of its rapid conception) to counter the same impediment caused by their flat-12 Alfa Romeo, Ferrari had chosen to persevere with their flat-12 and, wisely as it would turn out, invest in a turbocharged engine for the future rather than in a V12 for the short term.

Nonetheless, a seemingly insurmountable problem remained thanks to the flat-12 being too wide at a critical point where airflow made ground effect work within the sidepod tunnels on either side of the car. By designing a strong and narrow monocoque, Ferrari were able to achieve a wide underwing area on either side, aided by placing all the fuel bag tanks in a comparatively tall compartment behind the driver. A narrow nose box was covered by a substantial single piece of bodywork, its predominantly flat profile being designed to create maximum downforce and keep the passage of air to the rear wing as clean as possible. An additional 254 mm (10 inches) in the T4's overall length compared to its T3 predecessor increased and accentuated the broad and flat appearance which some commentators found ugly.

Engine	Ferrari Tipo 312B flat-12
Size	2992 cc
Power	515 bhp
Weight	595 kg (1312 lb)
Wheelbase	2700 mm (106.3 in)

TEAM HISTORY

By previous standards, Ferrari had enjoyed a comparatively stable period since Niki Lauda's success with the first of the 312T series in the mid-seventies. Lauda had been replaced by Gilles Villeneuve, a meteoric talent with the rare ability

among drivers to win Enzo Ferrari's affection, not to mention the approval of Mauro Forghieri, continuing as technical director and the designer of cars that the Canadian driver would use to the maximum, and sometimes beyond.

THE DESIGNER

Mauro Forghieri continued unchallenged as the driving force behind the Ferrari technical department and the inspiration for its racing cars.

FAMOUS DRIVERS

Jody Scheckter joined Ferrari in 1979 to find Gilles Villeneuve already established and much loved as a carefree racer who had the ability to drive the wheels off the cars – quite literally, as he would demonstrate spectacularly during the 1979 Dutch Grand Prix. A rear puncture while leading caused a spin into the dirt on the outside of the first corner. That did not deter Villeneuve from reversing onto the track and attempting to complete almost the full lap necessary to reach the pits. By the time he got there, the flailing rubber had terminally damaged the rear suspension. What remained of the wheel was being dragged behind the car. The Ferrari crew greeted their man as if he was the deserving winner of the race. Villeneuve had led the championship after victories in South Africa and the United States Grand Prix (West) at Long Beach. Two wins for Scheckter then moved the South African to the top of the table for the remainder of the season. Scheckter and Villeneuve worked well together but the talented and well-balanced combination could do nothing about the 312T5 which failed to work in tandem with the latest Michelin tyres, prompting Scheckter to retire at the end of 1980.

Gilles Villeneuve in the Ferrari 312T4 at Monaco. Ferrari tried running the rear wing further forward than normal on street circuits.

MEMORABLE RACE

Jody Scheckter arrived in The Netherlands leading the championship by six points. Gilles Villeneuve and Jacques Laffite were in joint second place, all three having won two races each. With four rounds remaining, the championship could pivot on the outcome of the Dutch Grand Prix.

During practice, Laffite's Ligier-Ford was in even more trouble on Zandvoort's undulating surface than the Ferraris of Villeneuve and Scheckter, the three championship contenders qualifying fifth, sixth and seventh, Scheckter ahead of his two challengers.

Scheckter's grid position would turn out to be academic when his clutch overheated at the start. The irony was that Scheckter had been deliberately cautious with the clutch by choosing not to do burnouts going to the grid. Villeneuve, against the advice of his team, had been smoking his tyres in typically spectacular fashion. Not only did his clutch hold out, Villeneuve shot into second place from the third row of the grid. A frustrated Scheckter could only look on as he nursed his car to the side and then completed the first lap without using his clutch. Once he felt the clutch had cooled down sufficiently, Scheckter went to work. He was in 19th place.

Jody Scheckter holds a slide during his powerful recovery drive with the Ferrari 312T4 in the 1979 Dutch Grand Prix. The South African has just taken fourth place from the Wolf-Ford WR9 of Keke Rosberg.

By lap seven, he was seventh, having just overtaken Laffite. 'The car was going so well, I was picking them off, one by one,' said Scheckter. 'I overtook [Jean-Pierre] Jabouille's Renault round the outside of Tarzan [the first corner], which is not something you'd normally do. Knowing that Gilles was up front really gave me an incentive and I must admit I was neglecting my car during those laps. I was getting onto the wrong lines and getting out of shape doing some pretty determined overtaking moves.'

Villeneuve, having overtaken the leading Williams of Alan Jones, then suffered the puncture and spectacular retirement outlined on page 133 under 'Famous Drivers'. By which time Scheckter was into second place, but too far behind to catch Jones in the remaining laps. The six points helped Scheckter extend his lead in a championship he would secure at the next race, appropriately Ferrari's home Grand Prix at Monza.

135

Renault RS10

'The very first Renault [F1 car] was almost undriveable! The RS10 was different. We'd had lots of problems with reliability but, by the time we got to Dijon, the car handled exceptionally and the engine didn't miss a beat. To finally win was a huge satisfaction on a personal level because of the massive amount of work I'd done with the engineers.'

Jean-Pierre Jabouille

Renault's first Grand Prix win in July 1979 marked a turning point. Apart from the successful use of an engine option that had been available for 11 years, Jean-Pierre Jabouille's victory in the Renault RS10 signalled the use of turbocharging as more than an alternative means of power – it had become essential. Renault would never claim the World Championship with turbo power, but other manufacturers would eventually produce forced induction engines good enough to win the Drivers' and Constructors' Championships for several successive years until outlawed in 1989. Renault had paved the way, victory in the French Grand Prix for their RS10 signposting the turbocharging future in a droning, but fast, vision of yellow and white.

THE CAR

The story of the RS10 was not so much about the chassis but the engine that powered it. The car was longer than its RS01 predecessor – a slender aluminium chassis marking Renault's recognition of the need to follow the ground effect trend. Renault diverged from traditional lines by running a larger rear wing than most, a sign that the RS10 had enough power to deal with the accompanying drag. The V6 engine and its ancillaries had undergone continual development in search of reliability and driveability, with throttle lag created by the turbocharger proving as difficult to overcome initially

Renault, with backing from Elf, took the brave decision to investigate the turbocharging alternative permitted by the engine regulations. Jean-Pierre Jabouille used his engineering and driving skills to help develop the Renault RS10 into a winning car.

as the overheating that had caused numerous piston failures. Introduced in 1979, the RS10 had adopted twin KKK turbochargers that gave improved throttle response as well as an impressive 520 bhp to push the car along.

Engine	Renault EF1 V6 Turbo
Size	1492 cc
Power	520 bhp
Weight	615 kg (1356 lb)
Wheelbase	2860 mm (112.6 in)

TEAM HISTORY

Playing a pioneering role in motor sport was not new to Renault. The first motor races – held on public roads and running from city to city – were staged in the 1890s with the first Grand Prix taking place in France in 1906. The commercial benefits accompanying success in competition were not lost on motor manufacturers, particularly Renault, which was established in 1899 and whose patron, Louis Renault, was a retired racer.

A Renault won the first French Grand Prix thanks, in large part, to being the first racing car fitted with hydraulic dampers and removable wheel rims. The latter were particularly advantageous when punctures were common on the rough roads of the day. While it took rivals 15 minutes to replace fixed wheels, Renault's Ferenc Szisz and his riding mechanic, Marteau, did the job in half that time. They won by more than 30 minutes.

It was not long before Renault manufactured their own engines and, significantly in view of what was to come 70 years later, Louis Renault patented the first turbo. With the death of his two brothers (one through an accident in motor racing), Louis Renault abandoned the sport to focus on his bourgeoning company.

The Renault name would not be associated with motor sport until the 1950s when a dealer established the Alpine tuning company in Dieppe and began preparing Renault cars for rallying. In the following decade, the introduction of the Renault 8 Gordini Cup matched a growing French interest in motor racing which, through success in sportscars and Formula 2, eventually led to the creation of Renault Sport and thoughts about Formula 1.

In strict secrecy, work began in 1975 on a Renault-Gordini V6 turbocharged Formula 1 engine. It was an avenue of development that had been open since 1966 and the introduction of the 3-litre formula in Grand Prix racing. The permitted turbocharging of a 1.5-litre unit was seen as no more than a sop to anyone left with an engine from the previous 1.5-litre formula. The considered view was that turbocharging under these circumstances would not be competitive when up against a 3-litre normally aspirated engine. Renault had other ideas. It took time to persuade sceptical members of the Renault board but, in 1975, the decision was taken to enter Formula 1.

Renault made their debut in the 1977 British Grand Prix. The RS01 was a complex if rudimentary car that was quickly dubbed 'The Yellow Teapot' because of its habit of frequently stopping in a cloud of steam and smoke. It was a slog, as Renault knew it would be, their task made even more difficult by also choosing to build a sportscar for the Le Mans 24 Hour race. Victory in the French classic in 1978 allowed attention to focus solely on Formula 1. The RS10 was the result. Within a couple of races it was apparent that victory for the Renault turbo had finally become a matter of 'when' and not 'if'.

THE DESIGNER

Bernard Dudot, instrumental in the design and lengthy development of the turbocharged V6 engine, was an engineering graduate who had joined Alpine in Dieppe before moving to Gordini to work on Formula 3 and rally car engines. In 1974 he began research, along with François Castaing and Jean-Pierre Boudy, on turbocharging a V6. Meanwhile, a single-seater *Laboratoire* chassis was created by André de Cortanze, an engineer who designed race cars and competed in them. Castaing would take over responsibility for the design of the RS01 and RS10 cars at Renault-Gordini's Viry-Châtillon plant in a Paris suburb, with Alpine's activities in Dieppe having been wound down. When the other engineers either left Renault or moved to other projects, Dudot would remain with Renault Sport to become technical director, Michel Tétu playing a major role in F1 car design.

FAMOUS DRIVERS

Jean-Pierre Jabouille raced in Formula 3 and became test and development driver for Alpine in 1973. The Frenchman's interest in engineering led to him racing his own car (with backing from Elf, the oil company behind the resurgence of French motor sport) and winning the Formula 2 Championship in 1976. Jabouille was the natural choice for Renault's foray into Grand Prix racing. Having entered just one car during their first two seasons of Formula 1, Renault signed René Arnoux to join Jabouille in 1979. Arnoux, like Jabouille, had previously made sporadic and unsuccessful appearances in Formula 1 before becoming a winner with Renault.

MEMORABLE RACE

The Renault RS10 was introduced in Spain, five races into the 1979 Grand Prix season. Little seemed to have changed as the Renault suffered from reliability problems at Jarama and in the next two races. Renault's home race at Dijon was next. An intense testing programme in the preceding days was helped by Dijon's comparatively high altitude, favouring the performance of the turbocharger. Jabouille claimed pole. He had been there before at Kyalami (even higher than Dijon), only to retire with engine trouble. On this occasion, however, he felt confident thanks to a perfect temperature on race day – not too hot, not too cold. And neither was he concerned when Gilles Villeneuve shot into the lead. Jabouille was content to bide his time and sit on the tail of the Ferrari. When Jabouille then applied pressure, a sideways moment by Villeneuve was enough to let the Renault through and immediately pull away. The highly emotional victory for Jabouille was, paradoxically, overshadowed by Arnoux in the other car. The final laps would be remembered for an extraordinary battle for second place as Arnoux and Villeneuve changed places as often as they banged wheels and momentarily left the road, with Villeneuve eventually splitting the two Renault drivers. Initially put out by the accolades heaped on Arnoux for his apparent bravado, such a landmark victory would be remembered with great affection 40 years later when Jabouille demonstrated the RS10 at the 2019 French Grand Prix.

Bravo! The Renault team celebrate their first victory at Dijon in 1979 after two years of struggle, the landmark win made all the sweeter by being at their home Grand Prix.

Ligier-Ford JS11

'My car is fantastic. For sure the best car I have ever driven. Quick on empty tanks, full tanks, hot weather here in Buenos Aires, cold weather when testing at Paul Ricard [in France]. We don't have any problems at all. It's absolutely fantastic – and the car is still very new!'

Jacques Laffite (speaking before the race debut of JS11 in Argentina)

Two races into the 1979 season, anyone betting against Ligier winning the championship would have been considered foolish, such had been the total dominance of the French cars. Despite another pole position and victory in Spain two months later, Ligier somehow contrived to lose the Drivers' Championship and slip to third in the Constructors' Championship, as Ferrari scored almost twice as many points. The Ferrari 312T4 was not necessarily a faster car (and certainty not as pretty as the JS11), the Italian team was simply better organised than a sometimes shambling operation led by the capricious Guy Ligier. An unnecessary change of specification on the JS11 would lead to the team's downfall just as surely as their drivers, Jacques Laffite and Patrick Depailler, being allowed to race against each other.

Engine	Ford-Cosworth DFV V8
Size	2993 cc
Power	470 bhp
Weight	585 kg (1290 lb)
Wheelbase:	2800 mm (110 in)

THE CAR

The JS11 was the first Ligier to use the ubiquitous Ford-Cosworth DFV engine, the French team having struggled for three seasons with the patriotic choice of a Matra V12. The consistent and reliable power of the lighter and more fuel-efficient British V8 was matched by Gérard Ducarouge's grasp of ground effect, now an essential part of any designer's remit, thanks to the Lotus 79 and its domination of the previous season. Ducarouge was one of the few imitators to appreciate the need to build a strong and stiff chassis to cope with downforce increasing, in tandem with a better understanding of ground effect. The JS11 featured deep sidepods with dramatic flip-ups ahead of the rear wheels, which allowed the wheels' rotation to extract air and accentuate the venturi effect created within the sidepods. This worked well initially, but the small team was unable to capitalise on their early success thanks, in part, to the actions of the owner. Insisting – wrongly – that the sidepods needed a re-design, Guy Ligier reacted to Ducarouge's resistance by physically smashing the existing sidepods in order to have his flawed preference put in place. By the time the error of his ways had been exposed by disappointing results, it was too late.

TEAM HISTORY

Using money made from his construction company, Guy Ligier went motor racing with moderate success before buying an ex-works Cooper-Maserati and entering six Grands Prix in 1966. The switch to a Brabham-Repco BT20 during 1967 brought little improvement to Ligier's track record, scoring his one and only championship point by finishing sixth in Germany. The following year, Ligier Cars was established in partnership with Jo Schlesser to build sports racing cars. When Schlesser was killed during the 1968 French Grand Prix, Ligier was prompted to retire from racing and preface the type numbers of his cars with 'JS' in honour of his close friend. Undaunted by limited success with sports cars, Ligier moved into Formula 1 by buying the assets of the Matra team and forming Equipe Ligier in 1976. Ligier also attracted sponsorship from SEITA, the French tobacco company marketing Gitanes cigarettes. When Jacques Laffite won the 1977 Swedish Grand Prix in a Ligier powered by a Matra V12, this was recognised as the first all-French victory in Formula 1. The next F1 victory for Ligier would come on the debut of the JS11 in the 1979 Argentine Grand Prix.

THE DESIGNER

Gerard Ducarouge had joined Matra Sports as an engineer during the early stages of the missile company's venture into motor racing. Responsible for the Formula 3 and Formula 2 cars, Ducarouge also designed the Formula 1 Matras run by Ken Tyrrell for Jackie Stewart in 1968 and

1969. He was also responsible for the Matra sportscars that won the Le Mans 24 Hours and dominated the endurance racing championships in the early 1970s. Following the acquisition of Matra Sports by Ligier, Ducarouge moved to the new team's headquarters in Vichy to assist Michel Beaujon and Paul Carillo with design work. The trio would be responsible for the JS11, Ducarouge playing the role of technical director.

FAMOUS DRIVERS

Jacques Laffite had been Ligier's sole driver from the outset in 1976, the former Formula 2 champion having previously struggled to make his name with the financially stretched team run by Frank Williams. Laffite's win in the 1977 Swedish Grand Prix was an outlier until the arrival of the JS11 in 1979 – which coincided with Ligier running a two-car team for the first time. Having spent four full seasons with Tyrrell and scoring his maiden victory at Monaco in 1978, Patrick Depailler was happy to accept equal status. Laffite was less enamoured with the arrangement. The no-holds barred contest between the two Frenchmen worked against the team when Laffite missed a gear and blew his engine while trying to wrest the lead from Depailler in the Spanish Grand Prix. In Belgium, Depailler crashed out while holding his team-mate at bay, but the furious pace had taken the best from Laffite's tyres and he could offer no resistance to Jody Scheckter's Ferrari 312T4 and a more prudent strategy that would ultimately win the championship. When Depailler broke his legs in a hang-gliding accident, the carefree but feisty little racer was replaced by Jacky Ickx for the final eight races. The Belgian veteran had long since passed his brilliant best and could offer little to prevent Ligier's slide from prominence. There would be occasional bright moments for Ligier in the coming seasons, but nothing would make up for the glorious opportunity lost in 1979.

Patrick Depailler heads for second place in the Brazilian Grand Prix, the second round of the 1979 World Championship. A 1–2 finish for the Ligier JS11 at Interlagos and a commanding lead in the title race would be frittered away as the season progressed.

MEMORABLE RACE

Previews of the 1979 Grand Prix season barely mentioned Ligier. Lotus and Mario Andretti were favourites to carry on where they had left off in 1978, particularly as the World Champions would use the tried, tested and very fast Lotus 79 in Argentina while the competition tried to catch up with completely new cars. The odds posted by a leading bookmaker showed Andretti to be favourite to win in Buenos Aires at 100/30. Jacques Laffite was 11th, at 25/1, with Patrick Depailler slightly better at 16/1. It would have been a rewarding bet for anyone willing to gamble on the Ligier JS11's performance during winter testing rather than write off the very impressive lap times at Paul Ricard as nothing more than a dubious distraction by a French team on a French circuit.

That view changed dramatically from the moment the blue cars proved to be immediately at home on the Buenos Aires Autodrome. The Argentine organisers were using the 5.9-km (3.7-mile) Circuit No. 15, but the feeling was that the Ligiers would have been quick on any of the variations available within the Parque Almirante Brown facility. When push really came to shove, the Ligiers claimed the front row, Laffite's pole position time being more than a second faster than the Lotus 79 of local hero, Carlos Reutemann, in third place. Andretti was languishing half a second further back on the fourth row of the two-by-two grid. Forlorn hopes that the JS11s might suffer teething problems were soon replaced by anticipation of the Ligier drivers taking each other out, as Depailler jumped into an immediate lead and showed no intention of giving it up. That ended after ten laps when Laffite forced his way through – an early sign of how Ligier's free-for-all policy would eventually work against them. On 21 January 1979, however, such caution seemed irrelevant as Laffite stroked home an easy victor, with Depailler finishing fourth, despite a pit stop. It went almost unnoticed that Ferrari and Williams had yet to unveil the cars that would finish above Ligier in the championship.

Defying pre-season predictions for 1979, the Ligier team dominated qualifying and the Argentine Grand Prix. The JS11 of Jacques Laffite (#26) starts from pole position with Patrick Depailler alongside in Buenos Aires.

Williams-Ford FW07

'When we turned up with FW07 at Silverstone, suddenly life was 100 per cent in the other direction. Loads of people were looking at their stopwatches; I'll never forget the despair on their faces. It was like God had given us a miracle, except it wasn't; it was something the guys had found in the wind tunnel.'

Sir Frank Williams

The FW07 announced Williams Grand Prix Engineering as a serious force in Formula 1. It did so by taking a quantum leap in performance, almost overnight. What had been a very good car became an outstanding one with the seemingly innocuous addition of a couple of pieces of metal. This happened in July 1979, a few days before the British Grand Prix. The tidying up of FW07's airflow beneath the car proved to be tailor-made for the fast expanses of Silverstone. The Williams demolished the lap record during testing. That translated into hard evidence during the Grand Prix weekend as Alan Jones qualified on pole and led the race for 38 laps until sidelined by a water leak. On cue, the second FW07, driven by Clay Regazzoni, led the final half of the race to give Williams the first of many Grand Prix victories. Had FW07 been race-ready earlier in the season, the Williams answer to ground effect would have brought the small team from Oxfordshire the World Championship one year sooner than it did in 1980.

THE CAR

Along with every other F1 technical director, Patrick Head had studied the Lotus 79 from afar and endeavoured to capitalise on and improve the ground effect principle introduced so successfully by the 1978 World Champions. Williams Grand Prix Engineering had made their debut that year with the FW06, a comparatively straightforward car designed to give reliable running and allow the new team to find its feet. A mechanical failure (due to a faulty component) on the FW06 in the later stages of the season had prompted Head to be even more thorough with his calculations, particularly given the forces likely to be placed upon the chassis by a ground effect car. This, plus the late arrival of sponsorship, led to the delayed arrival of the FW07. But when it appeared, the performance on track would show that Head, like Gerard Ducarouge at Ligier, had fully appreciated the need for a strong chassis and suspension.

Jones led the FW07's second race in Belgium until sidelined by a niggling electrical problem. Meanwhile Head and his aerodynamicist, Frank Dernie, were continuing to get to grips with the challenges and properties of ground effect within the car's sidepods. A gap detrimental to the creation of low pressure was noted in the area around the back of the engine and gearbox. The Williams machine shop quickly created a couple of metal panels and these were fitted to the affected area on either side of the gearbox. Little did Williams think that sealing the gap could have such a profound effect on the level of grip. When Alan Jones tested the FW07 at Silverstone, he had to persuade himself to keep his foot on the throttle for much longer than before when cornering. Frank Williams could not believe the times on his

stopwatch. The FW07 was lapping Silverstone, not tenths, but whole seconds under the lap record. It was a massive leap that would ensure, not just victory in the forthcoming race, but in four more Grands Prix, it was enough to move Williams into the runner up slot in the second half of the 1979 season. Development and refinement would make the FW07B a championship winner the following year.

Engine	Ford-Cosworth DFV V8
Size	2993 cc
Power	470 bhp
Weight	587 kg (1295 lb)
Wheelbase	2992 mm (106 in)

TEAM HISTORY

Frank Williams had been passionate about cars and movement for as long as he could remember. From riding on a bus to sitting in the passenger seat of a Jaguar XK150 belonging to a school friend's father, Williams was captivated by motorised transport. The faster they went, the better. The obvious path to becoming a racing driver was hindered by a lack of money and the fact that he was as wild as he was quick. Buying and selling racing cars and spare parts proved more successful and led to Williams supporting Piers Courage, an up-and-coming British driver. Their partnership eventually extended to Formula 1 and finishing second in two Grands Prix with a privately entered Brabham. In 1970, a deal to run a De Tomaso for the Italian manufacturer ended in tragedy when Courage was killed during the Dutch Grand Prix. Williams was devastated but picked himself up to run various cars and drivers, Frank's small team living hand-to-mouth and somehow getting by. A link with Walter Wolf (see 'Wolf-Ford WR1', page 118) may have solved his dire financial problems but it also taught Williams that he needed to do his own thing. The fresh start led to the creation of Williams Grand Prix Engineering and a tentative season in 1977 with a March-Ford before creating the first Williams F1 car for 1978.

Alan Jones was an essential part of a winning package, the Australian driver taking his Williams FW07 to four wins in 1979, including this one in Austria.

THE DESIGNER

After choosing to go it alone, the second most important decision in Frank Williams's career was to persuade Patrick Head to join him. After graduating in engineering, Head had worked for Lola, a mass producer of racing cars, before setting up his own business preparing engines for Super Vee cars and designing a much-admired single-seater car for the Formula 2 driver, Richard Scott. Head had turned to maritime pursuits when Frank's initial contact was to have Patrick join the Wolf-Williams team in 1976. Having gained experience working alongside Harvey Postlethwaite with a team that appeared to be going places, Head nonetheless chose to join Frank as, together, they founded Williams Grand Prix Engineering. Two key technical personnel to join the fledgling company were Neil Oatley, a junior draughtsman fresh from college, and Frank Dernie, an aerodynamicist formerly with Hesketh Racing.

FAMOUS DRIVERS

Watching practice for the 1977 Canadian Grand Prix, Frank Williams had been impressed by the efforts of Alan Jones. The 30-year-old Australian had grabbed his opportunity earlier in the year by using the heavy and fundamentally uncompetitive Shadow-Ford to win the Austrian Grand Prix in wet conditions that equalised driving talent. In Canada, Jones qualified seventh and finished fourth. He would be a perfect fit for the new team, Jones having an instant rapport with Head and Williams, all three being of a similar age and having the same sense of determination to make this work. When it came to running a second driver in 1979, Clay Regazzoni was the obvious choice for the same reason he had worked so well with Niki Lauda at Ferrari – the Swiss was experienced, fast and totally without pretension.

Alan Jones discusses the FW07 with Frank Williams (left) and Patrick Head (right) prior to victory in the 1979 German Grand Prix at Hockenheim.

MEMORABLE RACE

Having demolished the lap record to claim pole position for the British Grand Prix, there seemed little to prevent Alan Jones from giving Frank Williams his first Grand Prix win. It seemed even more certain when Jones led by 25 seconds after 37 laps. Then a whisp of steam from the back of the FW07 revealed the start of a water leak that would bring retirement. At the same moment, Clay Regazzoni had overtaken the Renault RS10 of Jean-Pierre Jabouille to assume what had become the lead. But would the neck on the water pump of Regazzoni's Ford-Cosworth DFV crack in the same way as his team-mate's? For 29 laps, the team was on a knife-edge as the laps counted down. When Regazzoni exited Woodcote corner for the last time and took the chequered flag, the grandstand lining the long pit straight stood as one. Regazzoni, with his bandit moustache and cheeky grin, was hugely popular. But the applause, spreading to the pit lane itself, was for Frank Williams. Everyone knew just what he had been through to reach such a magic milestone.

The Williams FW07 came into its own following small but crucial adjustments during testing for the 1979 British Grand Prix. When Alan Jones retired from the lead at Silverstone, Clay Regazzoni (pictured) was poised to give Williams their first win.

Brabham-Ford BT49C

'Going back to the Cosworth was like having a holiday [after nearly four seasons with Alfa Romeo engines]. Okay, the first BT49s were based on BT48 monocoques, but we designed and built two of them in six weeks. It was an absolute doddle compared to working with the Alfas.'

Gordon Murray CBE

Brabham could not get rid of the Alfa Romeo engine quickly enough. Its substitute, the Ford-Cosworth DFV, would be lighter, less thirsty and better suited to the need to create ground effect towards the rear of the car. The 1979 season, the only season with the Alfa V12, was not done and yet, in record time, Brabham produced the BT49 with a DFV in readiness for the final two Grands Prix. Refined during the following winter, the neat BT49 would help Nelson Piquet to three wins in 1980 and allow the Brazilian to give Alan Jones serious competition in his championship year with the Williams FW07. For 1981, the Brabham – now designated BT49C – was further improved, the ingenious nature of designer Gordon Murray coming to the fore when dealing with a ban on sliding side skirts and the implementation of a 60 mm (2.4 inches) minimum ground clearance rule. Murray proved the regulation was unenforceable thanks to a clever hydro-pneumatic system, Piquet winning another three Grands Prix and becoming an exhausted World Champion by hanging on to finish fifth in the final race of the season in Las Vegas.

THE CAR

When it seemed that the Alfa Romeo engineers were perhaps focusing on the debut of their own car for 1980, rather than developing the V12 in the back of the BT48, Brabham decided to revert to Ford-Cosworth DFV power and build the BT49 to accept the V8. The task was made relatively easy by utilising the BT48 chassis which had been the first to feature carbon fibre composite panels in a racing car. The BT49 was new from the cockpit back, with different sidepods, reduced fuel tank capacity (by 32 litres/7 gallons) and less weight – the Ford DFV being a stressed member in the usual manner.

From the moment of its first appearance in Canada towards the end of the 1979 season, the BT49 showed promise. Development over the winter included a compact Weismann five/six-speed transverse gearbox to aid ground effect air flow. Reliability with the transmission would prove elusive, Nelson Piquet relying on the more familiar Hewland gearbox to win at Long Beach, California, followed by victories at Zandvoort and Monza later in the year. For 1981, the car was revised further as the BT49C, with the introduction of more carbon parts bringing another reduction in weight. The design department's main focus was on refining a hydro-pneumatic system that would allow the car to settle lower (and produce more downforce) when running and return to the required 60 mm (2.4 inch) ground clearance when measured at a standstill. While arguments over the controversial new rule (and the Brabham method of dealing with it) occupied the pit lane throughout the season, Piquet got on with winning three more Grands Prix and claiming the Drivers' Championship (the team finishing runner-up to Williams in the Constructors' Championship).

Engine	Ford-Cosworth DFV V8
Size	2993 cc
Power	470 bhp
Weight	588 kg (1297 lb)
Wheelbase	2718 mm (107 in)

TEAM HISTORY

In the chase to create ground effect (and following the curtailed promise of the BT46B fan car with the Alfa Romeo flat-12), Brabham commissioned a V12 engine, which the Italian manufacturer produced in record time. Too quickly, in fact. The BT48 looked the part, but a trail of oil appearing from beneath a closed garage door during testing was an unfortunate portent of trouble ahead, exacerbated by the full-length underwing in the sidepods failing to work efficiently. A victory for Niki Lauda in a non-championship F1 race at Imola was scant consolation during an otherwise miserable period in 1979. Brabham's season would be unsettled further when Lauda suddenly decided to retire

from motor racing, leaving team boss Bernie Ecclestone and team manager Mike 'Herbie' Blash with no other option but to let the Austrian go.

THE DESIGNER

Gordon Murray continued to have his hands full, the Chief Designer dealing with a void created by the one-race life of the fan car in 1978, then working on a car to accept a new Alfa Romeo V12 for the following year, before hurriedly producing the BT49 during the second half of the 1979 season. The year 1980 was relatively quiet compared to the work needed in 1981 to make the BT49C compliant with controversial ground clearance regulations, with Murray and his assistant David North devising a clever answer that others either disagreed with or struggled to copy.

FAMOUS DRIVERS

When John Watson left Brabham for McLaren in 1979, Nelson Piquet was signed to complete his first full season as team-mate to Niki Lauda. That partnership reached an unexpectedly abrupt end halfway through the first day of practice for the Canadian Grand Prix in late September. Despite having just driven the BT49 for the first time, Lauda decided to quit there and then, leaving Ricardo Zunino to substitute for the final two races. The Argentine driver was kept on for 1980 but, after generally disappointing results, and failing to qualify at Monaco, Zunino was replaced by Hector Rebaque halfway through the season. The Mexican driver remained with Brabham into 1981 and scored points on four occasions.

Nelson Piquet laid down an impressive marker with the Brabham BT49 in 1980 when he claimed pole position, set fastest lap and won the United States Grand Prix (West) at Long Beach.

MEMORABLE RACE

The German Grand Prix was the 11th round of the 1981 World Championship. Nelson Piquet arrived at Hockenheim 17 points behind Carlos Reutemann and bruised – literally and metaphorically – by a heavy crash during the previous Grand Prix at Silverstone. Piquet had been in third place when his left-front tyre failed on the approach to Becketts. The Brabham had speared into the sleepers lining the outside of this fast section of track. As he lay on the grass banking waiting for an ambulance, Piquet considered he was lucky to get away with no more than severe bruising to his left foot. He was unfortunate in another sense because, had the Goodyear not imploded, it was likely Piquet would have won the race since the two Renaults ahead at the time were due to retire. As it was, he had come away from Silverstone almost two clear wins behind Carlos Reutemann after the Williams driver had finished second. Piquet's championship chances continued to look gloomy at Hockenheim when he qualified sixth, behind the Williams-Fords of Reutemann and Alan Jones, with the Renaults of Alain Prost and René Arnoux filling the front row.

Initially the race followed expected form as it developed into a battle between Renault and Williams. Prost led and it was Jones who relentlessly challenged the turbo car, the

The front wing on Nelson Piquet's Brabham BT49C shows signs of contact with René Arnoux (following in his Renault RE30) during the opening stages of the 1981 German Grand Prix. A win for Piquet at Hockenheim would be vital in the Brazilian's successful campaign to become World Champion.

Australian taking the lead at the halfway mark with an incisive piece of out-braking. Jones's lead lasted for 18 laps until the misfire that had cost him the Monaco Grand Prix returned and forced the Williams FW07C into the pits. Reutemann had experienced a similar misfire during the morning warm-up, but that would turn out to be the least of his worries when an engine failure caused yet another retirement.

Meanwhile, Piquet was having his own problems. Contact with Arnoux at the start affected the nose wing on the Brabham, and the handling was made worse not long after when part of the lower bodywork was damaged on some debris. Once Piquet had adjusted his driving to cope, he closed on the leader. With seven laps remaining, Piquet overtook Prost, whose Renault had refused to run properly throughout. Brabham's day was made complete when Hector Rebaque produced an aggressive charge from his customary position near the back of the grid to finish fourth. The championship picture had changed once more with the gap narrowing to eight points between Piquet and Reutemann. The championship would eventually be settled in Piquet's favour by a single point.

McLaren-Ford MP4

'Carbon fibre gave us a car that was much stronger integrally. But if you were pushing on, driving with your elbows out and they made contact with the sides of the cockpit, it was incredibly painful. Aluminium was inherently softer. It still hurt, of course, but it wasn't totally unyielding.'

John Watson MBE

The McLaren-Ford MP4 is one of a handful of the landmark cars in Formula 1 history that had a profound influence on racing car design. Carbon fibre had previously been incorporated here and there in the search for lightness. The MP4 redefined design parameters by making the entire monocoque from this 'space age' material. It was light yet strong. Despite initial concerns from observers unfamiliar with the black material, carbon fibre also had outstanding impact-resistant qualities. The result was a sleek machine which, in the case of the McLaren, not only defined a new generation of cars but also characterised the team's wholesale reorganisation and renaissance under the meticulous eye of Ron Dennis.

First introduced at the fourth Grand Prix in 1981, the latest McLaren soon began to show its worth, finishing third in Spain and then second in France. Two weeks later, John Watson scored an emotional win with the MP4/1 before his home crowd at the British Grand Prix. The MP4 ethos would provide the basis for further wins, the Ford-

John Watson gave the carbon fibre MP4 series the first of many victories with an emotional win for the Ulsterman and McLaren at the 1981 British Grand Prix at Silverstone.

Cosworth normally-aspirated V8 eventually giving way to the TAG-Turbo V6 that would power McLaren to the top of the championship in the mid-Eighties. In the meantime, the aluminium monocoque chassis would become obsolete thanks to this pioneering decision by John Barnard, McLaren's technical director.

THE CAR

The ever-increasing loads produced by succeeding generations of ground effect cars called for bigger sidepods and, as a result, narrower chassis. The problem with the latter was a reduction in rigidity, which was ironic given that the need for a lean central core was created by the very forces that were causing havoc with the car's fundamental need for structural probity. When thinking about this challenge at the McLaren drawing board, John Barnard investigated the possible use of carbon fibre. The individual strands may have been no thicker than a human hair but, collectively and with proper treatment, they could be woven as cloth. When saturated with resin and cured in an oven, the resulting matrix would be super-light and immensely strong. The challenge was shaping this material into a chassis that would be as resilient in compression as it clearly was in tension.

Barnard called upon the services of Hercules Incorporated, a chemicals company in the United States specialising in work on missile rocket motors and heavily involved in carbon fibre technology. Hercules made the monocoque sections, which were then flown to the UK, where they were bolted and glued together by McLaren. The result was a remarkably light chassis that was ready to accept the weight of a Ford-Cosworth DFV engine bolted on the back. Once clothed in a single piece of bodywork, the MP4 made its predecessor, the M30, look agricultural and old-fashioned. Such a comparison was a graphic indication of how McLaren had moved on.

Engine	Ford-Cosworth DFV V8
Size	2993 cc
Power	470 bhp
Weight	590 kg (1301 lb)
Wheelbase	2670 mm (105.1 in)

TEAM HISTORY

Bruce McLaren Motor Racing had fallen on hard times since the glory days of the M23 in the early 1970s. Their answer to the ground effect challenge, the McLaren M28, had been dismal failure in 1978; the cobbled-up M29 was better, but not by much. When McLaren finished joint-seventh in the 1980 championship with a mere 11 points, it was clear something needed to be done if long-time title sponsor, Marlboro, was to be prevented from taking their substantial backing elsewhere. The tobacco company was instrumental in arranging a merger between McLaren and Project Four Racing, a thrusting young company run by the 33-year-old Englishman, Ron Dennis, who had established a fine reputation. His partner, John Barnard, was equally regarded for his scrupulous attention to detail as a first-class engineer. The new company would be known as McLaren International. Their first car would be designated MP4; 'P4' standing for 'Project 4'; 'M' for 'Marlboro' (later to be changed to 'McLaren'). Dennis and Barnard were about to completely change the face of McLaren and, in some respects, F1 itself.

THE DESIGNER

John Barnard received a solid grounding in racing car design when working on production Formula Vee and sports cars for Lola Cars. In 1972, the Englishman joined McLaren, carrying out detail work on the M23 and McLaren IndyCar alongside Gordon Coppuck, only to leave after two years and work full time with IndyCar teams. In 1980, the Barnard-designed Chaparral 2K won the Indianapolis 500. That success brought Barnard to the attention of Ron Dennis, the two combining forces in the proposed take-over of the ailing McLaren team. When Barnard returned to the McLaren drawing office in 1980, he found the team had not moved on in five years.

FAMOUS DRIVERS

John Watson, having been with McLaren since the start of the 1979 season, continued under the new ownership in 1981 and won their first Grand Prix at Silverstone. His team-mate was Andrea de Cesaris, the fast but erratic Italian putting the carbon fibre chassis under unscheduled, but successful, crash testing. In 1982, de Cesaris made way for Niki Lauda's return as a Formula 1 driver, the Austrian and Watson each winning two Grands Prix.

John Watson sits on the pit counter between John Barnard (left) and Ron Dennis at Monaco in 1981.

157

158

MEMORABLE RACE

Apart from a few logical improvements, the McLaren MP4 remained much the same for 1982. The most significant difference was the driver in the car alongside John Watson. Ron Dennis had used his power of persuasion to tickle Niki Lauda's inherent curiosity and make a return to racing after two seasons away from the cockpit. Long Beach was the third race of the season, Lauda having finished fourth in South Africa and retired in Brazil. Any remaining thoughts about the two-time World Champion having lost his touch would be banished on race day in California.

Running third behind the pole position Alfa Romeo of Andrea de Cesaris and René Arnoux's Renault, Lauda was poised to attack the Frenchman when he spotted the Alfa Romeo of Bruno Giacomelli closing fast as they headed for a hairpin at the end of the main straight. Rather than block the Italian, Lauda moved to one side and left the door open. Seemingly grabbing a wonderful opportunity, Giacomelli steamed past the McLaren, misjudged his braking – and rammed the back of Arnoux. Lauda was second. Over the next nine laps, he whittled down de Cesaris's five-second lead and seized his moment when the Alfa Romeo got caught behind a back marker. Lauda remained unchallenged for the remaining 60 laps. This win, and another at Brands Hatch, would be matched by John Watson in the other McLaren, with the four victories contributing to McLaren finishing a strong second in the championship during the first full season with their revolutionary MP4.

Niki Lauda, three races into his comeback as a Formula 1 driver, sweeps his McLaren MP4 through the infield of the Long Beach street circuit on his way to an impressive win in the 1982 United States Grand Prix (West).

159

Brabham-BMW BT52

'We *had* to get the BT52 ready in time. There was no alternative. We had some of our fabricators and glass fibre specialists kipping down on the floor in sleeping bags for weeks at a time, snatching a few hours' sleep and then getting back on the job. I was working non-stop for three months as well; staying awake on pills. It was certainly the hardest winter I've ever experienced.'

Gordon Murray CBE

The Brabham-BMW BT52 defined the changing shape of Grand Prix racing in 1983. Gone were the sidepods which had become de rigueur since 1978 – a new rule for flat-bottom cars wiping out the major means of creating ground effect. Using the arrow-shaped BT52, Nelson Piquet may have won the Drivers' Championship for a second time, but it was the first for a turbo-powered car, Brabham having the additional satisfaction of narrowly beating Renault, the innovators of turbocharging in F1. Furthermore, the Anglo-German alliance did it by using pit stops for fuel and tyres as a race-winning strategy.

THE CAR

Having produced the BT51 in readiness for the 1983 season, Brabham's latest ground effect car was scrapped in the wake of a late change to the regulations in November 1982. Fears of a continuing increase in cornering speeds with the ground effect cars prompted the sport's governing body to demand that F1 cars should have flat bottoms, thus doing away with sidepods and the associated venturi effect creating suction. The majority of downforce would now be generated by an

Bernie Ecclestone (red sweater) listens in as Chief Mechanic, Charlie Whiting (left) and designer Gordon Murray discuss the Brabham BT52 with Nelson Piquet at Long Beach in 1983.

accompanying growth in the size of rear wings. At a stroke, an advantage had been handed to anyone running turbos since the less powerful, normally aspirated, engines would lose out when it came to pulling large rear wings through the air.

Brabham were halfway there, having begun a relationship with BMW and raced the German manufacturer's turbocharged four-cyclinder engine, albeit with limited success. A bizarre indication of an internal power struggle had occurred in the 1982 Canadian Grand Prix when Brabham scored a clean sweep, the winning BT50 powered by a turbo, while the BT49D finishing second had a Ford-Cosworth DFV in the back. For 1983, it would be BMW or nothing – and for a while it seemed like the latter as the BT51 became redundant overnight.

Rather than try and adapt the unraced ground effect car, Brabham started from scratch. Once revealed to the media at BMW's Munich headquarters on 3 March, 1983, it was immediately apparent that the BT52 was very different. Sporting the now familiar blue and white colours of Parmalat dairy products, the Brabham-BMW had an arrow-shaped plan with a needle nose, delta-shaped front wings and angled radiators ahead of the rear wheels. The compact rear quarter was due in part to a comparatively small 195- litre (43-gallon) fuel tank; an indication that pit stops would now – with the possible exception of shorter races on street circuits such as Monaco – be a permanent part of race strategy.

BMW, meanwhile, had been squeezing more power from the production-based M12/13 engine. The four-cylinder turbocharged unit eventually produced 640 bhp, with a ground-shaking 750 bhp available for a single banzai qualifying lap. A midseason upgrade (to BT52B specification) would include a stiffer version of the monocoque (continuing with a carbon fibre top and folded aluminium below), revised suspension and refined front bodywork.

Engine	BMW M12/13 Turbo
Size	1500 cc
Power	640 bhp
Weight	540 kg (1191 lb)
Wheelbase	2845 mm (112 in)

TEAM HISTORY

Having won the 1981 Drivers' World Championship and looking forward to switching from Ford to BMW turbo power for the following year, Brabham found themselves in some disarray. Despite – or, perhaps, because of – exceeding 322 kph (200 mph) through the speed traps during winter testing, the four-cylinder BMW proved fragile. Having declared that their engines would be raced throughout 1982, BMW were less than impressed when Brabham reverted to the upgraded BT49D chassis with Ford-Cosworth power for two races, only to have a win in Brazil declared invalid because of a row over water-cooled brakes. Matters were not helped by Brabham's drivers, Nelson Piquet and Riccardo Patrese, crashing more often than Bernie Ecclestone liked, the team boss having enough to deal with thanks to a threat by BMW to terminate the relationship if their engines were not used.

What was becoming a topsy-turvy season was epitomised by Patrese winning the Monaco Grand Prix (in a BT49D) without realising it at the end of a race, which had seen several different leaders in the final laps. Even more bizarrely, both Brabhams failed to qualify in Detroit – and then finished 1–2 in Canada a week later. As if things were not complicated enough, Brabham then introduced the concept of mid-race refuelling, although the success of this strategy could not be conclusively proven due to the BMW-powered cars either failing to finish or not lasting long enough to make the planned pit stop. Another apt summary of the season was Chief Designer Gordon Murray's decision not to attend the final race – a strange affair in the bland car park of a hotel in Las Vegas. The Caesars Palace venue had been used for the first time the previous year when Piquet won his first championship. Eleventh for the Brabham driver in the 1982 title race had made 1981 seem from another age.

THE DESIGNER

Work on the Brabham BT52 was but another chapter in a constant flow of design challenges faced by Gordon Murray and his assistant, David North. Murray spearheaded a compact workforce, ready and willing to translate the Design Chief's consistently novel ideas into metal and carbon fibre, either as, in the case of the BT52, brand new cars, or endless modifications to existing ones. The conversion of BMW's M12/13 production unit was the work of Paul Rosche, a quiet and gifted engine genius who had been with the company since 1957.

FAMOUS DRIVERS

Nelson Piquet entered his fifth season with Brabham in 1983. The Brazilian had formed a close relationship with everyone in this small team, to such an extent that the mechanics ran his fan club. The three wins in 1983 raised Piquet's tally to ten since joining the team. Largely at the behest of Brabham's Italian sponsor, Parmalat, Riccardo Patrese had been signed in 1982 following a season with Shadow, and four with Arrows. The Italian would claim his first Grand Prix victory at Monaco in 1982 and win his second at the final race of 1983.

MEMORABLE RACE

Alain Prost led Nelson Piquet by two points when they arrived in South Africa to settle the 1983 championship. It was a sign of the intense battle for turbo supremacy between Renault and Brabham that BMW brought no less than 13 engines to Kyalami (a total that, today, would be required to stretch across three seasons, never mind three days). Renault, under pressure to provide the first French World Champion, were never in the hunt, Prost qualifying fifth while Piquet prepared to start from the front row. Brabham hatched a clever plan to give their man victory while, at the same time, pushing Renault to breaking point. Instead of stopping Piquet late in the race, as had become the Brabham trademark, it was decided to start his car with a small amount of fuel and make an early pit stop. That way he could not only run in cool air at the front, but he would also force Renault to overextend themselves as they tried to keep up. The plan worked perfectly. Piquet's times during the first ten laps simply destroyed the opposition. By the time the Brabham made its way into the pits on lap 28, the battle was almost won. Prost lost all hope when the turbo failed. To be safe, Piquet dropped his lap times by two seconds. It mattered little that he had slipped to third by the finish; the championship was his. To round off a great year for the team, Riccardo Patrese won the race in the other BT52.

The Brabham BT52 redefined the shape of F1 cars following a major change to the regulations. Nelson Piquet clinched the 1983 World Championship with a clever drive in the South African Grand Prix at Kyalami.

McLaren-TAG MP4/2

'When I first drove the MP4/2 in a test session at Le Castellet [Paul Ricard], I was very impressed by the power and [throttle] pick-up of the TAG Turbo. The car immediately felt fantastic. It was like no race car I had ever seen. The detail work was beautiful.'

Alain Prost L d'H

This car took McLaren into the turbo era and destroyed the opposition. Porsche were commissioned to design and build a turbocharged V6 that would be funded by Techniques d'Avant Garde (TAG) and fully integrated with the next generation of MP4 carbon fibre chassis. The resulting collaboration was so successful that the McLaren-TAG won 12 of the 16 races, their drivers having exclusive bragging rights to the championship, with Niki Lauda beating Alain Prost by half a point. Prost would later become champion twice over with upgraded versions of the MP4/2 in 1985 and 1986.

Engine	TAG P01 Turbo
Size	1500 cc
Power	750 bhp (race boost)
Weight	540 kg (1191 lb)
Wheelbase	2794 mm (110 in)

THE CAR

Reluctantly at first, McLaren adapted an MP4/1 to act as a test bed for the TAG-turbo during the final races of 1983 in preparation for John Barnard's 'no compromise' MP4/2 for the following year. Apart from having to incorporate a turbo intercooler and associated plumbing, Barnard also had to cope with a V6 that was shorter than the Ford DFV V8, plus a larger fuel tank thanks to a ban on mid-race refuelling. The familiar broad sidepods were shorter than before and curved in at the rear to enclose the engine and gearbox. This was in association with neat rear suspension geometry, designed to give minimal disruption to upward curving diffusers, creating ground effect on either side of the gearbox. An indication of the layout's success would be rivals copying this 'Coke bottle' profile in future designs. A more tangible tribute would be McLaren winning the Constructors' Championship with twice as many points as runners-up Ferrari, the engineering integrity of the MP4/2 also being measured by Niki Lauda using the same car (chassis number 2) for the entire season.

TEAM HISTORY

In late 1982, Ron Dennis and John Barnard bought the shareholdings of former McLaren directors, Teddy Mayer and Tyler Alexander. Faced with the inevitable decline of the normally aspirated Ford-Cosworth DFV after 14 seasons, Dennis and Barnard examined the available turbo options. Rather than become a customer with either Renault or BMW, it was thought preferable to have a turbo unit designed specifically to fit the McLaren. But who would build this engine? And could McLaren afford it in any case?

Dennis had no hesitation in approaching Porsche, even through the German firm had previously shown no interest in returning to Formula 1 a couple of decades after their previous foray. The sports and GT manufacturer, intrigued by the technical challenge, agreed to the project. By paying for the initial design, McLaren ensured Porsche could not sell the engine to anyone else. As for the much larger financial investment needed to cover the entire project, Dennis entered a partnership with TAG, a Saudi connected corporation already familiar with Formula 1 thanks to a previous involvement with the Williams team. TAG had been founded by Akram Ojjeh. His son, Mansour, would

The McLaren MP4/2 won 12 of the 16 races in 1984, Alain Prost (pictured during the Belgian Grand Prix at Zolder) leading the championship most of the way but losing out to his team-mate, Niki Lauda, by half a point.

provide the impetus behind TAG Turbo Engines, the new company formed with McLaren to build Porsche's V6 to Barnard's exacting requirements.

THE DESIGNER

As Technical Director, John Barnard continued to have full responsibility for every detail behind the latest version of his MP4 carbon fibre concept. The V6 engine was designed by Hans Mezger, who had been part of Porsche's Formula 1 programme in the 1960s and led the design office responsible for the iconic 917 sports prototype.

FAMOUS DRIVERS

Halfway through the 1983 season, Niki Lauda had pushed McLaren to convert an existing car to test the TAG-Turbo rather than wait until its debut in the first Grand Prix of the following season. Although John Barnard, a complete perfectionist, had railed against such an untidy project, the MP4/1E did help ensure McLaren were well prepared with this complex change of power unit at the start of 1984. By which time, Lauda had other concerns.

When Alain Prost fell out with Renault following their championship defeat at the hands of Brabham-BMW in 1983, Ron Dennis had moved quickly to sign the disillusioned Frenchman at the expense of John Watson. Lauda, who had never felt threatened by Watson, was unhappy about Prost stepping in to benefit from the Austrian's preparatory work with the TAG-turbo. Nonetheless, the two drivers soon established a strong working rapport. This was helped by Lauda recognising that Prost was the quicker of the two and choosing to focus on the long game, winning races through a mix of experience and stealth. There was little to choose between them in terms of results, the McLaren drivers running neck and neck until the final race in Portugal, where Lauda took the title by the smallest margin in the history of the World Championship. The half point difference had been accounted for by the Monaco Grand Prix, won by Prost, being stopped early and triggering the allocation of half points.

MEMORABLE RACE

Alain Prost had led the 1984 championship all the way to the 12th round in mid-August. On a warm afternoon in Austria, Niki Lauda won the race and moved to the top of the table. He got there thanks to an element of luck but, principally, through patience and guile. It would turn out to be a pivotal point in the championship.

Not for the first time in 1984, Nelson Piquet had taken pole position in his Brabham-BMW BT53. The reigning World Champion had lapped the Österreichring at an average speed of more than 241 kph (150 mph) – an indication of the anticipated furious pace during the 51-lap race on this fast and majestic 5.9-km (3.7-mile) circuit.

Piquet shot into the lead, pursued by Prost. The rest were relatively nowhere. After several laps, trouble with fourth gear meant Prost had to hold the lever in place; not a welcome prospect on such a high-speed track. Just after half distance, Elio de Angelis had a sudden engine failure, the Lotus-Renault spewing oil through the downhill and very quick Rindt Kurve. The marshals were slow to react, Piquet arriving on the scene with Prost tucked beneath the Brabham's rear wing. Even with two hands on the wheel, Piquet barely managed to stay on the road. Prost, unsighted and one-handed, had no chance.

This put Lauda into second place. A few laps later, he took the lead. An easy win at home seemed on the cards until an enormous bang from the gearbox appeared to signal the end of his race. Finding third gear and figuring it would be a long walk back to the paddock, Lauda decided to limp towards the pits. On the way, he tried fourth gear and got no response. But when fifth was still available, it seemed possible to continue running. Piquet was 17 seconds behind. By managing as best he could without fourth gear, Lauda reckoned he was losing between four and five seconds a lap but, to his surprise and huge relief, the gap to Piquet remained the same. The Brazilian was nursing his tyres and had assumed Lauda was adopting his usual tactic of backing off and playing safe in the closing laps, but with the capacity to accelerate if Piquet closed in. It was only when Lauda told him of his troubles as they went to the podium that Piquet realised how an easy victory had been lost. Lauda was leading the championship for the first time.

Niki Lauda scored a crafty win at his home race in Austria to lead the championship for the first time in 1984.

Williams-Honda FW11

'FW11 was a terrific car. I loved it from the first moment I drove it. Honda came up with a very powerful engine that was also fuel efficient – which was important in 1986.'

Nigel Mansell CBE

The combination of Williams and Honda finally came on strong with the Williams FW11 in 1986. Nelson Piquet (pictured) started from pole position at Spa-Francorchamps but the Belgian Grand Prix was won by Nigel Mansell's FW11.

The FW11 marked the coming together of the Williams team's mastery of carbon-fibre construction and Honda's ability to produce a potent and driveable V6 turbo. The fact that the FW11 did not win the Drivers' Championship first time out was down to the contradictory element of Nigel Mansell and Nelson Piquet being so competitive, the title slipping between their collective fingers. The Williams-Honda FW11 won nine races in 1986 which, if nothing else, was a tribute to the team's resilience following a road accident that almost took the life of Frank Williams. The strength in depth demonstrated by everyone concerned – including the indominable team principal – was proven the following year with an updated FW11B which, this time, saw the battle as the sole preserve of Mansell and Piquet, the 1987 World Champion.

THE CAR

When it came to switch to turbo power, Williams started from scratch thanks to the first Honda engine arriving in bits; a V6 cylinder block, a couple of cylinder heads and a sump, plus a turbocharger in a separate box. There was neither an inlet manifold nor an exhaust. Not even a data sheet. Just an instruction to 'design what you think'. What Patrick Head actually thought has not been officially recorded, as he and his technical team got down to piecing it together in time to have a test car running for the final few races of 1983. That car, FW09, had an aluminium honeycomb monocoque which was not stiff enough to cope with the engine's lumpy power curve.

Despite an encouraging fifth place on FW09's debut in the final race of the season in South Africa, the bull-nosed car would achieve very little at the start of the following season as the team got to grips, in every sense, with perpetual understeer. Unlike McLaren and a TAG-Porsche engine designed specifically for their car, Williams were dealing with a power unit based on an engine previously used by Honda in Formula 2 – admittedly with great success. Failures were common, the team getting through as many as four engines during a race weekend. The one outstanding moment had occurred in Dallas in July when Keke Rosberg survived the heat and a crumbling track to finish first.

For 1985, Head accepted the inevitable by producing the FW10, Williams being the last of the leading teams to switch to a carbon fibre chassis. While Williams got their collective heads around the new method of construction, the engine continued to be problematic. Although ever more powerful, the torque was delivered in vicious bursts. The throttle was all or nothing, making life particularly difficult for the drivers if the track was wet.

Honda addressed the problem in time for Rosberg to pull off a brilliant win with a new V6 on the streets of Detroit. With Honda having quickly become the class of the field, Williams won the last two races of the season. By which time, the lessons learned were being designed into a totally new car in readiness for 1986.

The FW11 was more neatly packaged, with improved suspension, a slightly longer wheelbase and a more reclined position for the driver. The latest Honda engine was developed to cope with the fuel allowance for each race having been reduced from 220 to 195 litres (48 to 43 gallons). And the engine ran reliably, the FW11 winning nine races to easily secure the Constructors' Championship ahead of McLaren. The process would be repeated with the FW11B in 1987 although, this time, Williams would also win the drivers' title.

Engine	Honda RA 166-E Turbo
Size	1494 cc
Power	950 bhp (race boost)
Weight	540 kg (1190 lb)
Wheelbase	2855 mm (112 in)

TEAM HISTORY

Noting the on-coming turbo tide, Frank Williams had started discussions with Honda in early 1981 and finally agreed a contract in February 1983 for the supply of engines. A year later, the team had moved on from their original premises – a former carpet warehouse – to the edge of Didcot and a purpose-built factory big enough to allow Honda a secure workshop for engine rebuilds on site, rather than in Japan. It was a clear sign that the partnership was gearing up for a major assault on the championship. It took a season for the collaboration to gel. Just as they were poised to attack in 1986 following a promising pre-season test session at Paul Ricard, Frank Williams was seriously injured when his hire car left the road while en route to Nice airport. His life hung in the balance for several weeks, the spinal injury rendering him quadriplegic. Frank's high level of fitness (he was a keen runner) had helped keep him alive and his fierce determination to survive would be replicated by every single person at Williams Grand Prix Engineering. Frank made his first visit to a race for a short period during the British Grand Prix and then spent the entire weekend watching his beloved team perform in Hungary. Williams won both races. Frank attended every Grand Prix in 1987. His team had barely broken its stride.

THE DESIGNER

Patrick Head remained in sole charge of the technical department while continuing to work closely with Frank Dernie, the engineer who specialised in aerodynamics, and Sergio Rinland, who was charged with detail work. While Frank Williams recovered from his accident, Head assumed overall control of the team, ably assisted by an existing and efficient management structure.

FAMOUS DRIVERS

Having carried out early development work with the Honda engine (and winning three Grands Prix), Keke Rosberg left Williams for McLaren at the end of 1985. Nigel Mansell, who had moved from Lotus to Williams in 1984, was joined by double World Champion Nelson Piquet. It would prove to be an increasingly fractious relationship through 1986, the unchecked rivalry between the two leading to a complete loss of mutual trust, to the detriment of the team.

Nigel Mansell deep in thought as Patrick Head discusses the Williams FW11 during practice for the 1986 Australian Grand Prix.

MEMORABLE RACE

It had been neck and neck between Nigel Mansell and Nelson Piquet throughout 1986. Alain Prost, meanwhile, had been steadily accumulating points. By finishing second in Mexico, the McLaren driver had moved into second place on the table, six points behind Mansell and one ahead of Piquet as the scene shifted to Australia for the final round. Mansell was clear favourite to take the title, particularly when he claimed pole position on the streets of Adelaide.

At one third distance, Mansell was third, which would be good enough regardless of where Prost and Piquet finished. Prost's chances seemed to have disappeared, along with the air from a punctured tyre, as he made his way to the pits for fresh rubber. Goodyear duly reported to Williams that pit stops for their drivers would probably be unnecessary because the wear on Prost's discarded tyres appeared minimal. That may have been the case on the McLaren, but the Williams drivers were working their Goodyears harder thanks to the superior power of the Honda engine. Having re-joined, Prost worked his way past Mansell, Piquet having done the same sometime before to lead the race. Mansell remained on course for the championship. Then it all went wrong. As the FW11 powered down the back straight at more than 290 kph (180 mph), the left-rear tyre exploded, Mansell somehow wrestling the lurching, sparking Williams to a halt in the escape road at the end of the straight. Now Piquet looked set to win the title. But Patrick Head, alarmed by what he had seen on the television monitors, knew there was no option but to play it safe and bring Piquet into the pits for fresh tyres. Now Prost was the favourite. Piquet returned to give chase, setting fastest lap in the process. Prost crossed the line four seconds ahead of Piquet to win the championship.

The Williams FW11s of Mansell and Nelson Piquet fight for position during the Australian Grand Prix. Nigel Mansell (left) was on course to win the 1986 World Championship at Adelaide when a rear tyre failed.

McLaren-Honda MP4/4

'When the race team arrived at Imola with the [first] MP4/4, it just looked the bollocks. Ayrton [Senna] took it onto the track and the lap times just went quicker and quicker. It was getting dark – and Ayrton didn't want to stop. It was an absolutely amazing experience and gives me goose bumps to this day when I think about it.'

Indy Lall (Head of the McLaren test team)

The MP4/4 is fondly remembered by team veterans as the best Formula 1 car ever made by McLaren. Everything came together: the perfect integration of Honda turbo engine and chassis, coupled with close teamwork epitomised by scrupulous preparation and reliability. And last but certainly not least, two top drivers – Alain Prost and Ayrton Senna. The result was a car of simple, graceful lines that won 15 of the 16 races in 1988, and gave McLaren-Honda no less than ten 1–2 finishes. In the view of design project leader Steve Nichols, MP4/4 was the ultimate expression of teamwork.

THE CAR

Previews of the 1988 F1 season cast doubt on McLaren's chances. The end of the relationship with TAG-Porsche and a switch to Honda suggested McLaren would suffer because this would be the final shout for turbocharged engines before a ban at the end of the year. It seemed likely Honda would simply tweak the V6 turbo previously used by Williams and Lotus, and then focus on a new V10 normally aspirated engine in readiness for 1989.

Such an assumption would do the Japanese firm a serious disservice. Honda worked night and day although, early in 1988, their labours appeared to be in vain when the brand new V6 was installed the back of MP4/3B, a test car using a chassis from the previous season. Ayrton Senna, having joined from Lotus, was not impressed. The Brazilian's attitude would change completely when, late in the test session at Imola, an MP4/4 was hurriedly brought to the Italian track for its first run. Senna knew instantly he was onto a winner.

A new rule for 1988 required the driver's feet to be behind the front axle line and called for a complete rethink of the front suspension and steering. This, along with a smaller fuel tank (to comply with a capacity reduction to 150 litres/43 gallons), allowed the driver to assume a more reclined position, the objective being to have his shoulders below a lower fuel tank and engine profile. A reduced frontal area, lower sidepods and comparatively simple, but very effective, wings added to a sleek appearance created by a uniformly smooth bodyline running from front to rear.

Engine	Honda RA 168-E V6 Turbo
Size	1494 cc
Power	700 bhp
Weight	540 kg (1190 lb)
Wheelbase	2875 mm (113.2 in)

TEAM HISTORY

Ron Dennis, alert as ever to the constantly moving tempo of Formula 1, had realised the time had come for change. Rather than pay for the services of an independent engineering company, as he had done with Porsche and the TAG Turbo, the McLaren boss began to look for a committed long-term technical association. Ironically, the pieces for such a union had been unwittingly placed on the table when McLaren and Prost stole the 1986 championship from Williams-Honda at the eleventh hour. The loss of a title Honda desperately wanted to win had been exacerbated when Williams refused to take on board a Japanese driver (Satoru Nakajima). Confirmation of the McLaren-Honda deal came at the Italian Grand Prix in September 1987. The key point for Dennis was having an exclusive deal. Meanwhile, John Barnard had left McLaren at the end of 1986, Barnard's place being taken by Gordon Murray, former Technical Director with Brabham. McLaren had moved from the original premises chosen by Dennis in Boundary Road, Woking, to a much larger factory a few kilometres away in Albert Drive.

The McLaren-Honda MP4/4 was considered to be a seamless integration of chassis and engine, Ayrton Senna (pictured) and Alain Prost winning 15 of the 16 races in 1988.

THE DESIGNER

Taking over from John Barnard as Technical Director, Gordon Murray spent 50 per cent of his time on design and the other half on installing systems and chasing reliability. Steve Nichols (brought in by Barnard to work on MP4/1) had become head of car design to lead a compact team including Neil Oatley (ex-Williams and Haas-Lola) and Matthew Jeffreys. David North, in association with Weismann Transmissions, designed a six-speed gearbox and the necessary step-up from the low-mounted engine. Aerodynamics were handled by Bob Bell, who had joined McLaren from university in 1982. The Honda RA 168-E was the work of a design team headed by Osama Goto.

FAMOUS DRIVERS

The timing was right for Ayrton Senna to join McLaren. The Brazilian, apart from being favoured by Honda, had spent four seasons preparing for this. To finally prove himself, Senna wanted to beat Alain Prost, the driver he considered to be the best. Prost was equally happy to accept the challenge, the two drivers working well during most of 1988. With limited opposition, the story of the season was Prost v Senna, with the title going to Senna. The relationship would be gradually eroded by what Prost increasingly considered to be Senna's obsession with winning at all costs, a fixation that would lead to an explosive end to 1989, their final year together.

The battle for supremacy between the McLaren drivers came to a head at Suzuka when Ayrton Senna and Alain Prost collided while fighting for the lead of the 1989 Japanese Grand Prix. Marshals prepare to give Senna's MP4/4 a controversial push-start.

MEMORABLE RACE

The French Grand Prix, coming halfway through the 1988 season, was critical. Fastest in qualifying, Alain Prost had denied Ayrton Senna a record-breaking run of seven pole positions. Even worse from Senna's point of view, his team-mate was leading the championship, the McLaren pair already far ahead in the title race.

Senna had been fastest in the 30-minute warm-up on race morning and needed to ensure he could maintain that pace during 80 laps. It was not going to be easy because the Paul Ricard track surface was more abrasive than most and a mid-race tyre change might be necessary for the first time in six Grands Prix. (This was when tyres were designed to last, allowing drivers to race hard from start to finish.)

As it happened, the pit stops came close to determining the outcome as Prost lost his lead when briefly delayed. But that did not take into account Alain showing uncharacteristic aggression that weekend by actually looking super-quick rather than catching observers by surprise with his usual deceptive smoothness. Apart from sliding his McLaren and using the kerbs with abandon, Prost pulled off the overtake of the race when he seized an opportunity to trap Senna behind a backmarker and dive down the inside when Ayrton least expected it. To be fair to Senna, he was grappling with an inconsistent gearshift. But his troubles could have been much worse – and painfully personal.

As the pair ran flat-out, a trip across one particular kerb had dislodged a skid-block on Prost's leading MP4/4. It went through the floor of Ayrton's car and punched its way into the cockpit. Senna had felt a 'Bang!' somewhere beneath his backside – but pressed on because everything seemed okay. It was only when his mechanics subsequently examined the skid-block's spearing trajectory that everyone realised how close Ayrton had come to an unexpected tweak that would have made his eyes water.

Under the circumstances, Senna did well to finish second. It had been a classic battle – which was just as well since the remainder of the field, struggling in processional fashion a few kilometres behind, formed nothing more than a sideshow to the star billing of 1988 – Senna, Prost, and the McLaren-Honda MP4/4.

Ayrton Senna leads Alain Prost during the 1988 French Grand Prix, Senna being fortunate to finish second after a potentially painful incident.

Ferrari 640

'Enzo [Ferrari] did manage to see the 639 [640] before he died. He looked at it, smiled at me – and slightly shook his head. It would sum up general reaction to the gearbox; people asking: "What are we doing with this thing?"'

John Barnard

Not for the first time, John Barnard raised the technical bar. Having revolutionised chassis construction with the carbon-fibre McLaren MP4, Barnard moved to Ferrari and introduced the semi-automatic gear change. Flicking paddles behind the steering wheel may be as familiar to today's motorists as pressing the accelerator pedal, but in 1989 it was a daring innovation with massive benefits in lap time and drivability. The downside was initial unreliability, which accounted for Ferrari finishing third in the Constructors' Championship, some distance behind the latest McLaren, the MP4/5. But what the Ferrari 640 lacked in points-scoring across a season, it more than made up by qualifying for a permanent place in the F1 record of significant race cars that also looked the part.

THE CAR

From a design point of view, John Barnard had long been irritated by having to cater for a gear lever and its link to the back of the car. In addition to a manual shift requiring vital extra millimetres in cockpit width, the connecting rods running to the gearbox interfered with fuel tank design and keeping the right-hand side of the car tidy and efficient. An electronic gearshift would eradicate those handicaps at the push of a button. The initial plan was to have two buttons on the steering wheel sending electronic signals to a hydraulics activator on the gearbox – the left-hand button for downshifts; the right for changing up. The introduction of paddles would simplify the operation further, with the added bonus of being super-quick while, at the same time, electronic control ensured the engine was not over-revved. The absence of a clutch pedal would also have spatial benefits.

Maximising the opportunity to design a narrower cockpit, Barnard went to town by tidying up the front of the car and wrapping the sidepods around the radiators on either side, creating an extreme 'Coke bottle' shape with the radiator air exiting inside the bodywork, beneath the rear wing. With turbocharging banned for 1989, the regulations called for 3.5-litre engines of no more than 12 cylinders. Barnard broke further new ground by having the Ferrari V12 mounted on the back of the chassis by using four bolts and fixing the cam covers directly to the monocoque. This avoided the use of triangular plates, as popularised when connecting the top of the Ford-Cosworth DFV to allow for expansion. Critics said Barnard's idea would fail thanks to the heavier V12. It worked perfectly and provided yet another technical yardstick.

Engine	Ferrari Tipo 034 V12
Size	2997 cc
Power	660 bhp
Weight	500 kg (1102 lb)
Wheelbase	2880 mm (113.4 in)

TEAM HISTORY

In the ten years since Jody Scheckter's World Championship with the 312T4, Ferrari had won the Constructors' Championship in 1982 and 1983 but failed to claim the Drivers' Championship. A significant motor racing era ended with the death of Enzo Ferrari at the age of 90 in August 1988. Fiat's share of the company was raised to 90 per cent, with Piero Lardi Ferrari (Enzo's son) holding the remaining shares and taking nominal charge. Having agreed his deal with Enzo Ferrari, John Barnard found politics and Ferrari culture playing an increasingly exasperating part, particularly when trying to make the race team more efficient. The banning of a routine and elaborate lunch with wine at the race track proved markedly controversial thanks, in no small measure, to sniping by an influential Italian media. The written press felt duty bound to attack an English technical director who frequently shunned traditional

Italian suppliers in the interest of working with specialists he was more familiar with. The critics were emboldened when stories emerged of a shouting match between Barnard and Vittorio Ghidella in the racing department's car park. The recently elected Ferrari president, fearing loss of face if the electronic gearbox failed, demanded the new car had a traditional manual gearshift. Barnard refused, point blank. Ghidella's anxiety was intensified when the Ferrari 640 experienced endless problems during pre-season testing, the mood suddenly changing when, somewhat miraculously, Ferrari won the first race of 1989.

The smooth lines of the Ferrari 640 with its narrow cockpit and paddle-shift gearbox are evident as Nigel Mansell tackles the Monaco street circuit in 1989.

THE DESIGNER

John Barnard could not resist the opportunity to join Ferrari, a team responsible for producing both the car and the engine. From the outset, Barnard insisted on setting up a technical and manufacturing department within a new industrial estate at Shalford, near Guildford in Surrey. Having received Enzo Ferrari's blessing, Barnard pressed on with his plans despite outrage in Italy over what was seen as the export of their motor racing heritage – to England, of all places. Barnard worked with aerodynamicist Henri Durand to refine the bodywork when producing the Ferrari 639 (effectively, a test car) and the 640, which would be raced in 1989. The workforce at Shalford included Diane Holl, a 22-year-old design engineer who had previously spent time working in the wind tunnel with the March team. Barnard's choice of a female engineer – rare in Formula 1 at the time – caused further consternation at Ferrari's headquarters in Italy.

FAMOUS DRIVERS

With Williams having lost the Honda engine to McLaren for the 1988 season, the time was right for Nigel Mansell to leave and sign for Ferrari for the 1989 season, a move that suited both sides, such was the Englishman's reputation as a feisty and fast racer. Mansell's relationship with Ferrari and the Italian fans could not have got off to a better start when, against all odds, he won their first race together at Jacarepaguá in Brazil. Mansell's status as a swashbuckling Ferrari hero would rise further when he pulled off a brilliant win in Hungary. Mansell raced alongside Gerhard Berger, who had been with Ferrari for two years, the Austrian having won three races with the Ferrari turbo before adding one more in 1989 with the 640 in Portugal.

The passion of Ferrari at home. Fans greet Nigel Mansell's Ferrari 640 at Imola during the 1989 San Marino Grand Prix weekend.

MEMORABLE RACE

The 1989 Hungarian Grand Prix was one of Nigel Mansell's finest victories, made sweeter by the Ferrari driver breaking McLaren's stranglehold. Having struggled to make the Ferrari handle on the twisting Hungaroring during practice, Mansell had chosen to focus on preparing for the race. Such a bold decision meant starting from twelfth on the grid for a race in which overtaking would be extremely difficult.

Realising the magnitude of the task ahead of him, Mansell seized the opportunity to overtake four cars when the field was tightly bunched on the first lap. For the next 19 laps, Mansell took care of his tyres before deciding it was time to really get going. By lap 24, he was in fifth place. The fastest lap of the race so far indicated that Mansell was intent on reducing the 17-second gap to Alain Prost. By lap 41, he had caught and passed the McLaren to take what was now third place (due to a pit stop for a leading driver). That became second when the leading Williams of Riccardo Patrese retired with a holed radiator. The McLaren of Ayrton Senna was now leading the race. With 21 laps remaining, Mansell figured he would have to wait for his chance. It came on lap 58. As the leaders caught a backmarker, a moment's hesitation by Senna allowed Mansell to trap the McLaren behind the slower car and swoop into the lead. It had been a lighting reaction, for which Senna had no answer. To cap an excellent day for motor racing in general and Ferrari in particular, Mansell dedicated his win to the memory of Enzo Ferrari.

Nigel Mansell used the Ferrari 640 to pull off one of his greatest wins in the 1989 Hungarian Grand Prix.

Williams-Renault FW14B

'In medium speed corners, FW14B didn't feel that much different to a car with passive suspension. But in the quick stuff, the active suspension didn't always give you feedback in real time. You had to go in there, really believing the car was going to grip. And, boy, did it do that.'

Nigel Mansell CBE

The Williams FW14B was made – in every sense - for Nigel Mansell. One of the most sophisticated F1 cars of all time was also physically demanding and required total commitment from the driver; perfect territory for Mansell. The Englishman claimed nine of the 16 Grands Prix in 1992, clinching the World Championship with five races to go. Mansell's team-mate, Riccardo Patrese, won the Japanese Grand Prix and, being runner-up six times, helped ensure total domination of the Constructors' Championship by Williams-Renault.

THE CAR

Development started with the FW14, the car raced by Williams in 1991. The introduction of a semi-automatic gearbox proved troublesome at first and dented the Williams attack on a championship won by McLaren. The 'B' version was supposed to be a stop gap while the team worked on a better understanding of an active suspension in readiness for the FW15 but, in the event, such was the FW14B's immediate dominance that it remained in service for the remainder of 1992.

By controlling the car's ride height, active suspension allowed engineers to optimise the aerodynamics, the net result being huge amounts of downforce and a car that could go faster, more consistently. Wind tunnel tests also showed that by lowering the rear of the car and raising the front, the subsequent stalling of the rear diffuser would reduce drag and increase straight-line speed. A button on the steering wheel allowed the driver to change the car's attitude in this way and gain an extra 8–9.5 kph (5–6 mph) on the straights. The addition of traction control, coupled with the semi-automatic transmission, made the FW14B the most advanced car of a generation that would be ended with the banning of active suspension and other electronic aids at the end of the 1993 season. Renault made a valuable contribution with a V10 engine that had a competitive combination of power, weight, fuel consumption and reliability.

Engine	Renault RS3C/RS4 V10
Size	3493 cc
Power	760 bhp
Weight	505 kg (1103 lb)
Wheelbase	2921 mm (115 in)

TEAM HISTORY

The loss of Honda turbo engines had been keenly felt by Williams at the end of 1987. A normally aspirated Judd V8 had provided no more than a make-shift solution while a deal was done with Renault for 1990 and beyond. The installation of a new wind tunnel (so large, it had to be built outside the team's premises at Didcot's Basil Hill Road) came not long after the opening of the 929 square metre (10,000 square foot) Williams Conference Centre as an additional revenue stream. Frank Williams CBE (awarded in the 1987 New Year Honours) remained as Team Principal while continuing to come to terms with the debilitating injuries received in a road accident in 1986.

The Williams FW14B remains one of the most technically sophisticated Formula 1 cars, Nigel Mansell, carrying the famous red number 5, making full use of it to dominate the 1992 World Championship.

187

188

THE DESIGNER

The appointment of Adrian Newey as Head of Aerodynamics and Design in July 1990 would have a profound effect on not only the more immediate success of Williams but also Newey's long term influence on F1 design through McLaren and Red Bull. The Englishman had cut his teeth in IndyCar racing and with Leyton House, a small but innovative F1 team. While Patrick Head continued to provide overall technical direction, Newey's first task was to design the FW14 for 1991, (with Head taking charge of the semi-automatic gearbox and transmission), leading to the FW14B for the following season. Head described the FW14B as 'a massive step forward for us – but it was difficult'. Head and his technical team were able to tame the computer-controlled suspension and enjoy almost instant success with this car. Newey would later describe 1992 as one of the easiest seasons he ever had in F1. The Renault V10 was designed by Bernard Dudot.

FAMOUS DRIVERS

Riccardo Patrese had left Alfa Romeo to join Williams in 1988, the experienced Italian failing to visit the podium until the arrival of Renault engines the following year, when he finished third in the championship. Patrese won his first Grand Prix with Williams at Imola in 1990.

Despite failing to agree terms for 1989 and leaving in a huff, Nigel Mansell chose to return to Williams for 1991 after two difficult years at Ferrari. His timing on this occasion was spot on, particularly when it came to extracting the maximum from the FW14B. The active ride suspension required the driver to trust that the car would stick despite seemingly unimaginable entry speeds into the corners. The absence of power steering added a physical aspect to the job but Mansell's upper-body strength, allied to massive self-belief, meant he was able to wring the car's neck in a way few drivers could manage. Patrese had out-qualified Mansell at every race with the FW14 during the first half of 1991 and went on to score two wins. But dealing with the FW14B proved to be a different matter, the inability to commit to high-speed corners leaving Patrese with no option but to support Mansell's championship campaign with quiet dignity – with one exception.

Adrian Newey (left) and Race Engineer David Brown discuss the set-up of Nigel Mansell's Williams FW14B during practice for the 1992 Japanese Grand Prix.

MEMORABLE RACE

By the time the F1 teams reached France for the eighth round of the 1992 season at Magny-Cours, Nigel Mansell had won five of the races and was leading the championship. Riccardo Patrese may have been some distance behind in second place, but that was not going to prevent the Italian from having a go if the opportunity arose. His chance came at Magny-Cours when he started from the front row and snatched the lead from Mansell's pole position FW14B. Try as he might, Mansell could not get by as the Williams pair left their rivals far behind while having an intense race of their own – fuelled, on Patrese's part, by the news that Williams would not be retaining him for 1993. Mansell was receiving the full brunt of the Italian's previously unseen aggression.

With the advent of rain at the 15-lap mark, the battle for the lead took on a worrying complexion for the Williams management. This was, after all, the French Grand Prix being run in front of important guests from Renault and the team's fuel and lubricants supplier, Elf. With slick tyres glistening from the wet surface, everyone reduced their lap times. Everyone, that is, except Patrese and Mansell.

In the space of four laps, the gap to the car in third place went from 13 seconds to 23 seconds. It was a thrilling contest for everyone – bar those watching from the Williams pit. It was with some relief that Frank Williams and Patrick Head saw the red flag bring the race to a temporary halt. As the drivers waited on the grid, Head took Patrese to one side and made it clear in words of few syllables that he was free to defend his position, provided he did not put the chances of the team in jeopardy. Patrese knew Mansell would stop at nothing. In the event of a collision, and in the light of Head's comments, blame would be foisted on the Italian. It was Hobson's choice. When the rain stopped and the race restarted, Patrese took the lead once more. As he accelerated onto the pit straight at the end of the lap, Patrese kept to the left and raised his arm high in the air – a clear indication that Mansell was being waved through under sufferance. They completed the remaining 48 laps in that order. It was a dull final phase to the race. But the first quarter had been electrifying.

A tense fight between the Williams drivers for the lead of the 1992 French Grand Prix required the intervention of a word of warning from team management, Riccardo Patrese (#6) dutifully surrendering first place.

Benetton-Ford B194

'When it comes to Toleman/Benetton, the B194 was the best car I designed; a lot better than the 1995 car [the B195, which gave Schumacher his second title and Benetton their first Constructors' Championship].'

Rory Byrne

Few cars in the history of the Formula 1 World Championship created as much controversy throughout a season as the Benetton-Ford B194. This was the culmination of a vibrant young team finally coming together and producing a car that should have been the class of the field. Similarly, in 1994, Michael Schumacher came of age to win the first of seven world titles. But even the manner of his claiming the championship (colliding with the Williams of close rival, Damon Hill) at the final race would continue to choke the deserved respect for this car.

A season that had started convincingly with three wins in succession would quickly descend into one of ill-feeling, recrimination and a shocking sense of unease, propagated by the death of two drivers in one weekend at Imola. Coincidentally, Benetton would become the subject of accusations – never proved – of rule bending thanks to the alleged use of traction control (banned at the beginning of the season). There was more tangible trouble at Silverstone when mixed messages between the team and race control led to Schumacher ignoring a black flag. In Belgium, Schumacher's winning car was thrown out on a technicality. In between, there was a brief but terrifying inferno when a Benetton caught fire during a refuelling stop at Hockenheim.

The accompanying harsh official reprimands were created in no small part by growing animosity between Flavio Briatore, Benetton's outspoken team principal, and Max Mosley, the urbane president of the FIA, motor sport's governing body. In many ways the confident, sometimes cocky, team from Enstone in Oxfordshire was paying the price throughout 1994 for being in-your-face fast with the Benetton-Ford B194.

A classy and controversial combination. Michael Schumacher won the 1994 World Championship with the Benetton B194.

THE CAR

Continuing to grow at pace during 1993 by producing the B193 with active ride suspension and paddle-shift gear change, Benetton was nevertheless a step behind not only the championship-winning Williams FW15, but also the McLaren MP4/8. The latter was particularly galling because McLaren – aided, it had to be said, by the prodigious driving skill of Ayrton Senna – were customers of Ford, whereas Benetton were supposed to have priority over the latest developments on the Cosworth-built V8. Continuing to learn lessons and apply them, Benetton switched their attention to the 1994 car long before the 1993 season was finished. The B194 would be less sophisticated (because of the ban on active-ride suspension and other technical aids) but the new car would be carefully developed. As a result, the B194 was fast from the get-go, with designer Rory Byrne focusing on lowering the car's centre of gravity and reducing its weight to such an extent that ballast (easy to control and position) was needed. The latest Ford-Cosworth V8, the Zetec-R designed by Geoff Goddard, was both driveable and reliable.

Engine	Ford-Cosworth Zetec-R V8
Size	3499 cc
Power	580 bhp
Weight	515 kg (1135 lb)
Wheelbase	2880 mm (113 in)

TEAM HISTORY

In a manner appropriate for Benetton's rebel image, the team's roots stretched back to Toleman, a small outfit that had defied convention by designing their own Formula 2 car and dominating the 1980 season. Toleman, a car transport company from Essex, had entered motor racing through Alex Hawkridge. Realising the limit of his ambitions as an amateur driver, Toleman's managing director formed a team to run various proprietary F2 cars for promising youngsters. After deciding to do their own thing, one of Hawkridge's shrewdest moves was to give the relatively unknown Rory Byrne the opportunity to design the Toleman F2 car. Winning the F2 title was one thing, but observers thought Toleman's plans to step up to Formula 1 were fanciful. The first three years would prove predictably difficult but attitudes changed in 1984. Making the most of equalising wet conditions, Ayrton Senna came close to winning the Monaco Grand Prix in a Toleman powered by a turbocharged engine, built by Brian Hart in his humble workshop in Essex.

Meanwhile Benetton, a clothing and fashion company, had also been drawn to Formula 1. Having sponsored various local sports teams, Benetton could see how Grand Prix racing matched the Italian firm's global ambition. The connection began with sponsorship of the Tyrrell team in 1983, before switching to Alfa Romeo and then accepting the challenge of owning a team in its entirety. The timing was right to take control of the struggling Toleman operation, the Benetton B186 appearing in 1986. Having switched to BMW engines, Benetton scored their first win in Mexico. The appointment of Flavio Briatore as team manager in 1990 would typify Benetton's unconventional approach. With no experience in motor racing, Briatore ruffled a few feathers but the flamboyant Italian was unconcerned, particularly when Nelson Piquet won two races to give Benetton their most successful season to date. The management structure was expanded when Tom Walkinshaw (racing entrepreneur and successful entrant of the Jaguar sportscar team) acquired a stake and brought Ross Brawn with him to head Benetton's engineering team. At the same time (1992), the team moved across Oxfordshire from the original Toleman premises in Witney to a purpose-built factory at Enstone; another outward sign that Benetton meant business.

THE DESIGNER

Having helped engineer a friend's Formula Ford car in their native South Africa, Rory Byrne came to England in 1972 to pursue a career in racing car design. Having found work with Royale, it wasn't long before Byrne began designing championship-winning Formula Ford and sports racing cars. A link between Royale and Alex Hawkridge led to Byrne designing the first Toleman Formula 2 and Formula 1 cars. The subsequent success with what had become Benetton would later lead to Byrne becoming Chief Designer at Ferrari. Throughout his period with Benetton, Byrne worked closely with Pat Symonds, whose engineering skills would lead to a future role with other F1 teams and the sport's governing body, the FIA.

FAMOUS DRIVERS

An essential element of the Benetton success story had been the shrewd signing of 22-year-old Michael Schumacher at the end of 1991, the future World Champion winning his first Grand Prix the following year. Schumacher's team-mate in 1994 should have been J.J. Lehto but the Finnish driver was ruled out initially by a heavy accident during early testing of the B194. Jos Verstappen (father of Max) was thrown in the deep end, making his F1 debut at the first Grand Prix in Brazil. A comeback by Lehto was affected by the lingering effects of his injuries, Verstappen returning to the cockpit mid-season, only to be replaced by Johnny Herbert for the final two races.

MEMORABLE RACE

Going into the Hungarian Grand Prix on 14 August 1994, Benetton were under the cosh. In the midst of unsubstantiated claims of the illegal use of traction control, Michael Schumacher had been disqualified because of a black flag incident at Silverstone. Two weeks later, following a brief inferno in the pit lane at Hockenheim, Benetton had been accused of removing a filter from the refuelling hose. On the same weekend, the team had scored no points due to an engine failure for Schumacher. By claiming pole position in Hungary, Schumacher reasserted himself, the team doing the same by choosing to take the risk of three refuelling stops compared to two for everyone else. Not only did the strategy work perfectly, but Schumacher was also to demonstrate just why he was championship material.

In the closing stages, Schumacher's lead was such that he allowed Martin Brundle to unlap himself. As the McLaren went past, Schumacher detected that Brundle was in some sort of mechanical trouble. He radioed the Benetton pit and asked to have the running order. 'Schumacher – Hill – Brundle,' came the reply. 'Who's fourth?' 'Jos [Verstappen], 14 seconds behind Brundle.' 'Okay. Brundle is in trouble. Tell Jos I'm going to slow and let him unlap himself.' Verstappen did just that. On the very last lap, a distraught Brundle rolled to a halt with electrical trouble, giving Benetton a 1–3 finish, their first in almost four years.

After a troubled few races, Michael Schumacher and Benetton restored the status quo with a daring and mature performance at the 1994 Hungarian Grand Prix. Schumacher leads the Williams FW16 of his championship challenger, Damon Hill (#0).

Williams-Renault FW18

'Adrian [Newey] went to the trouble of making sure my size 11 feet fitted inside the cockpit and produced the most comfortable car I would drive in my entire motor racing career.'

Damon Hill OBE

After two troubled and difficult seasons for Williams, it finally came good in 1996. With the regulations having been in upheaval since the death of two drivers on one weekend in 1994, the Williams-Renault FW18 represented reasonable stability for the car, the team and its drivers. Damon Hill was finally able to focus entirely on the championship with a car in which he felt completely at home. Hill's main title rival turned out to be his team-mate, Jacques Villeneuve, the Canadian driver enjoying an impressive debut season. Williams won 12 of the 16 Grands Prix to score twice as many points as their closest rival, Ferrari, the title going to Hill, with nine pole positions and eight victories.

Hill's one opportunity to emulate his father, Graham (who had won Monaco five times), disappearing in a cloud of smoke. Nonetheless, FW18 was a very quick car, and Hill was ready to make good use of it.

Engine	Renault RS8 V10
Size	2998 cc
Power	750 bhp
Weight	600 kg (1323 lb)
Wheelbase	2890 mm (114 in)

THE CAR

The banning of active suspension and other so-called driver aids for 1994 had returned Williams to dampers and torsion bar or coil springs, meaning it was no longer possible to easily control the car's ride height. The overall shape of the car in 1994 had remained similar to the FW14B and FW15, winners of the championships in the two previous years. The most obvious difference with the 1995 car, FW17, was a raised nose and transverse gearbox, features carried into the 1996 version.

The secret to the FW18's success lay beneath the rear bodywork thanks to a unique diffuser, plus suspension and gearbox tweaks that had been introduced towards the end of the previous season. It was to the team's surprise and relief that rivals had failed to copy a development that had brought an immediate gain in lap time. Refinements on this during the winter would further enhance performance. The Renault V10 (complying with a capacity drop from 3.5 to 3 litres, introduced in 1995 as a means of containing speed) continued to have a perfect blend of reliability and driveability – most of the time. One of the few failures in 1996 could not have come at a more emotional moment. Hill was leading the Monaco Grand Prix when an oil pressure relief valve stopped working without warning,

TEAM HISTORY

Following Nigel Mansell's championship year with the FW14B in 1992, the one major drama to surround the team had been the Englishman's theatrical departure after failing to agree terms. By contrast, Alain Prost left at the end of 1993 as quietly as he had arrived 12 months before. Winning his fourth championship had seemed almost incidental. Williams looked set to continue this sublime path of success in 1994 when Frank Williams realised a long-held ambition by signing the triple champion, Ayrton Senna. Within three races, the world had been turned on its head with Williams at the epicentre of the terrible turmoil. When Senna was killed during the San Marino Grand Prix, the blame and recrimination would colour the next three years until the Williams name was cleared. Meanwhile, the company would continue to grow. With 224 full-time staff, it was necessary to move from Didcot to the former headquarters of a pharmaceutical company occupying a 32-acre site outside the village of Grove in Oxfordshire. The company's turnover had jumped from £12 million to £36 million. An operating profit of £6.6 million was registered for 1995. Track success in 1996 would also mark the beginning of an emergence from a troubled period, memorable largely for the team having pulled together in a manner that spoke volumes for its ethos and leadership.

THE DESIGNER

Adrian Newey had signed a new contract, giving him a say – he hoped – in policy matters such as the choice of drivers. (It had been Newey's belief that Nigel Mansell's presence in the cockpit would have won the 1995 championship with the FW17.) Newey continued to mastermind the design and aerodynamics, with Patrick Head remaining as Technical Director. Bernard Dudot continued to be responsible for the design of the Renault V10.

FAMOUS DRIVERS

Having spent a season learning the ropes as number 2 driver during his first full season in 1993, Damon Hill expected more of the same when Ayrton Senna replaced Alain Prost in 1994. Apart from having to deal with the shock of Senna's fatal accident on 1 May, Hill suddenly found himself thrust into the role of number 1 driver, carrying the hopes of the entire team and its traumatised sponsors. In the same way Graham Hill had stepped up to the plate at Lotus following the death of Jim Clark in 1968, his son responded magnificently by winning the Spanish Grand Prix and going on to take the championship to the wire in an intense battle with Michael Schumacher and Benetton. Along the way, Nigel Mansell had made occasional appearances (winning the final race of 1994). David Coulthard, having been elevated from the role of test driver for eight races, became Hill's full-time partner in 1995, winning his first Grand Prix in Portugal before leaving to join McLaren. The Scotsman's place in 1996 was taken by Jacques Villeneuve on the strength of a test session with Williams and the Canadian's equally impressive victory in the 1995 Indianapolis 500 and the CART (IndyCar) Championship.

Jacques Villeneuve laid down an immediate challenge on his F1 debut in 1996 by claiming pole and leading the Australian Grand Prix with his Williams FW18.

MEMORABLE RACE

At the end of a miserable season in 1995, Damon Hill had engaged in a significant mental reset in preparation for the coming year. He saw 1996 as his best opportunity yet. Hill's bête noire, Michael Schumacher, had left Benetton for a Ferrari team that would take time to deal with a management reorganisation; Adrian Newey and Patrick Head were refining a potentially quick Williams-Renault; Jacques Villeneuve, making his F1 debut, would be feeling his way in the other Williams; and, for the first time, Hill felt the team was fully behind him after a couple of seasons when their support had been ambivalent on occasions. Hill got off to a good start in Australia by finishing ahead of Villeneuve, after the novice had won pole position but was hampered by an oil leak in the race. Brazil was next.

The twisting Interlagos circuit was tricky at the best of times; more so when the heavens opened as the cars headed for the grid. Drivers were alarmed to see fountains of water spewing 500 mm (20 inches) into the air from trackside drains unable to handle the deluge. There were doubts that the race would

Damon Hill's Williams FW18 fends off a challenge from the Jordan 196 of local hero, Rubens Barrichello, at the start of the 1996 Brazilian Grand Prix.

start. But as soon as the countdown began, Hill knew he needed to take an immediate lead and leave the 21 cars behind him to deal with the inevitable opaque wall of spray. On the other hand, the leading driver would be the first to find the more treacherous patches of an already slippery track.

Hill made a perfect start. After two laps, he was already six seconds clear and settling into the task. With refuelling being part of the race strategy, Hill had chosen to run with plenty of fuel initially, the penalty of the additional weight being offset by being able to run far enough into the race to reach the stage when slick tyres could be fitted during the single pit stop. Hill waited until lap 40 of the 71-lap race before diving into the pits. It was perfectly timed. Hill not only rejoined in the lead but also opened the gap to the Benetton of Jean Alesi in second place. Hill would later describe it as his best race of the year; a very good year, as it would turn out.

McLaren-Mercedes MP4-13

'Adrian Newey, Neil Oatley and the whole team designed a brilliant car in 1998. It was just perfect. Okay, there were a couple of things but, compared to other teams, we were 1.5 to 2 seconds ahead, which is light years in F1.'

Mika Häkkinen

McLaren had made significant changes, the most visible being the red and white of Marlboro replaced at the beginning of 1997 by a distinctive silver livery signifying sponsorship from the West tobacco brand and, more importantly, a partnership with Mercedes-Benz. It would take 12 months for the alliance to gel – the appearance of the McLaren-Mercedes MP4-13 in 1998 marking McLaren's intention to win their first championship since 1991. This was the first car designed from scratch by Adrian Newey since his move from Williams, and Mika Häkkinen and David Coulthard went on to win nine of the 16 Grands Prix. The resurgence would continue into 1999 as this car provided the nucleus for MP4-14 and another championship for Häkkinen. A separation of the car's generic nomenclature and the model number by a hyphen instead of a slash was an expressive sign of McLaren's almost obsessive attention to detail.

David Coulthard played a vital part in the McLaren MP4-13 story in 1998, the Scotsman winning the San Marino Grand Prix and finishing second six times.

THE CAR

One of Adrian Newey's first tasks was to work out the best way to deal with the latest technical regulations, introduced in the continuing quest to slow F1 cars and also make them safer. A reduction in the car's width and the need to have the front suspension mounted outside a specified area around the pedals (to help protect the driver's feet), in addition to the wheels being closer to the bodywork, placed great emphasis on controlling all-important airflow around the front of the car. Dry weather tyres now had mandatory grooves in the belief that the accompanying reduction in grip would improve the spectacle while further reducing speed. McLaren had the additional complication of switching from Goodyear to Bridgestone tyres. Contrary to a recent trend, the MP4-13 featured a low nose with the front wing attached by curved supports. By lengthing the wheelbase, the all-important centre of gravity could be lowered further still. A narrow airbox with a triangular inlet sat high above the Mercedes engine, the V10 having a lower crankshaft and lighter cylinder heads.

Engine	Mercedes-Benz FO 110G V10
Size	2997 cc
Power	760 bhp
Weight	600 kg (1323 lb)
Wheelbase	3060 mm (120.5 in)

TEAM HISTORY

Having been through patchy periods with Ford and Peugeot engines, Ron Dennis was perceptive as ever when deciding McLaren's long-term future. Dennis had watched with interest as Mercedes-Benz dipped a toe in the water by supporting Sauber's venture into Formula 1. At the same time, Norbert Haug, the Mercedes motor sport boss, was aware that his company needed to step up its involvement on every front. It was clear to McLaren and Mercedes that each could provide the solid mutual commitment needed for success in a rapidly evolving sport. The partnership began in 1995 and it took time for the two large organisations to find a comfortable working relationship. The same applied to Ilmor Engineering, manufacturer of the Mercedes V10. Meanwhile, the close of 1996 marked the expiry of Marlboro's contract with McLaren and the end of a 23-year relationship, the longest such alliance at the time in any sport. The next phase of McLaren's sporting profile would be revealed on 13 February 1997 at London's Alexandra Palace. It was an all-singing, all-dancing launch as the Spice Girls and Jamiroquai headlined the announcement of a new title sponsor, West, and the appearance of the car in a silver livery, very much in keeping with the Mercedes-Benz motor sport heritage. The pressure was on. McLaren responded by finishing first and third in the opening race of the season in Melbourne. A trio of wins throughout the year would set the scene for a focused campaign with MP4-13 in 1998.

THE DESIGNER

Adrian Newey joined McLaren as Technical Director on 1 August 1997 with a personal mission; to prove he could take full responsibility for the design of a successful Formula 1 car and dismiss the tacit, if fanciful, impression that he sometimes needed to be kept in check. The entire concept of MP4-13 was his, although Newey worked closely with Neil Oatley (responsible for MP4-12 and the mechanical design of MP4-13), Henri Durand (in charge of aerodynamics) and long-time McLaren employee and former design project leader, Steve Nichols. The Mercedes V10 engine was the work of Mario Illien, the founder (along with Paul Morgan) of Ilmor Engineering. Having produced engines for Chevrolet in IndyCar racing, Ilmor supplied a V10 engine for the car designed by Newey when technical director at Leyton House, formerly the March F1 team. Ilmor stepped up a gear by working with Mercedes as the motor manufacturer returned to F1 with Sauber in 1993. The following year, Mercedes acquired Chevrolet's 25 per cent share of Ilmor Engineering.

FAMOUS DRIVERS

Mika Häkkinen had learned the F1 ropes during two seasons with Lotus before becoming a test driver with McLaren in 1993. The Finn stepped up to the race team, replacing Michael Andretti for the final three Grands Prix and finishing third in Japan, his second race with the McLaren-Ford MP4/8. Despite reliability problems with a Peugeot engine, Häkkinen claimed fourth in the 1994 Drivers' Championship. His first year with the Mercedes V10 ended in a serious accident when a tyre failed during qualifying for the Australian Grand Prix. Häkkinen's life was saved by an emergency tracheotomy at the trackside. He made a full recovery and won his first Grand Prix in Spain at the end of the 1997 season.

David Coulthard's move from Williams in 1996 brought a podium finish, followed by two victories the following year and a mildly controversial finish in Spain when he was asked to let Häkkinen through to his maiden win.

MEMORABLE RACE

McLaren-Mercedes and Mika Häkkinen led their respective championships as they arrived in Japan for the final race of 1998, but Michael Schumacher and Ferrari remained within striking distance. Both sides knew the championship could go either way, Häkkinen having won seven races, Schumacher claiming six. The Ferrari driver took pole, with Häkkinen alongside. McLaren had it all to do, particularly at Suzuka, arguably the trickiest of the 16 tracks in the championship. Knowing nothing less than a win would suffice, McLaren put their entire focus on their driver's well-being.

'They really gave me space,' recalled Häkkinen. 'Not too much marketing and media work. I could have time to myself. Ron [Dennis] was excellent when it came to details like that. The team was incredible with me psychologically; trying to build me up going into the last GP. The feeling was: there's no way Ferrari can beat us. Absolutely no way! We were fully focused and so strong together. It was an incredible feeling.'

McLaren had not won a driver's championship since 1991. Ferrari's drought stretched back to Jody Scheckter in 1979. The pressure showed when Schumacher stalled and had to start from the back of the grid. Häkkinen took an immediate lead and soon came under pressure from the second Ferrari of Eddie Irvine, an acknowledged Suzuka expert. Häkkinen remained calm and gradually teased out his lead to three seconds; breathing space in one sense, but insufficient to prevent Irvine from seizing the opportunity should Häkkinen make the slightest mistake.

Meanwhile, Schumacher was working his way into third place – which would immediately become second if he caught Irvine. Then, with 20 laps to go, Schumacher picked up a puncture from debris caused by a collision between two back-markers. His race was run. Häkkinen kept Irvine at arm's length and brought MP4-13 home to what would be McLaren's last Constructors' Championship until 2024, and the first of two Drivers' Championships in succession for the so-called 'Flying Finn'.

Mika Häkkinen locks the brakes on his McLaren MP4-13 after crossing the line at Suzuka to win the Japanese Grand Prix and the 1998 World Championship.

Jordan-Mugen Honda 199

'Finishing third in the championship with the Jordan-Mugen Honda 199 was fantastic. No question this car helped us haul ourselves from being no-hopers to having a crack at the championship.'

Eddie Jordan

At one point during 1999, Jordan Grand Prix came close to making a serious and unexpected bid for the championship. Heinz-Harald Frentzen had won two Grands Prix. But when the German driver seemed certain to score a third victory and move close to the top of the championship, his Jordan-Mugen Honda 199 came to a halt with a footling technical failure that underscored this small team's vulnerability and relative inexperience. Nonetheless, the bright yellow car with its garish sponsorship scheme summed up a rock'n'roll outfit that cheerfully punched above its weight and brought colour to Formula 1. The Jordan 199 was as worthy as it was welcome while jousting with giants.

THE CAR

After a few seasons struggling with engines from Ford, Yamaha, Hart and Peugeot, Jordan Grand Prix made a useful step forward in 1998 by doing a two-year deal with Mugen Honda, the company formed in 1973 by Hirotoshi Honda, the son of Honda Motor Company founder, Soichiro Honda. The engine manufacturer and tuning company gradually built a solid reputation in the motor racing world before venturing into Formula 1 in 1991 with the Tyrrell and, later, the Footwork, Lotus and Prost teams. When Prost switched to Peugeot for 1998, Jordan was ready to design and build the 198 chassis to accept the Mugen Honda V10, the combination going on to provide Jordan's first Grand Prix win in Belgium.

The Jordan-Mugen Honda 199 was a logical progression – reduced weight, lower centre of gravity, optimised aerodynamics, a new six-speed gearbox – to match the latest V10. Throughout the 1999 season, Mugen would continue developments that were both useful and reliable. Jordan could not always reciprocate, particularly in Canada when a brake disc failure cost a certain second place.

The most frustrating retirement would come in Germany at the European Grand Prix. Frentzen had claimed pole position at the Nürburgring and was leading comfortably when the team executed a perfectly timed pit stop to keep the German driver in the lead. Then the engine died as he accelerated from the pits. Frentzen had not been reminded to turn off a device designed to prevent the V10 from stalling during the pit stop. Had he won, Frentzen would have been one point behind the leader of the championship, with two races remaining.

Engine	Mugen Honda MF301HD V10
Size	2994 cc
Power	684 bhp
Weight	600 kg (1323 lb)
Wheelbase	3050 mm (120 in)

TEAM HISTORY

Having run a team and won in every category he entered in the junior formulae, Eddie Jordan could not resist making the move to Formula 1 for the start of the 1991 season. Operating out of a small unit on the Silverstone trading estate, the Irishman knew life would be tough as he went into his first year with a budget of £6 million – which had to include the purchase of engines from Ford. In addition, Jordan Grand Prix would be required to prequalify for the right to practice, never mind race – a punishing process made necessary by an entry of 34 cars for races that would only accommodate 26 starters. Jordan not only survived but also scored points halfway through the season by finishing fourth and fifth in Canada. Eddie Jordan may have proved adept at spotting talent when he gave Michael Schumacher his first F1 drive in Belgium that year, but Jordan's contractual naivety would be exposed almost immediately when the future World Champion was purloined by Benetton.

Jordan at least had the consolation of moving into an elegant purpose-built factory across the road from the Silverstone circuit. An excellent fifth place in the Constructors' Championship at the end of Jordan's first season would be crushed by F1's harsh reality, and a place at the bottom of the table the following year. It was not much better in 1993 but Jordan would be the most improved team of 1994

by returning to fifth place in the championship. Having climbed the ladder, it was a slither down the slippery slope once more due to a lack of funds and development in 1995. The familiar story would continue through the next two seasons, the first sign of a much-anticipated turnaround coming with substantial backing from Benson & Hedges. An aggressive marketing campaign by the tobacco company would be matched by the team as Jordan began scoring points consistently before finally winning a Grand Prix in August 1998.

THE DESIGNER

Gary Anderson, a stalwart of Jordan Grand Prix from the start, had stepped aside halfway through 1998. The Technical Director now worked alongside Mike Gascoyne, who had previously focused on aerodynamics at McLaren and Tyrrell. Introducing modifications to the team's systems as well as the 198, Gascoyne took responsibility for the Jordan 199. He was supported by Mark Smith (mechanical design), John McQuilliam (composite design), John Iley (aerodynamics) and John Davis (Head of R&D).

FAMOUS DRIVERS

After an unrewarding season with Arrows in 1997, Damon Hill moved to Jordan and led home a 1–2 in the 1998 Belgian Grand Prix. There had been controversy when team orders prevented Ralf Schumacher from challenging Hill during the closing stages of the wet race at Spa-Francorchamps. Schumacher was replaced by Heinz-Harald Frentzen for 1999, the German driver having won the 1997 San Marino Grand Prix during his two years with Williams. Frentzen would win twice and score seven times more points than Hill in 1999, a lacklustre year for the former World Champion eventually leading to his retirement.

Damon Hill gave Jordan their first Grand Prix win with the Jordan 198. Pictured here with the Jordan 199 in Hungary, the former World Champion retired at the end of 1999.

MEMORABLE RACE

Jordan never expected to win the 1999 French Grand Prix. But they did it with the help of 'Big Dave'. Well-heeled teams would use links with satellite technology to predict the weather on race day; Jordan would rely on a phone call to the local airport. On 27 June 1999, with menacing clouds in the distance, they went one better and dispatched their odd-job man, Big Dave, with an umbrella and mobile phone. He was told to find an elevated point a few kilometres away, but in direct line with the prevailing wind and the Magny-Cours race track. His job was to report on the arrival of rain, its intensity and, more importantly, its likely duration.

For the first 20 laps, Frentzen held a handy fourth place, not far behind the fancied runners from Ferrari and McLaren. Then the Jordan pit wall received a call from Big Dave. 'It's pissing down,' he said. 'And there's no likelihood of a let-up.' With the rain due to arrive and trigger pit stops for fuel and wet-weather tyres, the Jordan crew quickly calculated that, in the likely event of a safety car, it might be possible to save enough fuel to have Frentzen run the remainder of the race without stopping again. As the field dived into the pits, relatively brief stops indicated the wide-spread intention of stopping again and probably returning to slick

Heinz-Harald Frentzen acknowledges the chequered flag at the end of the 1999 French Grand Prix, the first of two wins for the German driver with the Jordan 199.

tyres in the event of the track drying out. Jordan were relying on Big Dave's words 'no likelihood of a let-up' when the order went out to fill Frentzen's car to the brim, even though there were 50 laps remaining. It was a huge gamble.

The rain intensified. Jordan were mightily relieved when a safety car appeared on lap 25 and ran for 11 laps. Frentzen was able to save fuel, but would it be enough as the safety car disappeared and the race resumed? Frentzen held third place, which became second, and then first, as the cars ahead made the predicted final stops for fuel, but not for slick tyres thanks to the track remaining wet. Treating the throttle as gently as he dared, Frentzen remained in front and had enough fuel left to take the chequered flag. A bedraggled Big Dave was the unsung hero of the day.

Stewart-Ford SF3

'To stand on the podium as the winning constructor with the Stewart-Ford SF3 at the Nürburgring – the same place where I had stood twenty-six years before after my last F1 Grand Prix victory – was a big moment; an emotional occasion.'

Sir Jackie Stewart

Having become a legend behind the wheel, Jackie Stewart took the more diverse but equally difficult option of running his own Grand Prix team. The three-time World Champion established Stewart Grand Prix with his youngest son, Paul, during the summer of 1996. With backing from Ford, and the accompanying use of the latest Ford engine, the first Stewart Formula 1 car made its initial tentative run on Ford's test track at Boreham in Essex on 19 December 1996. Stewart had enough experience to know that the first season would be difficult. And so it proved, the team hobbled by a seemingly relentless sequence of failures on the car and its V8 engine, a second place at Monaco being an emotional outlier. The 1998 season would show little improvement, but a change of technical direction and a much improved engine for 1999 would bring victory in the European Grand Prix and fourth in the Constructors' Championship. The team was then sold to Ford and rebadged as Jaguar. Compared to what would happen next during Jaguar's subsequent disastrously overblown campaign, the success of Stewart Grand Prix in 1999 was both salient and sensible.

THE CAR

As with any new project, particularly the design of a Formula 1 car from scratch, the learning curve at Stewart Grand Prix had been steep and taxing. A new technical director was appointed in November 1998 and would scrap much of what had already been laid down for 1999. The new version of SF3 was fast enough to lead the second race in Brazil, but fragile enough to retire with engine failure. One aspect of the car's original architecture that could not be changed was the fuel tank size, which would prove to be too small for effective race strategies. A more conventional six-speed, semi-automatic transmission replaced a pioneering carbon-fibre gearbox that had been troublesome from the outset with SF1 and SF2. Following the purchase of Cosworth Racing by Ford during 1999, an accompanying increase in commitment would allow successful development of the smallest V10 produced thus far by the British company. The introduction of a hydraulic differential halfway through the season would also sharpen performance and, as it turned out, suit the driving style of one driver better than the other.

Engine	Ford CR1 V10
Size	2998 cc
Power	790 bhp
Weight	600 kg (1323 lb)
Wheelbase	2451 mm (96.5 in)

TEAM HISTORY

Jackie Stewart had no intention of running a racing team after he retired from driving at the end of 1973. He was busy with commitments as global ambassador for blue chip companies such as Ford, Rolex and Goodyear, in addition to media roles with ABC Sports in the USA. The emphasis shifted slightly in 1988 when Paul Stewart, having abandoned thoughts of emulating his father as a driver, focused on championship-winning campaigns in junior formulae with Paul Stewart Racing (PSR). Formula 1 was not on this ambitious team's horizon until a chance conversation several years later between Jackie Stewart and Ford's motor sport management team.

Returning to Michigan on their private jet from the 1995 Canadian Grand Prix, the executives were concerned about the company's image and investment with the struggling Sauber team. Speaking bluntly, Stewart said Ford should either get out or start from scratch. Given the company's commitments on several fronts, quitting was not an option. Stewart was asked if he would be interested in putting together a proposal on the best way forward. Six months later, the Ford Motor Company agreed to back a new team to be known as Stewart Grand Prix (SGP). Jackie, meanwhile, had used his contacts to win support from the Malaysian tourist board and other high-profile organisations not previously involved in motor racing. PSR provided the nucleus of a team that would quickly grow to 180 people at a base in Milton Keynes. Having struggled to put points on the board in their first two seasons, it would be a different story in 1998, when the team won its only Grand Prix and was taken over by the Ford Motor Company in a deal worth £70 million.

THE DESIGNER

Gary Anderson (formerly leading the design teams at Jordan and Arrows) joined Stewart Grand Prix in November 1998 to work alongside Alan Jenkins, designer of the SF1 and SF2. Having been responsible for the concept of the Stewart-Ford SF3, Jenkins left the company not long after. The Ford CR1 engine was the responsibility of Nick Hayes and Jim Brett at Cosworth Racing.

FAMOUS DRIVERS

Rubens Barrichello and Jan Magnussen raced the Stewart-Ford SF1 in 1997, with Magnussen being replaced by Jos Verstappen during the following season. The option on Verstappen's contract for 1999 was allowed to lapse, the Dutchman making way for Johnny Herbert, winner of two Grands Prix with Benetton-Renault in 1995. Barrichello had much less experience, the Brazilian having made his F1 debut with Jordan in 1993, four years after Herbert had begun a varied Grand Prix career with Lotus, Benetton, Sauber and, briefly, Tyrrell and Ligier. It was Herbert who would benefit most from the introduction of a new differential on the SF3.

Johnny Herbert hustles his Stewart SF3 through a chicane at Monza during the team's third season in 1999. With support from the Ford Motor Company, Jackie Stewart became a Grand Prix winner as an entrant after establishing a Formula 1 team with his youngest son, Paul.

210

MEMORABLE RACE

Previews of the 1999 European Grand Prix majored on championship contenders McLaren and Ferrari. The battle had been intensified when Michael Schumacher, a title favourite, crashed and broke a leg during the British Grand Prix, leaving his Ferrari team-mate, Eddie Irvine, to take the fight to McLaren's Mika Häkkinen. The pair were level on points at the head of the table as the teams arrived for this next round at the Nürburgring. Stewart-Ford drivers Rubens Barrichello and Johnny Herbert, 7th and 13th in the championship respectively, figured in few, if any, predictions for a podium finish, never mind a win. On the day, Barrichello finished third, and Herbert would finish a remarkable first, Stewart Grand Prix's only win. How had this happened?

In a dry-wet-dry race, Herbert used his vast experience to work with the team and make the perfect strategy calls, choosing the right tyres at the right time. He didn't reach the top three until the race had passed half distance. By which time, the favourites had seemed intent on throwing this race away with errors, some of which bordered on comedy.

The first 32 laps had been led by Heinz-Harald Frentzen until the German's chance of a win at home was lost by the simplest of mistakes (see 'Jordan-Mugen Honda 199', page 204). David Coulthard's turn at the front would last for five laps before the Scotsman slid off the wet track and into the tyre barrier. That summed up a disastrous day for McLaren when a decision to stop too early for wet tyres had relegated Häkkinen to an also-ran.

Rather than make the most of McLaren's woes, Ferrari then ruined Irvine's chances when a pit stop turned into a scene from a circus. Having waited for as long as possible to change from dry to wet tyres, a stop for Irvine would be tactically perfect for him, but disastrous for a team that had just finished dealing with the other Ferrari driven by Mika Salo (Michael Schumacher's replacement). In the hectic moments following Salo's departure, a well-meaning mechanic had taken one of the tyres made ready for Irvine and added it to those recently removed from Salo's car. When Irvine arrived seconds later, nobody knew where the tyre had gone. For 25 seconds, Irvine was stationary with three wheels on his car. Game over. But not for Stewart Grand Prix, as Jackie Stewart proudly shared the podium with his two drivers after a thoroughly well-worked result.

The Stewart-Ford team celebrate their only F1 victory as Johnny Herbert wins the 1999 European Grand Prix at the Nürburgring.

Ferrari F2004

'In 2003, Ferrari hadn't progressed as much as perhaps we felt we should have done. We sorted ourselves out and 2004 reflected that. The F2004 was as good as it looked; no hidden shortcomings. It was a very good car.'

Ross Brawn OBE

As soon as Ferrari began testing the F2004 in early 2004, they knew a fifth consecutive title was likely.

This chapter could have been about any one of five Ferraris produced from 2000 to 2004, such was the Italian team's stranglehold on the championship throughout that period. The F2004 has been chosen because it won 15 of the 18 races in 2004; an impressive return, even by Ferrari's powerful standards during the early years of the millennium. Ferrari completed more laps (2,196) than any other team in 2004 which, with 18 races, had thus far been the longest season in F1 history. Michael Schumacher won 12 of the opening 13 rounds while on his way to a seventh World Championship. The 2004 season, with eight 1–2 finishes for Ferrari, would be the peak of a gradual ascendancy stretching across several years by a dream team headed by Jean Todt, directed by Ross Brawn, engineered by Rory Byrne and represented so successfully on the race track by Schumacher and Rubens Barrichello.

THE CAR

Because of consistent success across four seasons, the technical team at Ferrari was in the happy position of being able to evolve previous winning designs rather than being forced to make wholesale changes and start from scratch. Nonetheless, rivals' pursuit of this perpetual raising of the bar meant the F2004 had to remain one step ahead, as Scuderia Ferrari had been reminded by a close contest with Williams-BMW and McLaren-Mercedes in 2003. Ferrari may have used the successful aerodynamic package from the 2003 car but detail changes such as a lower nose profile, reduction in wheelbase, a smaller fuel tank and a lighter and more rigid gearbox confirmed there would be no resting on laurels at Maranello. Meanwhile, the engine department continued to develop the V10 while bearing in mind a new requirement to have each engine last for the entire race weekend. Any breach of the cost-saving initiative would bring a ten-place grid penalty.

Engine	Ferrari 053 V10
Size	2997 cc
Power	865 bhp
Weight	600 kg (1192 lb) including driver
Wheelbase	3050 mm (120 in)

TEAM HISTORY

Ferrari had experienced a downturn in the early 1990s when the departure of Nigel Mansell, Alain Prost and John Barnard (Technical Director) coincided with the Ferrari V12 engine losing out to smaller, lighter and more fuel efficient V10s. Things got so bad that the charismatic Luca di Montezemolo was tasked with returning to the F1 team and producing results similar to those he had achieved at Ferrari with Niki Lauda 20 years before. A smart move was the appointment of Jean Todt as Team Principal. The Frenchman had previously masterminded Peugeot's World

Championships in rallying and sportscar racing. With the help of adequate backing from Marlboro, Todt's first step was to sign Michael Schumacher. The double World Champion's move from Benetton helped persuade Ross Brawn to do the same and accept the role of Technical Director. After the expected settling-in period, the revised team gathered momentum as a cohesive unit that was strong in every department, Todt being shrewd enough to take care of the inevitable Italian politics and allow his team to focus solely on winning races. Ferrari challenged McLaren in 1998 and won the Constructors' Championship the following year. The illusive drivers' title finally came Ferrari's way in 2000 to herald an unprecedented five-year run of crushing control.

THE DESIGNER

Having decided to leave Benetton, quit motor sport and live in Thailand, Rory Byrne was eventually unable to resist Ross Brawn's blandishments. Byrne became Chief Designer in 1996 and gradually established a chain of command. In 2004, there were signs of Byrne wishing to reduce his role when Aldo Costa became Chief Designer, but remained under the watchful eye of Byrne, who assumed the title of Vehicle Designer. For 2004, John Iley (formerly with Jordan and Renault) took charge of aerodynamics. The engine department was headed by Paulo Martinelli.

FAMOUS DRIVERS

Despite his championship years with Benetton in 1994 and 1995, Michael Schumacher will be forever associated with Ferrari due to his five consecutive world titles from 2000 to 2004. Initially partnered by Eddie Irvine, the Irishman's place was taken by Rubens Barrichello in 2000, with the Brazilian remaining with Ferrari for six years, winning nine Grands Prix, two of them with the Ferrari F2004 in 2004.

Michael Schumacher won five consecutive World Championships with Ferrari, the F2004 playing a significant part in 2004. Here, he celebrates victory in Bahrain.

MEMORABLE RACE

The pressure was on. The Italian Grand Prix may have been in the final quarter of a season dominated by Ferrari, but this was Monza. Victory was not just expected, it was demanded, as if by rite. Michael Schumacher had clinched his seventh World Championship in Belgium two weeks before. But the fact that Ferrari hadn't actually won that race at Spa-Francorchamps intensified the pressure to do it at home.

Rubens Barrichello claimed pole at Monza, with Schumacher qualifying third to line up behind his team-mate. But within five laps, the normally vociferous crowd was noticeably subdued. Schumacher had spun back to 15th place and Barrichello was in the pits after starting on what would turn out to be the wrong tyres.

A downpour on race morning had thrown a curve ball. Despite the track being damp in places, dry weather tyres would have been the informed choice at anywhere other than Monza. The high-speed nature of this circuit called for low downforce that resulted in a very fast but potentially skittish car. With the approach to the first chicane remaining wet, Barrichello had no wish to be braking from 322 kph (200 mph) to 120 kph (75 mph) in 130 metres (426 feet) with the rear of his car dancing all over the road. Barrichello was alone among the frontrunners in choosing the safe option of an intermediate tyre, which was the correct choice – for about three laps.

Monza was normally slow to dry because of overhanging trees. But the appearance of the Sun not long before the start made slicks (which were grooved in 2004) worth the gamble. Barrichello quickly built up an eight-second lead, an advantage that would disappear in a single lap as the racing line dried and the grooved slick tyres came into their own. As the Brazilian headed towards the pits, it was little consolation to note that his initial fear about being unable to control the car on slicks on the opening lap had been confirmed when Schumacher spun to the back of the field. With Barrichello re-joining in ninth place, two ahead of the recovering Schumacher, Ferrari had it all to do.

What happened next made everyone realise just what Ferrari were capable of when the chips were down. It was as if the F2004 was running on 'fast forward'. The performance was so superior that Ferrari's adventurous thinking allowed an extension from two stops to three, a strategy normally avoided at a circuit on which the lap speed was so high that time spent standing still in the pits would be massively expensive. With the championship settled, Ferrari had nothing to lose. Barrichello's pace when he got back to the front was so powerful that he was able to establish a margin large enough to allow the third and final stop for fresh Bridgestone tyres without losing his lead. Schumacher eventually hauled himself onto his team-mate's tail but held station on a day that belonged to Barrichello. Whatever way you looked at it, Ferrari had scored their eighth 1–2, and all was well with the world at Monza.

Rubens Barrichello leads a consummate performance by Ferrari as the reigning champions finish 1–2 with the F2004 at Monza in September 2004.

Renault R25

'We were making huge steps with this car and surprising everyone. After the 2004 car, which was good but difficult to drive, the R25 seemed even better. It was very important to have a car that did exactly what you asked.'

Fernando Alonso

The Renault team was effectively Benetton, ten years on from the double championships won with Michael Schumacher. Although the workforce more or less remained the same, the team from Oxfordshire had been through various changes, particularly within management, driver line-ups and overall control. The most obvious transformation was in the name – Renault having taken over from the fashion brand in 2000. After several years of mediocre mid-field performances for what would affectionately become known as 'Team Enstone', the appearance of the Renault R25, coupled with the rise of Fernando Alonso as a world-class driver, broke Ferrari's stranglehold and finally brought Renault a World Championship almost 30 years on since the motor company's first tentative venture into Formula 1.

THE CAR

Technical departments within the ten F1 teams were stretched to the maximum in the latter part of 2004 thanks to the sport's governing body announcing a series of late and significant changes to the 2005 cars, in the continuing quest to reduce performance. The front wing would be raised and the design of the rear wing and diffuser restricted in a bid to cut downforce. Each engine needed to last for two race weekends instead of one. But the most far-reaching change concerned tyres – the set run by a driver in final qualifying had to be used for the entire race. That meant up to four times longer wear and tear than previously (depending on

After years of reorganisation, Renault (formerly Benetton) finally came good, coupled with the rise of Fernando Alonso as a world-class driver. The Spaniard won seven races with the Renault R25 in 2005 to become the youngest World Champion at the time.

the number of pit stops in a race during 2004). Pit stops for refuelling would continue in 2005, but the rule revision required a massive reset not only for Bridgestone and Michelin, but also for the teams when designing a car that would be as kind as possible to its tyres.

Renault (along with McLaren-Mercedes) did the best job. Renault's priority was to integrate every detail of the R25 around a completely new V10 engine in terms of weight, stiffness and packaging. Part of the car's success would be attributed to the design of the keel (the structure beneath the raised nose to support the front wing while, at the same time, providing a location for the inner ends of the lower suspension arms). Rather than follow the popular route of a twin keel, Renault chose a so-called vee-keel which had greater rigidity. It would help transform the R25 into an eminently driveable car, unlike its predecessor, the R24.

Engine	Renault RS25 V10
Size	2998 cc
Power	900 bhp
Weight	605 kg (1334 lb) including driver
Wheelbase	3100 mm (122 in)

TEAM HISTORY

The departure of Michael Schumacher at the end of 1995 marked a sudden decline as Benetton failed to win a Grand Prix for the first time since 1988 and slipped from first to third in the Constructors' Championship. The following season was not much better, although Gerhard Berger did win the German Grand Prix; an outlier result in a year when the team continued to feel the effect of Ross Brawn and Rory Byrne leaving to join Schumacher at Ferrari. Benetton's struggle was exacerbated in 1998 when Renault officially withdrew and handed its engine programme to Mecachrome, an engineering company based in Toulouse. Thanks to a minimal budget, the French V10 fell behind in competitiveness, as reflected by the team finishing fifth in the Constructors' Championship, the slide continuing into 1999 with a miserable 16 points, 112 fewer than Ferrari at the top of the table.

The seeds of a revival were sown in 2000 when Renault began a return to Formula 1. The motor manufacturer purchased the operation at Enstone for US$120 million and commissioned a new V10 engine on the understanding that the team would continue to be known as Benetton for two more years. An initial improvement to fourth in the 2000 Championship was followed by a regression to seventh the following year. Appropriately enough, the rebranding as Renault in 2002 marked an impressive rise to fourth, progress which continued in 2003 when Fernando Alonso laid down a marker for both himself and the resurgent team by winning the Hungarian Grand Prix. Victory for Jarno Trulli at Monaco in 2004 contributed to a close contest with BAR-Honda for the runners-up place, Renault losing out by 14 points. Ferrari had scored more points than these two combined. That was about to change as Renault and Alonso accelerated to the top of their respective championships and Ferrari slumped.

THE DESIGNER

While the heads of various technical departments may have come and gone over the preceding years, Pat Symonds remained Executive Director of Engineering and as a pillar of experience and calm. Bob Bell was similarly skilled as Technical Director, with design responsibility for the R25 being handled by Tim Densham. James Allison was Deputy Technical Director. The team at Enstone worked closely and effectively with Rob White, Cosworth's former Chief Engineer having become Technical Director at Renault Sport in France. The seasoned Bernard Dudot had returned in 2003 to take overall charge of the engine department at Viry-Châtillon.

FAMOUS DRIVERS

Fernando Alonso's arrival as a Formula 1 driver was measured. Having started driving karts when he was so small that blocks were required on the pedals, Alonso went on to win championships in karting and junior formulae. Despite making his Formula 1 debut with the small Italian team, Minardi, in 2001, the Spaniard chose to gain further experience as a test driver with Renault in 2002, rather than continue racing at the back of the field. It paid off in 2003 when Alonso was promoted to the race team and, aged 24 years and 58 days, became the youngest Grand Prix winner at the time. Two years later, he became the youngest World Champion after winning seven races with the Renault R25.

Alonso's team-mate, Giancarlo Fisichella, had also made his F1 debut with Minardi, the Italian going on to drive for Jordan and Sauber. Having raced with Benetton from 1998 to 2001, Fisichella returned to what had become Renault in 2005 and won the first race of the season in Australia. It would prove to be a false dawn as Fisichella slipped to fifth in the Championship, with Alonso scoring twice as many points.

MEMORABLE RACE

The San Marino Grand Prix was arguably Fernando Alonso's finest of seven victories in 2005. Having already won two of the first three races, the chances of Alonso making it a third at Imola were compromised by a new rule for 2005 requiring a driver to use the same engine for two races. Renault were in a quandary. Giancarlo Fisichella had suffered a major engine failure at the previous race in Bahrain. Alonso had won, but subsequent examination of his V10 had shown it to be going the same way. It had another race to run.

Renault's desire and confidence was such that they chose not to take the safe option of changing the engine and incur a ten-place grid penalty. The decision appeared to be paying off as Alonso took the lead when the pole position McLaren-Mercedes of Kimi Räikkönen retired with transmission failure. But trouble was looming. Having started from 13th on the grid following problems during qualifying, Michael Schumacher was on a charge. With 20 laps remaining, he was up to second place and closing rapidly on Alonso, now struggling with an engine on its last legs. Forced to reduce his pace by two seconds a lap, Alonso produced a thrilling defensive display and saved his engine by going slowly into the chicanes and then using the Renault's excellent traction to accelerate out and leave Schumacher little opportunity to attack when braking for the next corner. It was a cheeky and mature performance while under immense pressure.

Struggling with a down-on-power engine in his Renault R25, Fernando Alonso managed to hold off the Ferrari F2005 of Michael Schumacher to win the 2005 San Marino Grand Prix at Imola.

McLaren-Mercedes MP4-23

'2008 was a hardcore year. But I've great memories of that McLaren-Mercedes. Particularly crossing the line in Brazil, not knowing if I'd won the championship. When they told me I had, I just couldn't believe it. Absolutely incredible!'

Sir Lewis Hamilton

Nothing had been clear-cut – right up to the final corner of the last lap of the final race. Lewis Hamilton clinched the 2008 World Championship in the dying seconds of the season, but McLaren failed to win the Constructors' Championship with the McLaren-Mercedes MP4-23. Yet this car was a logical development of the MP4-22, which had been the class of 2007, only for the team's points to be stripped away because of the so-called 'Spygate' scandal that had made 2007 one of the most divisive and edgy seasons in the history of Formula 1. By giving McLaren their first World Championship in nine years, MP4-23 had helped a healing process that embraced more than winning races. It had allowed McLaren-Mercedes to return to business as usual.

THE CAR

Despite the departure of Technical Director Adrian Newey to Red Bull at the end of 2005, the MP4-23 continued the theme of fine attention to detail and shrink-wrapping the rear bodywork around the Mercedes-Benz V8 and its associated parts. For the MP4-22 in 2007, no fewer than 11,000 individual components had been reviewed and, where necessary, revised. Work on MP4-23 had begun in a similar vein in March 2007 with the first wind tunnel tests taking place two months later. Although comparable in appearance to its predecessor, MP4-23 had a slightly longer wheelbase. The on-going search for perfection had produced development across the aerodynamic spectrum, particularly with the multi-planed front wing, which had grown increasingly complex over the preceding seasons. A regulatory revision to the roll-hoop led to an ingenious solution that met with the required dimensions while allowing a through-flow of air to the engine and rear wing. Design of the transmission had to take into consideration the need for each seven-speed gearbox to last for four races. The V8 conformed to the latest 19,000 rpm limit while being designed and constructed, as before, by Mercedes-Benz High Performance Engines (formerly Ilmor Engineering) at Brixworth in Northamptonshire.

Engine	Mercedes-Benz FO 108V V8
Size	2398 cc
Power	750 bhp
Weight	605 kg (1334 lb) including driver
Wheelbase:	3188 mm (125.5 in)

TEAM HISTORY

McLaren had been through a difficult period following Mika Häkkinen's World Championships in 1998 and 1999. The new millennium opened convincingly enough during another close contest, which was won by Michael Schumacher and marked the beginning of five years of domination by Ferrari. McLaren, meanwhile, began a slow slide down the table, bottoming out with fifth place in 2004, their worst ranking since 1983. Having moved into the McLaren Technology Centre (a purpose-built complex designed by Sir Norman Foster, the superstar architect of the time, and opened by Her Majesty Queen Elizabeth II in May 2004), McLaren enjoyed a return to competitiveness, winning ten races in 2005 and finishing runner-up to Renault. That was followed by a winless 2006 and what should have been a triumphant year in 2007. Losing the Drivers' Championship by a single point was one thing; having a winning total in the Constructors' Championship forcibly and publicly removed, quite another. McLaren paid this penalty, plus a US$100 million fine, for their part in the so-called 'Spygate' scandal involving the furtive receipt of classified technical information belonging to Ferrari. The 2008 season would be a tough test of McLaren's resilience and the fortitude of their embattled leader, Ron Dennis.

THE DESIGNER

Adrian Newey's role as Technical Director had begun to look uncertain in 2001 when he was on the point of joining the fledgling Jaguar team, until persuaded to stay on by Ron Dennis. Rumours about Newey's future began to circulate once more in 2005, prior to his departure to Red Bull at the end of the year. Mike Coughlan, having been with the design team since 2002, was appointed Technical Director, a post he would hold until having to stand down in the wake of the Spygate scandal. Technical responsibility was then shouldered by Paddy Lowe (Director of Engineering), Neil Oatley (Director of Design and Development), Tim Goss (Chief Engineer) and Simon Lacy (Head of Aerodynamics).

As Director of Engineering at Mercedes-Benz High Performance Engines, Andy Cowell was responsible for the 2.4-litre V8.

FAMOUS DRIVERS

Having come within one point of winning the championship at the end of his debut season in 2007, Lewis Hamilton was hungry to capitalise on that experience. Heikki Kovalainen, having stepped up from test driver to racing with Renault in 2007, replaced Fernando Alonso at McLaren. Victory in the Hungarian Grand Prix would be his best result in a F1 career spanning 111 starts. Hamilton, meanwhile, was to win the first of seven World Championships.

The MP4/23 helped mark a return to normality for McLaren-Mercedes in 2008 after a bruising season in 2007. Lewis Hamilton (seen during qualifying at Silverstone) helped his championship cause with a brilliant win in a wet British Grand Prix.

MEMORABLE RACE

Lewis Hamilton arrived in Brazil for the final race with a seven-point lead over Felipe Massa. When the Ferrari driver took pole for his home event, it was clear he was not going to give up without a fight. Apart from two periods spent dealing with routine pit stops, Massa led all the way. He could do no more. But where was Hamilton? He needed to finish fifth, a position he had held until rain turned the race and the championship on its head with five laps to go.

After a stop for wet weather tyres, Hamilton struggled for grip and dropped to sixth place as the Toro Rosso of Sebastian Vettel swept past. For a moment it seemed Massa would snatch the championship in the same way his team-mate, Kimi Räikkönen, had denied Hamilton and McLaren in 2007 at the same race. Everything hung on this final lap. Ahead of Vettel and Hamilton, Timo Glock was holding fourth place, the Toyota driver having taken a gamble by avoiding a pit stop and remaining on grooved slicks. It looked like it might pay off.

As Hamilton started the last lap, he had no idea where he was. Before the race, the team had told him to do exactly what they said when it came to tactics and not to question it. Halfway around the final lap, Hamilton received an urgent radio message: 'You've got to pass Glock! You've got to pass Glock!'

'I'd been focused on trying to get Vettel,' said Hamilton. 'I was sixth and I knew I had to get back to fifth, otherwise the championship was gone. Then they said I had to pass Glock. Where was he? I had no idea. I couldn't be sure about anything.'

At the start of the long climb to the finishing line on the last lap, an increase in the drizzle made the surface too slippery for the Toyota. Vettel and Hamilton had eaten into Glock's fourth place advantage before overtaking the hapless German at the final corner. Meanwhile, at the top of the hill, Massa had crossed the line to win at home and, apparently, crown a perfect afternoon by snatching the championship. But, along with the vast majority of those present, Massa's spectating and momentarily delirious family were not aware of the significance of Glock's sudden struggle that would cause the title fight to swing dramatically and finally in Hamilton's favour.

Had the increase in rain come about 15 seconds later, Glock would have made it up the hill and Massa would have been World Champion. But it wasn't to be. Lewis Hamilton had won the title in his McLaren-Mercedes MP4-23. After 5,764 km (3,582 miles) of racing, spread across more than 1,000 laps during 18 races in 17 countries, the title had been decided in the last kilometre.

A muted reception for Lewis Hamilton at Interlagos as he finishes the Brazilian Grand Prix, unaware that fifth place has been good enough to win the 2008 World Championship.

Brawn-Mercedes BGP001

'It's such an unlikely story – winning the Drivers' and the Constructors' Championships in your first season. It's hard to imagine circumstances coming together like this ever again.'

Ross Brawn OBE

Reaching Melbourne and the first race of the 2009 season would be a massive achievement in itself. Brawn Grand Prix – formerly known as Honda Racing F1 – had been on the point of closure just three months before. Any thought of winning the Australian Grand Prix was dismissed as pure fantasy. And yet that is precisely what the marginally financed and partly traumatised little team did. A pair of virgin-white cars had arrived with the paint barely dry, and Jenson Button and Rubens Barrichello not only occupied the front row of the grid, they also went on to finish first and second. It beggared belief.

Proving that this was neither a fluke nor a flash in the pan, Button went on to win five of the next six races with such ease that the championship seemed a formality. This being Formula 1, however, initial sentimental support for the underdogs had swiftly shifted to blunt accusations of cheating through the use of a trick piece of rear bodywork on the Brawn-Mercedes. The rejection of subsequent protests proved the revamped team had successfully exploited a grey area in the regulations. This confirmation of legality also triggered imitations that allowed the competition to rapidly close down the performance advantage of a team without the budget to further develop their clever idea and stay ahead.

At the same time, Button's position at the top of the championship was under attack from within in his own team, as Barrichello gathered momentum and won two races. Just when the title looked like it was slipping from this grasp, Button produced a champion's performance in every sense at the penultimate race in Brazil. In the space of twelve months, the small operation from Brackley in Northamptonshire had gone from one end of the championship to the other. It was one of the most remarkable chapters in the colourful story of the Formula 1.

The Brawn BGP001, pictured in the hands of Jenson Button on its first appearance during testing at Barcelona, was on the pace straight away. Rivals wrongly assumed the Brawn was running below the legal weight limit in order to set fast times and attract sponsorship for the snow-white car.

THE CAR

When Ross Brawn arrived at the Honda F1 team at the end of 2007, the former Ferrari Technical Director chose to concentrate on a significant rule change for 2009 rather than waste energy and effort on the unexceptional car he had inherited for 2008. Brawn's best-laid plans were torpedoed 12 months later by Honda's sudden and devastating decision to quit F1 with immediate effect.

One of the most pressing problems was finding a replacement for the Honda engine. Despite having to deal with the complexity of KERS (Kinetic Energy Recovery System) being introduced on F1 engines, Mercedes agreed to supply the latest version of their V8. Apart from not wishing to see Brawn go under, the decision was helped by the production capacity at Mercedes High Performance Engines being eased slightly by a limit of eight engines per driver for the entire season. The deal with Mercedes was only concluded one month before the first race. Meanwhile, the diminished workforce had to work quickly by adapting a chassis originally designed for the Honda V8.

Technical changes for 2009 had the intention of reducing downforce. A Honda engineer scrutinised the revised regulations and found loose wording in the paragraphs defining the size and location of the rear diffuser. By creating another diffuser beneath the existing one, Brawn had effectively doubled the extraction of air and downforce in a crucial area. Toyota and Williams had also spotted the loophole, but neither of them had designed the most efficient angles for the diffuser, nor found the necessary balance in their cars, front to rear. From the moment Button first drove the new car, he sensed the exceptional grip and balance. The Brawn-Mercedes BGP001 was in a different league.

Engine	Mercedes-Benz FO108W V8
Size	2398 cc
Power	750 bhp
Weight	605 kg (1334 lb) including driver
Wheelbase	3160 mm (124.4 in)

TEAM HISTORY

While Ross Brawn was establishing himself as an outstanding guiding light with Ferrari, the nucleus of the team he would eventually own was gradually evolving.

It began when newcomers, British American Racing (BAR), bought the ailing Tyrrell team and filed an entry for the 1999 F1 season. Meanwhile Honda, rather than returning to F1 with their own team, entered into a partnership with BAR and endured a couple of mediocre seasons. There was progress of sorts in 2003, but there would be a significant step forward the following year as BAR-Honda finished second to Ferrari in the championship. The expectation behind Honda's acquisition of 45 per cent of the team in January 2005 was not matched by results, with BAR-Honda sliding back to sixth. Honda bought the remaining shares in 2006, the Honda Racing F1 Team giving Jenson Button his maiden F1 win in the Hungarian Grand Prix – only for the inconsistency to continue as an uncompetitive car brought a mere six championship points at the end of the following season.

Brawn was appointed as Team Principal in November 2007 and immediately set his sights on dealing with fundamental rule changes due to come into force in 2009. Plans were proceeding at pace when, on 28 November 2008, Honda dropped their bombshell. Overnight, the priorities of Brawn and his CEO, Nick Fry, changed from finding performance to avoiding closure. There were several prospective buyers. In the end, Brawn and Fry reached an agreement to purchase the team for £1 in return for a £92.5 million budget from Honda equal to the amount the motor company would save in redundancies. Even so, 300 team members would lose their jobs. The buyout was completed on 5 March 2009. The Australian Grand Prix was three weeks away.

THE DESIGNER

John Owen was Design Project Leader. As Head of Aerodynamics, Loïc Bigois managed different concept teams, including a small group headed by Ben Woods which acted on the all-important diffuser design initiative of Honda's Saneyuki Minegawa.

FAMOUS DRIVERS

With Honda's sudden withdrawal coming so late, Jenson Button had no option but to wait and hope. It worked both ways. Ross Brawn was also facing Hobson's Choice when it came to choosing drivers. Button took a pay cut to help the dire financial situation. The uncertainty was such that Rubens Barrichello was initially signed for only the first four races before securing the full season.

MEMORABLE RACE

No one knew what to make of it; a pair of white cars, almost devoid of sponsorship, sitting on the front row in Melbourne. Could the speed seen during qualifying be maintained for 58 laps? Would a car with very little testing prove reliable?

Jenson Button made a clean start from pole. The first worry for Brawn came immediately as the anti-stall device on Rubens Barrichello's car kicked in unexpectedly and led to a slow getaway by the Brazilian. More trouble arrived at the first corner, where Barrichello was hit from behind, the impact sending the Brawn into the side of Mark Webber's Red Bull. Barrichello's luck began to turn when he was able to avoid a pit stop and continue in seventh place with minimal damage to the front wing.

After just three laps, Button led Sebastian Vettel by 4.5 seconds but the gap would remain constant as the Red Bull driver broke free from an early challenge from behind. As the race began to settle down, Button and Vettel were out on their own. Having started on the harder Bridgestone tyres, Button was able to continue without stopping early, a tactic that stood the team in good stead when a Williams crashed on lap 18. Thinking on their feet, Brawn brought Button into the pits immediately and had him under away without losing the lead before the safety car appeared. When racing resumed, he had to deal with a fresh attack from Vettel but, once again, the white car managed to pull away from the dark blue one.

With little or no time to practice, the Brawn team was venturing into another unknown when the scheduled pit stops began. They had taken the opportunity to replace the nose on Barichello's car, with the Brazilian moving up to seventh. When the second round of pit stops began on lap 44, Button came close to losing his five second lead as he overshot his pit, but he rejoined just in front of Vettel.

Fortunately for Brawn, the Red Bull driver had his hands full as he came under attack from the BMW of Robert Kubica. When these two collided and crashed, a surprised and very happy Barrichello came through to inherit second place, a position he held to the finish. It was the first time that a new team had finished first and second on their debut, since Mercedes-Benz did it at the 1954 French Grand Prix. In truth, that result at Reims was half-expected. By no means could the same be said about events at Melbourne in 2009.

Celebrating after a remarkable debut in Australia in March 2009, Ross Brawn (left) joins Jenson Button and Rubens Barrichello, the drivers split by Nick Fry, Brawn's CEO holding the trophy for the winning constructor.

Red Bull-Renault RB9

'Once we got into the swing of the dominance [in 2013], we cruised to four consecutive double championships which, no matter how many times you say it, is still difficult to believe: we won the double four times in a row!'

Adrian Newey OBE

This car represented both the culmination of a powerful four years and the end of the opening phase of Red Bull Racing's emergence as a colossal Formula 1 force. Five seasons had been spent slowly dragging the former Jaguar Racing team from a rudderless muddle to a well-drilled organisation capable of making the most of Adrian Newey's technical brilliance. Sebastian Vettel had pushed the Brawn drivers in the second half of 2009, the RB5 demonstrating Red Bull's potential. Their first championship in 2010 may have been a close-run thing but it heralded an era in which Vettel and the team would go from strength to strength, concluding with the RB9 wiping the floor in the second half of 2013.

Vettel won 13 of the 19 Grands Prix. Along the way, the German driver matched the long-standing record established across the 1952/53 seasons when Alberto Ascari won nine races in succession. Mark Webber contributed to Red Bull's dominance in 2013 by claiming two of the team's 11 pole positions. If nothing else, the potential tediousness of Red Bull's success had been enlivened by a long-standing conflict between the two drivers intensifying, frequently in public. Either way, the Red Bull-Renault RB9 created a landmark sign-off to the 2.4-litre V8 era, as the F1 teams prepared for a move to 1.6-litre hybrid engines.

Red Bull's legacy was a substantial one. Since the V8 had replaced the V10 as the required power unit in 2006, the team from Milton Keynes had won 47 of the 147 Grands Prix. A significant factor in this hegemony had been an association with Renault since 2007, the RB9 giving a graphic demonstration of the specialised skills shared between an Austrian-owned team, British racing know-how and French automotive strength.

THE CAR

The basic design parameters of the Red Bull RB9 had been laid down in 2009. RB5 may have been Adrian Newey's answer to a fundamental change in the technical rules, but Red Bull's Technical Director was wrong-footed by the clever introduction of a double diffuser on the Brawn-Mercedes BGP001 (see page 226). Once Red Bull's catch-up was complete, the RB5 became the dominant car, but it was too late to close the gap on Brawn. For Newey and his team, it was the work of a moment to include the double diffuser on the 2010 car and design the gearbox and rear suspension to suit. Going out on a limb the following year, by positioning the comparatively heavy batteries at the rear of RB7 (rather than the popular choice of amidships behind the fuel tank), allowed Red Bull to rule the 2011 championship. The RB8 was less successful by comparison, but a championship-winning car nonetheless and worthy of being the basis for continuing development on RB9 to match the shifting requirements of racing in 2013. Newey's attention remained focused on utilising the exhaust gases for maximum aerodynamic effect while retaining the same successful architecture at the rear. During the early part of the season, however, Red Bull had frequent problems with the standard issue tyres. A change by Pirelli to tougher rubber (thanks to a spate of tyre failures) changed everything as Red Bull won the final nine races.

Engine	Renault R27-2013 V8
Size	2398 cc
Power	750 bhp
Weight	642 kg (1415 lb) including driver
Wheelbase	3100 mm (122 in)

TEAM HISTORY

Having purchased Stewart Grand Prix (see page 209), the Ford Motor Company proved it was better suited to the mass production of motor cars rather than going racing. Five seasons under the Jaguar name brought just two podium finishes. In November 2004, Red Bull ended Ford's misery by buying the Formula 1 team. The energy drinks company, having previously sponsored Sauber and various drivers in F1, agreed to continue racing in 2005 with the latest chassis designed by Jaguar and powered by a Cosworth V10.

The RB9 represented the peak of a dominant four-year phase by Red Bull. Sebastian Vettel (pictured) locking his brakes during the Brazilian Grand Prix, won 13 of the 19 races in 2013.

The turnaround was impressive, with Red Bull Racing (as the team from Milton Keynes was now known) regularly scoring points. A deal was arranged with Ferrari for the supply of V8 engines in 2006, but the most significant move by far was when Team Principal Christian Horner tempted Adrian Newey to leave McLaren and become Technical Director. By finishing third at Monaco, David Coulthard claimed Red Bull's maiden podium. Newey's first car, the RB3, coincided with a switch to Renault engines for 2007 and the start of a gradual climb into consistent contention. Red Bull scored their first pole position and maiden victory on the way to finishing second to Brawn in the 2009 championship.

THE DESIGNER

Having been with Williams and McLaren, two teams that had won championships before his arrival, Adrian Newey was attracted by the challenge of starting from scratch with Red Bull. The potential downside of a new team with no track record was overcome in Newey's mind by the powerful determination to succeed shown by Team Principal Christian Horner, and Dietrich Mateschitz, the visionary co-founder of Red Bull. Apart from being free to exercise his creative genius, Newey encouraged and coordinated a design team providing ideas in their particular fields. Peter Prodromou was Head of Aerodynamics while Rob Marshall acted as Chief Designer. Rob White remained as Technical Director of Renault F1's engine operation at Viry-Châtillon in France.

FAMOUS DRIVERS

Having won championships in karting and various junior formulae, Sebastian Vettel became part of the Red Bull Junior Team, a scheme designed to foster potential F1 talent and run under the critical eye of a former F1 driver, Helmut Marko. Vettel became the youngest F1 winner at the time when he drove his Toro Rosso (Red Bull's junior team) with exceptional maturity in the wet to score an impressive victory in the 2008 Italian Grand Prix. Vettel's promotion to the senior team in 2009 was virtually guaranteed. The German driver was joined by Mark Webber, who had raced previously for Minardi, Jaguar and Williams, his best result having been third at Monaco with Williams-BMW in 2005.

MEMORABLE RACE

The mood within Red Bull was edgy going into the second round of the 2013 championship. Despite having won both drivers' and teams' titles for three years in succession and being ranked as favourites for a fourth, Red Bull had been beaten at the opening race in Australia. A win for Lotus and Kimi Räikkönen had been as unexpected as the wear rate on the latest Pirelli tyres affecting the RB9 more than others. Sebastian Vettel may have won pole for the next race in Malaysia (as he had done in Melbourne) but it was clearly no guarantee of success over 56 laps. It was with some relief that the sequence of corners on the Sepang circuit proved more favourable to Red Bull. But potential trouble arose when Mark Webber, who had started from fifth on the grid, worked his way into the lead as early as lap nine. Having started the race on intermediate tyres in damp conditions, Webber's timing had been perfect when choosing to stop for slicks. Vettel, having come in a lap too soon for a similar tyre swap, found himself following a team-mate who clearly had no intention of giving up the lead.

There was history between these two. In Turkey in 2010, they had collided while disputing the lead. When going for

Tense moment at Sepang. Sebastian Vettel (nearest camera) and Mark Webber run wheel-to-wheel while disputing the lead of the 2013 Malaysian Grand Prix.

the championship in Brazil two years later, Vettel had been infuriated by Webber's uncompromising attitude at the first corner, Vettel being forced to back off and become trapped in an unruly melée that had caused the Red Bull to spin not long after. How would it work out this time in Malaysia?

Vettel felt Webber's deliberately slow pace had backed the World Champion into the clutches of his pursuers to such an extent that Vettel emerged from the final round of pit stops in fourth place. Webber continued to lead, but Vettel soon sliced his way into second place. Fearing a repeat of Turkey 2010, the Red Bull pit issued the instruction 'Multi 21'; a reference to car #2 (Webber) staying ahead of car #1 (Vettel). Vettel ignored the team order. The Red Bull management held their collective breath as Webber squeezed Vettel as much as he dared against the pit wall as the pair blasted past at 290 kph (180 mph). Vettel was through. It was a 1–2 finish. But the recriminations within Red Bull were far from over.

Mercedes W11

'The Mercedes W11 was a piece of art; a masterpiece designed to perfection by a large group of people.'

<p align="right">Sir Lewis Hamilton</p>

When it comes to Mercedes, the choice could have been made from any F1 car from the W05 of 2014 to the W11 raced in 2020, such was the British-based team's dominant grip on the championship during that period.

A new era in F1 prompted Mercedes to throw everything into being a step ahead of the competition when the changes came into force at the beginning of 2014. F1 engineers were starting with a clean sheet of paper thanks to a revolutionary switch from normally aspirated engines to hybrid power plants.

It was a matter of not only designing the new engine but also accommodating complex ancillary equipment within the chassis. As manufacturer of both elements, Mercedes were able to synchronise the two into an effective package. Of the other ten teams, only Ferrari enjoyed such close technical coordination. Mercedes did it best.

THE CAR

The Mercedes W11 was the next phase of a design process begun in 2014 and evolving in tandem with changing technical regulations. On paper, Mercedes stroked to both the Drivers' and Teams' Championships in 2014 with 16 wins for Lewis Hamilton and Nico Rosberg in 19 races. In reality, it was a tough season as Mercedes worked hard to stay on top of potentially disastrous reliability problems. With so many lessons learned in this new formula, it was only natural that the 2015 car, W06, would be a development of the W05. And so it proved with a dominant season crowned by another double championship.

The team's advantage continued into 2016 with yet another evolution of the fundamental design principles, Mercedes W07 winning 19 of the 21 races. It might have been more had Hamilton and Rosberg not collided while disputing the lead on the first lap of the Spanish Grand Prix. This was indicative of a tense in-house battle that ran until the very last race, Rosberg winning the championship in Abu Dhabi, and then choosing to retire.

2017 brought a change in aero regulations, so the wider and longer car looked different to its predecessors. The W08 was fast but so tricky to drive that it became known as 'The Diva'. Gradually, the performance group got their act together and secured a fourth consecutive double championship thanks to 12 wins, 15 poles and 26 podiums for Hamilton and Valtteri Bottas.

The W09 looked similar to its predecessor except for the introduction of the halo, a mandatory safety device to protect the driver's head. Learning from problems with the W08, the 2018 car was more predictable, which it needed to be in the face of stiffer opposition from Ferrari and Red Bull, but nevertheless Hamilton and the team took their respective championships yet again.

In 2019, wider and simplified front wings changed the balance of the W10 and made it difficult to drive. Dogged work helped the team become the first to secure six consecutive double championship wins as Mercedes celebrated their 125th anniversary in motor sport.

Concerned about the encroaching competitiveness of rivals in 2019, Mercedes doubled down on their already intense work rate and produced the W11 to extend a remarkable run of success even further. Bursting with new ideas and a raw pace that Hamilton and Bottas loved to exploit, the W11 was, at times, a full second clear of the competition. Not only that, W11 had a menacing, purposeful look thanks to a black paint scheme introduced to mark the team's commitment to improving diversity.

The Mercedes AMG Petronas F1 team tackled the project as if they had nothing to lose. Double championships once more proved that to be the case. On his way to a seventh world title, Hamilton showed the W11 to be the fastest of all as he established a stunning average speed of 263 kph (163.4 mph) when claiming pole position at Monza.

Engine	Mercedes-AMG F1 M11 EQ Performance V6
Size	1600 cc
Power	950+ bhp
Weight	746 kg (1645 lb) including driver
Wheelbase	3698 mm (145.59 in)

TEAM HISTORY

Having been a leading light in Grand Prix racing during the 1930s, the same principles of excellence applied during a brief return in the mid-1950s. The so-called Silver Arrows eventually dominated almost every race, giving Juan Manuel Fangio a world title in 1955 and Stirling Moss his maiden Grand Prix victory. Mercedes then withdrew completely from motor sport when one of their sports cars flew into the crowd and killed more than 80 people during the 1955 Le Mans 24-Hour race.

A return to F1 in 1994 was comparatively low key as Mercedes supported the Sauber team and funded engines made in England by Ilmor Engineering. Rebadged as Mercedes-Benz, the V10 engines were then supplied to McLaren in 1995, this partnership going on to win World Championships with Mika Häkkinen in 1998 and 1999, and with Lewis Hamilton in 2008. This particular affiliation with McLaren came to an end in 2005.

In 2009, the firm from Stuttgart bought the Brawn team, renamed it Mercedes, and began to prepare for a major shake-up of the rules in 2014. The switch from normally aspirated 2.4-litre V8 engines to 1.6-litre V6 hybrid turbocharged power units was thoroughly researched by what had become Mercedes High Performance Powertrains (formerly Ilmor Engineering and Mercedes High Performance Engines).

The combination of engine and chassis would lead to Mercedes becoming one of the most successful teams in Formula 1 history as Lewis Hamilton won six Drivers' Championships between 2014 and 2020, and Nico Rosberg taking the title with Mercedes in 2016. In the meantime, Mercedes supplied power units to several teams.

Bursting with new ideas and raw pace, the Mercedes W11 with its menacing black paintwork extended an exceptional run even further with double championships in 2020.

THE DESIGNER

The Mercedes W11 was designed by a technical group headed by James Allison. Before becoming Technical Director at Mercedes, Allison had spent several years with Ferrari. The Cambridge graduate joined Mercedes in 2017 and became Chief Technical Officer four years later. John Owen and Mike Elliot were key players in the design and development of the W11. Andy Cowell headed the design team at Mercedes High Performance Powertrains.

FAMOUS DRIVERS

Lewis Hamilton made what appeared to be a questionable move when he switched from McLaren – which had been his mentor since an early age – to Mercedes for 2014. It would turn out to be one of the best decisions of his career. Valtteri Bottas drove the second W11 in 2020. George Russell, Mercedes' reserve driver, raced the W11 in the 2020 Sakhir Grand Prix in Bahrain when Hamilton was side-lined with Covid-19.

Lewis Hamilton enjoyed a remarkable run with Mercedes, the Briton winning 83 Grands Prix between 2013 and 2024.

MEMORABLE RACE

The Covid-19 pandemic of 2020 wreaked havoc with the Grand Prix calendar, forcing F1 to race where it could. Circuits not used for a long time were called into action. Istanbul Park was one such, with the Turkish organisers resurfacing the 5.3-km (3.3-mile) track. The job was completed just 10 days before the teams arrived in mid-November. This, combined with rain, would set the scene for a brilliantly intuitive drive by Lewis Hamilton.

The Mercedes W11, having been on pole for all the previous 13 races, struggled more than most for grip on a smooth, exceptionally slippery surface. Hamilton qualified sixth, a massive five seconds slower than Lance Stroll's pole position Racing Point-Mercedes, which proved very effective when generating tyre temperature. When the same wet conditions applied on race day, Hamilton's hopes of victory appeared slim.

Almost without exception, the 20-car field started on wet tyres, Hamilton hanging on in sixth place. A stop for intermediate tyres on lap eight brought little respite but, as the laps went by, Hamilton's pace gradually increased in accompaniment with tyre temperature. As others either spun or made pit stops, Hamilton found himself in third place just after half distance. Stroll's 22-second lead had shrunk to less than half as Hamilton's shrewd perception and race craft came into play.

As the cars in front stopped for fresh intermediate tyres, Hamilton realised that by staying on the same rubber, the worn, almost slick treads would perfectly suit a track that was gradually drying. As the others re-joined, Hamilton was not only in the lead, but pulling away. He won by more than half a minute – a spectacular way to clinch his seventh championship.

The travel-stained Mercedes W11 of Lewis Hamilton won the 2020 Turkish Grand Prix with its intermediate tyres reduced to slicks and providing perfect grip. The mandatory so-called Halo, introduced in 2018 to provide added protection to the driver's head, can be clearly seen.

Red Bull-RBPT RB19

'Going into the second year of a pretty stable set of regulations, we fully expected everyone to close up. To have the advantage we had in 2023 was totally unexpected. Maximising the shape of the underside on RB19 was the key to the whole thing.'

Adrian Newey OBE

Red Bull rewrote their own record-breaking statistics with the RB19. When Max Verstappen won the 2023 Italian Grand Prix, it was Red Bull's 15th successive win – an all-time high in Formula 1. Red Bull failed to win just one of the 22 races on their way to claiming the Constructors' Championship for the first time in nine years. By finishing first and second in the Drivers' Championship, Red Bull transcended their glory days at the start of the decade. There could have been no better tribute to the technical excellence of the RB19.

THE CAR

The return of ground effect in 2022 represented the biggest rule change to affect Formula 1 since the downforce-producing phenomenon had been banned at the end of 1982. The Red Bull technical team were better prepared for it than most. Adrian Newey's F1 experience stretched back to the introduction of flat-bottomed cars in 1983. He knew enough to appreciate the potential hazard of so-called 'porpoising' – the bouncing sensation created by

the car moving too close to the track surface and suddenly breaking the suction created by ground effect. While rival drivers were pummelled mercilessly, Max Verstappen and Sergio Pérez experienced a comparatively smooth ride with the RB18. Newey had not only mastered the suspension but he had also designed a floor with high-arched tunnels shaped differently to any other car on the grid. The overall effect was to maintain ground effect across a range of ride heights. Seventeen wins in 22 races provided a positive foundation for RB19 and a crushing performance in 2023.

Although similar in appearance to RB18, the latest car had been reengineered to capitalise even more on the advantages of its predecessor. One major development was paring RB19 down to the weight limit, the loss of 12 kg (26 lb) being worth up to 0.3s a lap on most circuits. In general terms, the design team focused on race performances rather than qualifying. That said, Red Bull claimed 14 Grand Prix pole positions to accompany 11 fastest laps. The power unit played its part, Honda having officially withdrawn at the end of 2021, leaving Red Bull to continue work (with Honda's support) on the V6 within Red Bull Powertrains located on the Red Bull campus at Milton Keynes.

Engine	Red Bull Honda RBPT001 V6 turbo
Size	1600 cc
Power	1000+ bhp
Weight	798 kg (1759 lb)
Wheelbase	Not disclosed

TEAM HISTORY

Red Bull made a shaky start to the hybrid era in 2014. Whereas Mercedes arrived fully prepared and blitzed the opposition, Red Bull scratched by with three wins. Strangely for a team with such a dominant record spread across the first four seasons of the decade, culminating in the RB9 (see page 230), Red Bull actually went backwards in 2015 with the RB11 and endured their first winless year since 2008. Lessons learned by both Red Bull and Renault (supplying an engine branded as a TAG-Heuer) may have brought two wins in 2016, but the RB12 remained a long way behind the all-conquering Mercedes W07. A change in aero regulations for 2017 should have played into Adrian Newey's hands but, with his attention being thinly spread across other projects during the first half of the season, the profile of RB13 not only fell short initially, but was also compromised by having to make allowances for the continuing lack of power from the Renault engine.

Finally, four years after the introduction of the turbo hybrid era, Red Bull began to turn the corner in 2018 by winning four races to consolidate third in the championship. The switch to Honda power in 2019 brought a slow start, continuing aero development then leading to an improvement marked by three wins and another third place in the Constructors' Championship. The Covid-19 pandemic meant development of the RB16 carried into 2021 with RB16B although, by the end of the season, this was a markedly different car, albeit a successful one. Red Bull took the drivers' title (marred by controversial circumstances) with Max Verstappen, while giving second best to Mercedes in the Constructors' Championship. It meant Red Bull were poised to raise the bar during successive seasons, starting with RB18 in 2022 and leading to the incomparable RB19. The crowning of Verstappen as World Champion in 2022 came days before the untimely death of Dietrich Mateschitz, the enigmatic and farsighted co-creator of the Red Bull energy drinks company.

Red Bull rewrote their own record-breaking statistics with the RB19 in 2023. Max Verstappen heads for victory at Monaco, one of 21 Grand Prix wins for Red Bull that year.

THE DESIGNER

Adrian Newey may have continued to use his intuitive brilliance to fully appreciate and capitalise on the bigger picture, but the Chief Technical Officer never missed an opportunity to praise the input and support of his specialist team, specifically Pierre Waché (Technical Director), Enrico Balbo (Head of Aerodynamics) and Craig Skinner (Chief Designer).

FAMOUS DRIVERS

Max Verstappen was the perfect product of the Red Bull Junior Team. The Dutchman made his F1 racing debut with Toro Rosso in the 2015 Australian Grand Prix, becoming the youngest full-time F1 driver at the age of 17 years and 166 days. He scored his first points two races later and went on to finish fourth twice. A second season with Red Bull's junior squad was interrupted after four races when Verstappen was called up to the senior team as a replacement for Daniil Kvyat, the Russian driver having fallen from favour. The pressure associated with the expectation of racing with Red Bull appeared to have no effect on Verstappen as he continuing his record-breaking progress by winning the very next race in Spain. Verstappen was similarly unaffected by criticism of his driving tactics as he became an established part of Red Bull and made himself ready for the team's gradual rise in competitiveness. In the space of 20 months with the RB18 and RB19, Verstappen won 34 Grands Prix – more than the vast majority of F1 drivers would claim in their lifetime. Initially partnered by Daniel Ricciardo, Verstappen raced the Red Bull RB19 alongside Sergio 'Checo' Pérez, the Mexican having raced for Sauber, McLaren and Force India/Racing Point before joining Red Bull in 2021. Pérez won two races and two pole positions with the RB19 to finish runner-up to Verstappen in the championship.

Max Verstappen stands on top of his Red Bull RB19 and acknowledges the crowd in Abu Dhabi after his 19th and final win in 2023.

MEMORABLE RACE

After four Grands Prix in 2023, Max Verstappen led Sergio Pérez by a mere six points. Pérez had closed the gap thanks to quality wins in Saudi Arabia and Azerbaijan. There was talk of Verstappen finally coming under pressure from his team-mate, particularly when Pérez claimed pole at Miami and a ragged lap relegated the reigning champion to ninth. Was Verstappen's reign about to be cancelled by the confident Mexican? Verstappen said he didn't think so – winning from the fifth row of the grid wouldn't be a problem. Defensive arrogance or supreme self-confidence? Given the Dutchman's formidable record, it was likely to be the latter.

Pérez made a good getaway to lead the first ten laps – by which time Verstappen had sliced his way to fourth with arrive-and-dive examples of precision overtaking. And this was with the supposedly less competitive hard tyre, rather than the softer medium chosen by the majority on the front four rows of the grid. By the time the race had reached quarter distance, Verstappen was in the top three and closing in on the Aston Martin of Fernando Alonso, who was four seconds behind Pérez.

By lap 15, it was a Red Bull 1–2, Verstappen chasing Pérez. Four laps later, with the hard tyre clearly quicker, Pérez relinquished his lead and ditched his medium tyres (each driver being obliged, if the race was run in dry conditions, to use two different types of tyre). Pérez rejoined in second place. The question was, how long could Verstappen keep going in the lead before his tyre performance dropped off? Another 26 laps, as it turned out. Which meant, with just 12 laps remaining, Verstappen could rejoin on a set of the very fast – if less durable – soft tyre. Pérez may have been back in the lead, but it was only a matter of time before his team-mate delivered a devastating blow to the Mexican's morale. It was a sobering experience. Pérez had been beaten by a driver in an identical car starting from ninth on the grid. Verstappen would win another 16 Grands Prix in 2023. Pérez, none.

Max Verstappen (leading) crushed his Red Bull team mate in Miami after Sergio Pérez had won two of the first four races in 2023.

McLaren-Mercedes MCL38

'There has been a lot of effort in improving every area; not just making the car quicker – which is obviously massively important – but team morale, reliability, pit stops, strategy. Everything you need to win races.'

Lando Norris

Given the team's illustrious history spread throughout the pages of this book, the significance of the MCL38 can be measured in 2024 by McLaren's return to the top of the Constructors' Championship for the first time in 26 years. The restoration of competitive status had been relatively sudden, largely due to a restructuring under the watchful eye of Zak Brown. The former racing driver and marketing guru had inherited a disillusioned and largely dysfunctional team when he became Chief Executive Officer of McLaren Racing in 2018. The process of rebuilding took many forms, largely personality orientated in the management and technical departments. The internal reorganisation had complemented the rise of Lando Norris and the shrewd signing of Oscar Piastri, both young drivers making the most of the McLaren-Mercedes MCL38 to score their maiden Grand Prix victories in 2024 and bring a significant first title to the third evolution of a team founded by Bruce McLaren 61 years before.

THE CAR

The McLaren-Mercedes MCL38 incorporated many lessons learned with its idiosyncratic predecessor, the MCL60 (numbered out of sequence to mark the 60th anniversary of McLaren Racing). A new design team constantly developed the 2024 car during the season, primarily to improve performance in slow-speed corners and lessen tyre degradation, along with the regular aims of increasing aerodynamic efficiency and mechanical grip. Upgrades were typified by a new front wing, floor, sidepod inlets and brake ducts introduced at the Miami Grand Prix in May. Work also continued on the rear wing and lower beam with a view to creating a low pressure area and increase downforce through an accelerated rate of air flow exiting the sidepods. On high speed tracks such as Monza, the rear wing and beam design were circuit specific. During initial design, and throughout the season, the technical team had been assisted greatly by

McLaren's own wind tunnel having come on stream in August 2023. Previously, McLaren had used Toyota's wind tunnel in Cologne. Driven by positive feedback from race fans when first introduced in 2022, McLaren expanded the use of the traditional papaya orange in a livery dominated by exposed black carbon fibre (officially referred to as 'anthracite'). The former champions won six Grands Prix, two sprint races and a total of ten pole positions in 2024. But, in truth, McLaren would have won more (and possibly given Norris the drivers' title) but for strategy misjudgements and driving errors. The MCL38 was potentially that good.

Engine	Mercedes-AMG F1 M15 E Performance V6
Size	1600 cc
Power	1000 bhp
Weight	798 kg (1759 lb)
Wheelbase	Not disclosed

TEAM HISTORY

McLaren Racing had been through torrid times since the silver-sprayed momentum spearheaded by Mika Häkkinen and his World Championships in 1998 and 1999, followed by Lewis Hamilton's maximisation in 2008 of the liaison with Mercedes-Benz. Adrian Newey had moved to Red Bull; Ron Dennis had stepped away (temporarily) from the racing team in 2009, his replacement as CEO, Martin Whitmarsh, then being ousted in a palace coup following a dismal season in 2013. Jenson Button had barely scraped into the top ten in the Drivers' Championship and the team failed to score a podium finish for the first time since 1980. A virtual repeat the following year heralded a switch to Honda engines for 2015, by which time the Mercedes team's stranglehold of the hybrid era was well established. McLaren's results in 2017 hit an all-time low, with a move to Renault engines bringing only a marginal improvement the following year, by which time Dennis had left the company.

With morale rock bottom and the team having had four different bosses in seemingly as many years, Zak Brown had accepted the poisoned chalice that came with being appointed CEO in 2018. A former driver (mainly in sportscar racing), Brown had carved a reputation, and a small fortune, through sponsorship acquisition. His first job at McLaren Racing was to turn around the loss-making commercial division. Ninth in the championship in 2017 became sixth, then fourth, followed by third in 2020. A regression in 2022 prompted Brown to make his most significant move when he appointed Andrea Stella as Team Principal, the former Ferrari engineer helping pull together a strong technical team that included Rob Marshall from Red Bull and David Sanchez from Ferrari. The blame culture Brown had inherited was replaced by very effective communication between departments – as the success of the MCL38 would prove.

THE DESIGNER

Rob Marshall, formerly Chief Designer with Red Bull, became Technical Director at McLaren in May 2023. For 2024, his team included Neil Houldey (Technical Director of Engineering), Peter Prodromou (Technical Director of Aerodynamics) and Mark Temple (Technical Director of Performance). David Sanchez, hired from Ferrari, left McLaren in April 2024. Following the departure of Andy Cowell to Aston Martin, Hwyel Thomas led the engine design team at Mercedes High Performance Powertrains in Brixworth.

FAMOUS DRIVERS

Lando Norris, the youngest ever karting World Champion at the age of 14, made his F1 debut with McLaren in the 2019 Australian Grand Prix and scored his first championship points at the next race in Bahrain. Third place in Australia in 2020 marked the first of several podium finishes across successive seasons, Norris's first win eluding him until the 2024 Miami Grand Prix. Three more victories with the McLaren-Mercedes MCL38 would bring second place in the Drivers' World Championship. Partnered in his first two seasons by Carlos Sainz, followed by Daniel Ricciardo in 2021, Norris had another Australian team-mate when Oscar Piastri was signed for 2023. The former Formula 3 and Formula 2 champion had an impressive weekend towards the end of the season by winning the sprint race and finishing runner-up in the Qatar Grand Prix. Piastri scored his first Grand Prix victory in Hungary, and a second win in Azerbaijan contributed to fourth place in the 2024 championship.

Diligent work by drivers and team helped turn the MCL38 into a race winner in 2024 and return McLaren to the top of the Constructors' Championship for the first time in 26 years.

MEMORABLE RACE

There may have been an element of luck involved but Lando Norris's victory in the Miami Grand Prix not only marked his first win but also laid down an impressive marker for the rest of the season. Finally, McLaren had consistently quick race pace.

A win had appeared unlikely after qualifying as Norris lined up fifth, one place ahead of Oscar Piastri. This was largely because the MCL38, even allowing for a raft of upgrades on Norris's car, did not get on particularly well with the softest tyre in the Pirelli range during a flat-out lap of the 5.412-km (3.362-mile) street circuit. Hard and medium tyres would be a different story during the 57-lap race… assuming everything went according to plan.

Sergio Pérez immediately rewrote strategy plans across the board when an ill-judged attempt to take second place at the first corner prompted urgent avoiding action by a cluster of cars on the Red Bull's tail. While Norris lost ground in the ensuing scuffle, Piastri seized the opportunity to move into third, which became second four laps later. Watching from what had become sixth place, Norris was encouraged by the comparative ease with which his team-mate had dealt with the Ferrari of Charles Leclerc. The McLaren clearly had race pace. But Norris could not use it thanks to being stuck behind Pérez.

A key moment came when Pérez stopped to change from medium to hard tyres. Now in clean air, Norris put the hammer down, setting a succession of fastest race laps. As those in front made their stops, Norris found himself in the lead – but knowing that he, too, would need to change to the hard tyre. Nonetheless, his pace had been such that he would leapfrog the two Ferraris and his team-mate. The question of whether he had done enough to also get ahead of Max Verstappen's leading Red Bull became academic on lap 28.

A collision between two backmarkers prompted a call for the safety car – during which time Norris could make what amounted to a 'free' pit stop with minimal loss of time. He was further assisted by the safety car initially failing to pick up his leading McLaren, thus ensuring Norris got in and out of the pits without losing his lead. Verstappen's hopes of pressuring Norris were soon crushed as the McLaren pulled out half a second a lap with apparent ease. Game over at Miami, game on for the rest of the season.

Lando Norris was poised to capitalise on a slice of good luck and the McLaren MCL38's race pace in Miami to win his first Grand Prix in May 2024.

INDEX

Note: page numbers in **bold** refer to information contained in captions.

24 Hours of Le Mans 34, 41, 68, 71, 83, 137, 141, 235

A
ABC Sports 209
Abu Dhabi Grand Prix 234, **242**
Adelaide 173, **173**
Agnelli dynasty 109
Aintree 8, **14**, 30, **30**, **32**, 34, **41**
Alesi, Jean 199
Alexander, Tyler 164
Alfa Romeo 27, 30, 37, 132, 150–1, 159, 189, 193
 Alfa Romeo 158 10–13, **11**, **13**, 20
 see also Brabham-Alfa Romeo
Alfieri, Giulio 27
All American Racers (AAR) 68–9, 71, 79
Allison, Cliff 53, 54
Allison, James 219, 237
Alonso, Fernando 218–20, **218**, **220**, 223, 244
Alpine 137
Alta engines 41
Amon, Chris 86, 87, **87**
Anderson, Gary 205, 209
Anderstorp **104**, 114, 116, **117**, 130
Andretti, Mario 86, 87, 116–17, 122–3, **123**, 125, **125**, **127**, 127, 130, 142
Andretti, Michael 201
Anglo American Racers 68, 69
Antique Automobiles Racing 87
Argentine Grand Prix 17, **17**, 19, 24, 118, 140, 142, **142**
Arnoux, René 137, 139, 152–3, **153**, 159
Arrows 161, 205, 209
Ascari, Alberto 19, 20, 23, **23**, 27, 230
Aston Martin 34, 244, 247
Austin 7 53, 79
Australian Grand Prix **170**, 173, **173**, **197**, 201, 226, 227, 242, 247
Austrian Grand Prix 127, **144**, 146, 166, **166**
Auto Union 10–11, 15
Avus track, Berlin 37–9, **39**
Azerbaijan Grand Prix 244, 247

B
Baghetti, Giancarlo 45, 46–7, **47**
Bahrain Grand Prix 237, 247
Balbo, Enrico 242
Bandini, Lorenzo 68–9
BAR-Honda 219, 227
Barcelona **226**
Barnard, John 155, 156, **156**, 164–5, 175, 177, 180–1, 183, 213
Barrichello, Rubens **199**, 209, 211, 213, 215–16, **216**, 226–7, 229, **229**
Beaufort, Carel de 50
Beaujon, Michel 141
Behra, Jean 27, 34, 39

Belgian Grand Prix 19, 24, 45, 57, **57**, 68, **69**, 71, **71**, 78, 81, **81**, 86, **98**, **164**, **168**, 204–5, 216
Bell, Bob 177, 219
Bellamy, Ralph 92, 104, 125
Bellentani, Vittorio 27
Beltoise, Jean-Pierre 83, 84–5
Benetton 197–9, 204, 215, 218–19, **218**
 B186 193
 see also Renault
Benetton-Ford
 B192 7
 B194 7, 192–4, **192**, **194**
Benetton-Renault 209
Benson & Hedges 205
Berger, Gerhard 183, 219
Berthon, Peter 49
Big Dave 206–7
Bigois, Loïc 227
Blash, Mike 'Herbie' 151
BMW 164, 193, 229
 see also Brabham-BMW;
 Williams-BMW
Bondurant, Bob 69
Bonnet, René 83
Bonnier, Jo 47
Boreham 208
Bottas, Valtteri 234, 237
Boudy, Jean-Pierre 137
Boyer, Bernard 82, 83
Brabham, Sir Jack 8, 40–1, **41**, 43, **43**, 62–4, **64**, 66, **66**, 68, 73, 76, 81, 88, 92, 94, 129
Brabham 68, 86, 88, 109, 125, 132, 145, 175
 BT3 64
 BT7 57
 BT20 **72**
 BT42 129
 BT44 129
 BT48 150
 BT49D 161
 BT51 161
Brabham-Alfa Romeo
 BT45B **121**
 BT46 **127**, 129
 BT46B 128–30, **129–30**
Brabham-BMW
 BT52 160–3, **160**, **163**
 BT53 166
Brabham-Ford 94
 BT49C 150–3, **151**, **153**
Brabham-Repco, BT19/BT20 62–6, **62**, **66**, 68, 140
Brands Hatch 68, 78, 82, **90**, 94, **94**, **97**, 159
Brawn, Ross 193, 212–13, 215, 219, 226–7, 229, **229**
Brawn Grand Prix 226, 230, 235
Brawn-Mercedes BGP001 226–9, **226**, 230
Brazilian Grand Prix 141–2, 142, 159, 193, 198–9, **199**, **224**, 226, **231**
Bremgarten 11, 15
Brett, Jim 209
Briatore, Flavio 192, 193
Bridgestone tyres 201, 216, 219, 229
Bristol engines 41
British Aircraft Corporation 129

British American Racing (BAR) 227
 see also BAR-Honda
British Grand Prix 8, 10, 11, **14**, 19, 27, 30, **30**, 32, 34, **34**, 36, 40–1, **41**, **49**, 58, 66, 68, 75, 79, 84–5, **85**, **90**, 92, 94, **94**, **97**, 103–4, 107, 137, 148, **148**, 154, **154**, 156, 169, 211, **223**
BRM (British Racing Motors) 31, 44, 59, **60**, 69, 71, 73, 75, 79, 81, 88, **88**, 98, 99, 125
 BRM H16 75
 BRM P57 48–50, **49**, **50**, **57**
 BRM P61 48
 BRM V16 49
Brooks, Tony 30, 32, **32**, 34, 36, 37, 39, **39**, 43
Brown, Alan 32
Brown, David **189**
Brown, Zak 246, 247
Bruce McLaren Motor Racing 78, **78**, 156
 see also McLaren; McLaren, Bruce
Brundle, Martin 6–7, 9, 129, 194
Bryne, Rory 192
BS Fabrications 104
Bucknum, Ronnie 58, 59–60
Buenos Aires Autodromo 17, 142
Buenos Aires Grand Prix 25, 142, **142**
Button, Jenson 226, **226**, 227, 229, **229**, 247
Byrne, Rory 192, 193, 213, 215, 219

C
Canadian Grand Prix 79, 82, 97, 103, 119, 125, 146, 151, 161, 209
CanAm 78, 79, 87, 104
carbon fibre 154–6, **154**, 161, 164–5, 169
Carillo, Paul 141
CART (IndyCar) Championship 197
Castaing, François 137
Castellotti, Eugenio **19**, 20, 23
Cevert, François 87, 97–8, **98**, 115
Chapman, Colin 30, 32, 52–4, **54**, 62, 72–3, 75, 90–2, 94, **94**, 123, 125, 129
Chassagny, Marcel 83
Chevrolet 201
Chiti, Carlo 37, 45
Chrysler 82
Citroën 41
Clark, Jim 8, 48, **50**, 52–4, **52**, **54**, 57–8, **57**, 66, **66**, 71–2, **72**, 75, **75**, 197
Clermont-Ferrand **82**, 87
Coaker, Graham 86, 87
Collins, Peter 19, **19**, 20, 28–9, 32, 34, 36–7
Colombo, Gioacchino 11, 27
Colotti gearboxes 41
Concorde 87
Cooper, Charles 41
Cooper, John 41
Cooper Car Company 31–2, 40–1, 44, 64, 79
 Cooper T41 41
 Cooper T43 41
 Cooper T45 40, 41
 Cooper T51 40–3, **41**, **43**, 53
Cooper-Climax 58
 T51 8, 36

Cooper-Maserati 140
Coppuck, Gordon 79, 103, 104, 156
Costa, Aldo 215
Costin, Frank 30, 32, 75
Cosworth 193, 219, 230
 DFV 71
 see also Ford-Cosworth
Cosworth Engineering 73, 75
Cosworth Racing 209
Coughlan, Mike 223
Coulthard, David 197, 200–1, **200**, 211, 231
Courage, Piers 145
Coventry-Climax engines 40, 41, 52–3, 68
Covid-19 pandemic 237, 239, 241
Cowell, Andy 223, 237, 247
Crawford, Jim 92

D
Daimler-Benz 14, 15
Dallas 169
Davis, John 205
de Angelis, Elio 166
de Cesaris, Andrea 156, 159
de Cortanze, André 137
de Graffenried, Baron Emmanuel 'Tuolo' 27
De Tomaso 145
Dennis, Ron 154, 156, **156**, 159, 164–5, 175, 201–2, 222–3, 247
Densham, Tim 219
Depailler, Patrick 115–17, **115**, 140–2, **141–2**
Dernie, Frank 146, 170
Detroit 169
di Montezemolo, Luca 109, 213
di Portago, Alfonso **19**
Dijon 139, **139**
Donington Grand Prix 15
Ducarouge, Gerard 83, 140–1, 144
Duckworth, Keith 75
Dudot, Bernard 137, 189, 197, 219
Dunlop 50
Dunne, Bill **71**
Durand, Henri 183, 201
Dutch Grand Prix **52**, 58, 66, **66**, 72, **72**, 119, 127, **127**, 133–5, **135**, 145

E
Eagle-Weslake 73
 AAR-103 68–71, **69**
 V12 7
Ecclestone, Bernie 129, 130, 151, **160**
Elf **136**, 137, 191
Elf Team Tyrrell 96
Elizabeth II 222
Elliot, Mike 237
English Racing Automobiles (ERA) 49
Equipe Matra International 82
European Championship 15, 208
European Grand Prix 204, 211, **211**

F
Fagioli, Luigi 10, 11
'Fan Cars' 128–30, **129–30**, 150–1
Fangio, Juan Manuel 6, 10–11, **11**, **13**, 14–15, **14**, 17–20, **17**, **19**, **20**, 23–5, **23–4**, 27–9, **27**, **29**, 34, 235
Farina, Giuseppe 10–11, 13, **13**, 27
Federation Internationale de l'Automobile (FIA) 10, 192, 193

Federation Italiana Scuderie Automobilsche (FISA) 46
Ferrari, Alfredo 'Dino' 36, 37
Ferrari, Enzo 11, 31, 36–7, 44, 45, 109, 111, 133, 180, 183–4
Ferrari, Piero Lardi 180
Ferrari 10–11, 14, 17, 19–20, **20**, 23, 25, 27–31, 34, 36–7, 39–41, 43, 45, 53, 59, **60**, 68–9, 71, 73, 88, **88**, 99, 103, **103**, 118–19, 121, 125, 129, **129**, 139–40, 142, 146, 189, 193, 196, 198, 202, 205, 211, 218–19, 222, 227, 231, 234, 237, 247, 248
 312B3 109
 312P 109, 180
 312T 108–13, **109**, **111–12**, **121**, **127**
 312T4 132–5, **133**, **135**, 140, 141
 312T5 133
 639 180, 183
 640 180–4, 181, **181**, **183–4**
 801 *see* Lancia D50
 Dino 156 (Sharknose) 44–7, **45**, **47**, 54
 Dino 246 36–9, **37**, **39**, 45
 F2004 212–16, **213**, **215–16**
 F2005 **220**
 see also Lancia-Ferrari
Fiat 109, 180
Fiat 500 Topolino 41
Fiorano 109, 113, 118, 132
Firestone 90, 91
Fisichella, Giancarlo 219–20
Fittipaldi, Emerson 90, 92, **92**, 102–4, **104**, 107, 115
Footwork 204
Force India/Racing Point 242
Ford Motor Company 75, 161, 201, 204, 208, 209, 230
 see also Benetton-Ford; Brabham-Ford; Formula Ford; Hesketh-Ford; Ligier-Ford; Lotus-Ford; March-Ford; Matra-Ford; McLaren-Ford; Shadow-Ford; Tyrrell-Ford P34; Williams-Ford; Wolf-Ford
Ford-Cosworth 71, **72**, 129, 154–5, 161, 193
 DFV engine 72–3, 75, 78–9, 82, 86–7, 97, 103, 108, 114, 119, 121, 123, 140, 148, 150, 155, 161, 164, 180
 V8 engine 82, 90, 121
Forghieri, Mauro 45, 108, 109, 111, 133
Formula Ford 87, 193
Formula Junior 64
Formula One Constructors' Association (FOCA) 119
Formula One Constructors' Championship 30, 32, 40, 41, 48, 78, 90, 97, 103, 104, 109, 119, 136, 140, 150, 164, 169, 180, 186, 192, 202, 204, 215, 216, 219, 222, 226, 240–1, 246, **247**
Formula One World Championship 13, 17, **19**, **20**, 23–4, 29–31, **29**, 36–8, 40, 43–4, 52–3, 62, 64, **64**, 81, 88, **92**, 97, 102, 107, 123, 130, 132, 136, **141**, 144, 150, 152, 161, **163**, 165, **173**, 186, **187**, 192–3, **192**, **202**, 213, 218, 222–3, **224**, 235
Formula Three 41, 64, 83, 87, 92, 98, 119, 140, 247
Formula Two 37, 41, 53, 72, 82, 87, 98, 119, 137, 140–1, 146, 169, 193, 247
Formula Vee 156

Foster, Sir Norman 222
Fraschetti, Andrea 37
French Grand Prix 24, **24**, 37, 46, **47**, 49, 64, 66, 68, **78**, **82**, **87**, 136–7, 139–40, **139**, 154, 179, **179**, **191**, **191**, 206, **207**, 229
Frentzen, Heinz-Harald 204, 205–7, **207**, 211
Fry, Nick 227, **229**

G
Gardner, Derek 98, 115
Gascoyne, Mike 205
General Motors 63
German Grand Prix **11**, 19, 28–9, **29**, 39, **50**, **50**, 64, 87, 90, 104, 108, 113, 119, 127, 140, **146**, 152–3, **153**, 219
Ghidella, Vittorio 181
Giacomelli, Bruno 159
Ginther, Richie 45–7, 49, **50**, 58–60, **60**, 69
Glock, Timo 224
Glover Trophy 36
Goddard, Geoff 193
Gold Cup 92
Gold Leaf 73, 90
González, José Froilán 10, 17, 27
Goodwood 7, 36
Goodwood Festival of Speed 6
Goodyear 60, **71**, 91, 114–15, 152, 173, 201, 209
Gordini 137
Goss, Tim 223
Goto, Osama 177
Gregory, Masten 41
Group Lotus 54
Gurney, Dan 7, 47, **47**, 50, **50**, 57, 58, 64, 68–9, **69**, 71, **71**, 79

H
Hahne, Hubert 87
Hailwood, Mike 104
Häkkinen, Mika 200–2, **202**, 211, 222, 235, 247
Halo device **239**
Hamilton, Sir Lewis 6, 222–4, **223–4**, 234–5, 237, **237**, 239, **239**, 247
Hart, Brian 193
Hart 204
Haug, Norbert 201
Hawkridge, Alex 193
Hawthorn, Mike 28–9, **30**, 34, 36–7, **37**
Hayes, Nick 209
Hayes, Walter 72–3
Head, Patrick 144, 146, **146**, 169, 170, **170**, 173, 189, 191, 197–8
Henton, Brian 92
Herbert, Johnny 193, 209, **209**, 211, **211**
Hercules Incorporated 155
Herd, Robin 79, 86, 87
Herrmann, Hans 14, 15
Hesketh, Lord Alexander 119
Hesketh Racing 118, 119, 146
Hesketh-Ford 119
Hewland 150
Hill, Damon 192, 194, **194**, 196–9, **199**, 205, **205**
Hill, Graham 48–50, **49**, **50**, 54, **57**, 71–2, 75, **75**, 78, 92, 196
Hill, Phil 44–7, **45**, 69
Hobbs, David 104

251

Hockenheim 90, **146**, 152, **153**, 192, 194
Holl, Diane 183
Honda, Hirotoshi 204
Honda, Soichiro 58, 204
Honda 183, 187, 241, 247
 RA272 58–60, **59**, **60**
 RA 168-E 177
 S360 59
 see also BAR-Honda; McLaren-Honda; Williams-Honda
Honda Motor Company 58, 204
Honda Racing F1 226, 227
 see also Brawn Grand Prix
Horner, Christian 231
Houldey, Neil 247
Hulme, Denny 62, **62**, 64, 66, **66**, **72**, 78–9, 81, 88, 103–4, **104**, 107, **107**
Hungarian Grand Prix 183–4, **184**, 194, **194**, **205**, 219, 223, 227, 247
Hungaroring 184
Hunt, James 102–4, **103**, 107–8, 113, 119

I
Ickx, Jacky 88, **88**, 92, 141
IGM (Ian Gordon Murray) 129
Iley, John 215
Illien, Mario 201
Ilmor Engineering 201, 222, 235
 see also Mercedes High Performance Powertrains; Mercedes-Benz High Performance Engines
Imola 150, 175, **183**, 189, 192, **220**
Imperial Tobacco 90, 123
Indianapolis 500 68, 156, 197
Indy Eagle 69
IndyCar 69, 72, 86, 98, 103, 104, 156, 189, 201
Intercontinental Formula 44
Interlagos **141**, 198–9, **224**
International Trophy 36
Irvine, Eddie 202, 211, 215
Isle of Man TT 58
Istanbul Park 239
Italian Grand Prix 15, 19, **19**, 24, 44, 46, 59, 68, 90, **109**, 125, 175, 216, **216**, 231, 240

J
Jabouille, Jean-Pierre 135, 136, **136**, 137, 139, 148
Jacarepaguá 183
Jaguar 208, 223, 230, 231
 XK150 145
Jaguar Racing 230
Jano, Vittorio 11, 20, 37
Japanese Grand Prix **177**, 186, **189**, 201, **202**
Jarama **75**, 78, 88, **88**, **115**, 139
Jarier, Jean-Pierre 125
Jeffreys, Matthew 177
Jenkins, Alan 209
John Player 73, 90, 123
Jones, Alan 135, 144–6, **144**, **146**, 148, **148**, 150, 152–3
Jordan, Eddie 204
Jordan 209, 215, 219
 196 **199**
Jordan Grand Prix 204, 205
Jordan-Mugen Honda 199 204–7, **205**, **207**
Judd V8 engine 187

K
Kerr, Phil 107
Kinetic Energy Recovery System (KERS) 227
Kling, Karl 14, 15
Kovalainen, Heikki 223
Kubica, Robert 229
Kvyat, Daniil 242
Kyalami 139, 163, **163**

L
Lacy, Simon 223
Laffite, Jacques 119, 134–5, 140–2, **142**
Lall, Indy 174
Lancia, Gianni 19
Lancia, Vincenzo 19
Lancia 14, 17
 D50 18–23, **19**, **23**
Lancia-Ferrari 36
 D50 *see* Lancia D50
Lauda, Niki 102–3, **103**, 108–9, **109**, 111, **111–12**, 113, 119, 121, **121**, **127**, 128–30, **129**, 132, 146, 150–1, 156, 159, **159**, 164–6, **164**, **166**, 213
Le Mans 15, 19
 see also 24 Hours of Le Mans
Leclerc, Charles 248
Legardère, Jean-Luc 83
Lehto, J.J. 193
Lewis-Evans, Stuart 32, 34
Leyton House 189, 201
Ligier, Guy 140
Ligier Cars 140–1, 209
Ligier-Ford 134
 JS11 140–2, **141–2**
Lola Cars 146, 156
Lola Mk4 50, **50**
Long Beach, California 119, 133, 150, **151**, 159, **159–60**
Lotus 44–5, 48, 66, 68–9, 71, 78, 86, 98, 107, 119, 142, 170, 175, 197, 201, 204, 209, 232
 Lotus 12 53, 54
 Lotus 18 54
 Lotus 21 52, 53
 Lotus 24 52, 53
 Lotus 25 123
 Lotus 33 **66**, 75
 Lotus 38 69
 Lotus 43 75
 Lotus 56 90
 Lotus 63 92
 Lotus 76 90, 123
 Lotus 77 125
 Lotus 78 87, 123, 125, 128
 Lotus 80 125
 Mark 1 53
 see also Group Lotus
Lotus Engineering 53
Lotus-Climax 66
 25 48, **50**, 52–7, **52**, **54**, **57**, 62, 75
Lotus-Ford 116–17
 49 8, 72–6, **72**, **75**, **76**, 78, 84–5, **85**, 90, 92
 72 76, 90–4, **90**, **92**, 97, 102, 107, 123
 79 87, 122–30, **123**, **125**, **127**, 132, 140, 142, 144
Lotus-Renault 166
Lowe, Paddy 223

M
Maddock, Owen 32, 41
Magnussen, Jan 209
Magny-Cours 191, 206
Malaysian Grand Prix 232–3, **233**
Mansell, Nigel 168–70, **168**, **170**, 173, **173**, 181, 183–4, **183–4**, **184**, 186, **187**, 189, **189**, 191, 196–7, 213
Maranello 19, 45, 98, 213
March 119, 125, 183, 201
March-Ford 145
 701 8, 86–8, **87–8**, 96–7, 125
Marko, Helmut 231
Marlboro 156, 200, 201, 215
Marshall, Rob 231, 247
Marteau (riding mechanic) 137
Martinelli, Paulo 215
Maserati 11, 14, 15, 17, 34, 71, 73
 4CLT 25
 250F 7, 11, 19, 24–9, **24**, **27**, 30, 68
 A6 25
 see also Cooper-Maserati
Mass, Jochen 104
Massa, Felipe 224
Massimino, Alberto 27
Mateschitz, Dietrich 231, 241
Matra 98, 99, 140
 MS1 83
 MS10 82, 83, 98
 MS11 82, 83
 MS84 82, 84–5, 98
 Tyrrell Matra-DFV 72
Matra Automobiles 83
Matra International Team 72
Matra Sports 83, 140–1
Matra-Ford 81
 MS80 82–5, **82**, **85**, 86, 96, 98
Mayer, Teddy 78, 104, 164
Mays, Raymond 49
McLaren, Bruce 41, 43, 69, 78–9, **78**, 81, **81**, 104, 246
McLaren 7–8, **71**, 86–8, 92, 119, 125, 129, 151, 169–70, 173, 183–4, 186, 189, 194, 197, 205, 211, 215, 231, 235, 237, 242
 M2B 79
 M4B 79
 M5A 79
 M16 IndyCar 103
 M19 103, 104
 M26 103
 M28 156
 M29 156
 M30 155
 MCL60 246
 MP4-12 201
 MP4-22 222
 MP4/3B 175
 MP4/5 180
McLaren International 156
McLaren Racing 103, 104, 246, 246–7
McLaren Technology Centre 222
McLaren-Ford
 M7A 78–81, **78**, **81**
 M23 78, 102–7, **103**, **104**, **107**, 156
 MP4 154–9, **154**, **159**, 180
 MP4/8 193, 201
McLaren-Honda MP4/4 7, 174–9, **175**, **177**

McLaren-Mercedes 213, 219, 220
 MCL38 8, 246–8, **247–8**
 MP4-13 200–2, **200**, **202**
 MP4-23 6, 222–4, **223**
McLaren-TAG MP4/2 164–6, **164**
McQuilliam, John 205
Mecachrome 219
Mercedes 30, 241
 W05 234
 W06 234
 W07 241
 W09 234
 W10 234
 W11 234–9, **235**, **239**
 see also Brawn-Mercedes;
 McLaren-Mercedes
Mercedes AMG Petronas F1 234
Mercedes High Performance Engines 222, 223, 227, 235
 see also Ilmor Engineering; Mercedes High Performance Powertrains
Mercedes High Performance Powertrains 235, 237, 247
 see also Ilmor Engineering; Mercedes High Performance Engines
Mercedes-Benz 6, 10–11, 19, 200, 201, 229, 235, 247
 300 SL gullwing road car 15
 300 SLR 15
 W25 15
 W125 15
 W154 15
 W196 14–17, **14**, **17**, 23, **23**
Mexican Grand Prix 58, 59, 60, **60**, 64
Mezger, Hans 165
Miami Grand Prix 244, **244**, 246–8, **248**
Michelin 133, 219
Miles, John 92
Mille Miglia 19, 37
Mina, Ettore Zaccone 20
Minardi 219, 231
Minegawa, Saneyuki 227
Modena Autodrome 37
Monaco Grand Prix 13, **13**, 19, 23–4, **23**, **27**, **37**, 40–1, 44–5, 48, 53–4, 59, 62, **62**, 64, 69, 72, **76**, 78, 81, 83, **92**, 101, **101**, 118, 121, **121**, **133**, 141, 151, 153, **156**, 161, 165, **181**, 193, 196, 208, 219, 231, **241**
Mont Tremblant-St Jovite 97
Montezemolo, Luca di 109, 213
Monza 10, 14–15, 19–20, **19**, 23, **23**, 30, 36–8, 41, 44–5, 68, 78, **109**, **125**, 135, 150, **209**, 216, **216**, 234, 246
Monza Autodrome 19
Morgan, Paul 201
Moroccan Grand Prix 30
Mosley, Max 86, 87, 192
Mosport 119
Moss, Sir Stirling 14, 15, 19, 23–4, **23**, 30, **30**, 32, **32**, 34, **34**, 36, 41, 43, 45, 53–4, 235
Motor Racing Developments (MRD) 64
Mugen Honda 204
 see also Jordan-Mugen Honda 199
Munaron, Gino 25
Murray, Gordon 128–9, 150–1, 160–1, **160**, 175, 177
Musso, Luigi **19**, 20, 27, 36, 37

N
Nakajima, Satoru 175
Nakamura, Yoshio 59
Nazis 15
Neubauer, Alfred 14, 15
Newey, Adrian 189, **189**, 196–8, 200–1, 222–3, 230–1, 240–2, 247
Nichols, Steve 174, 177, 201
Norris, Lando 8, 246, 247, 248, **248**
North, David 129, 151, 161, 177
Norton 31
Nürburgring 15, 24, 44, 64, 204, 208, 211, **211**
 Nordschleife **11**, 18, 28–30, 36, 45, **45**, 50, **50**, 58–9, 69

O
Oatley, Neil 146, 177, 200–1, 223
Ogilvie, Martin 125
Ojjeh, Akram 164
Ojjeh, Mansour 164–5
Oldsmobile 62–3
Oliver, Jackie 75, 88, **88**
Orsi family 25
Österreichring 166
Oulton Park 92
Owen, Alfred 49
Owen, John 227, 237

P
Parmalat 161
Parnell, Reg 10
Parnelli 125
Patrese, Riccardo 161, 163, 184, 186, 189, 191, **191**
Paul Ricard (Le Castellet) 140, 142, 164, 169, 179
Paul Stewart Racing 209
Pérez, Sergio 'Checo' 241–2, 244, **244**, 248
Pescara 30
Peterson, Ronnie 86–7, 90, 92, 99, 107, 115, 125, **125**, 127, **127**
Peugeot 201, 204, 213–15
Phillippe, Maurice 75, 92
Piastri, Oscar 8, 246–8
Piquet, Nelson 104, 150–3, **151**, **153**, 160–1, **160**, 163, **163**, 166, **168**, 169–70, 173, **173**, 193
Pirelli 230, 232
Pomona, California 59
porpoising 240–1
Porsche 39, 47, **47**, 50, 68, 164, 165
 356 speedster 59
 804 **50**
 see also TAG-Porsche
Portuguese Grand Prix 197
Postlethwaite, Harvey 118, 119, 146
Prodromou, Peter 231, 247
Project Four Racing 156
Prost, Alain 152–3, 163–6, **164**, 173–5, **175**, 177, **177**, 179, **179**, 184, 196–7, 204, 213
PSR 209

Q
Qatar Grand Prix 247

R
Race of Champions 82
Rahal, Bobby 119
Räikkönen, Kimi 220, 224, 232

Rainier, Prince 121
RALT 64
Ramirez, Jo **71**
Rebaque, Hector 125, 151, 153
Red Bull
 RB3 231
 RB5 230
 RB7 230
 RB9 241
 RB11 241
 RB12 241
 RB13 241
 RB16 241
 RB18 241, 242
Red Bull Junior Team 231, 242
Red Bull Racing 189, 222, 223, 229–30, 234, 247–8
 see also Toro Rosso
Red Bull-RBPT RB19 240–4, **241–2**
Red Bull-Renault RB9 230–3, **231**
Rees, Alan 86, 87
Regazzoni, Clay 109, **109**, 111, 144, 146, 148, **148**
Reims 14–15, 36, 37, 46, **47**, 68, 229
Renault, Louis 137
Renault 135, 152–3, 159–60, 163–5, 215, 222–3, 241, 247
 R25 218–20, **218**, **220**
 RE30 **153**
 RS01 137
 RS10 136–9, **136**, **139**, 148
 see also Benetton-Renault; Lotus-Renault; Red Bull-Renault; Williams-Renault
Renault 8 Gordini Cup 137
Renault Sport 137, 219
Replacement Pty Limited 62–3
Reutemann, Carlos 111, 113, 125, **127**, 142, 152–3
Revson, Peter 103, 104, 107, **107**
Ricciardo, Daniel 242, 247
Rindt, Jochen 72, 75–6, **76**, 84–5, **85**, 90, **90**, 92, 94, **94**
Rindt, Nina **94**
Rinland, Sergio 170
Riverside 53
Rob Walker Racing 40, 41, 53
Rodríguez, Pedro 81
Rolls-Royce 49
Rosberg, Keke **135**, 169, 170
Rosberg, Nico 234–5
Rosche, Paul 161
Rouen 49, 64, **78**
Rouen-Les-Essarts 24, **24**
Royale 193
Rudd, Tony 49, 125
Russell, George 237

S
St Jovite 78
Sainz, Carlos 247
Sakhir Grand Prix 237
Salo, Mika 211
Salvadori, Roy 41
San Marino Grand Prix **183**, 196, **200**, 205, 220, **220**
Sanchez, David 247
Sano, Shoichi 59
Sauber F1 11, 201, 209, 219, 230, 235, 242

253

Saudi Arabian Grand Prix 244
Scarfiotti, Luidovico 69
Scheckter, Jody 104, 107, 113–19, **117–18**, 121, **121**, 132–5, **135**, 141, 180, 202
Schell, Harry 27
Schlesser, Jo 140
Schumacher, Michael 192–4, **192**, **194**, 197–8, 202, 204–5, 211, 213, 215–16, **215**, 218–20, 222, **225**
Schumacher, Ralf 205
Scott, Richard 146
Scott-Brown, Archie 57
Sebring 43, **43**
Second World War 10, 11, 14, 15, 25, 37, 41, 49, 59
SEITA 140
Senna, Ayrton 7, 174–5, **175**, **177**, 179, **179**, 184, 193, 196–7
Sepang circuit 232, **233**
Serenissima 79
Servoz-Gavin, Johnny 82, 83, 87
Shadow 161
Shadow-Ford 146
Shelby, Carroll 59, 68
Siffert, Jo 75, 87, 88
Silver Arrows 235
Silverstone 8, 10, 11, 15, 36, 49, 78, 84–5, **85**, 98, 101, 107, **107**, 119, 144–5, **148**, 152, **154**, 156, 192, 194, 204, **223**
Skinner, Craig 242
Sky F1 6
Sky Sports F1 9
Smith, Mark 205
Solitude road circuit 44
South African Grand Prix 87, 103, 104, 107, **112**, 113, 133, 159, **163**
Spa-Francorchamps 30, 52, 57–8, **57**, 68–9, **69**, 71, **71**, 81, **81**, **168**, 205, 216
Spanish Grand Prix **75**, 78, 87–8, **88**, 97, **115**, 141, 154, 197, 201, 234
'Spygate' scandal 222, **223**
Stella, Andrea 247
Stewart, Sir Jackie 71–2, 81–8, **82**, **85**, **88**, 96–9, **97**, **98**, **101**, 115, 140–1, 208, 209, **209**, 211
Stewart, Paul 209, **209**
Stewart Grand Prix 208–11, 230
Stewart-Ford SF3 208–11, **209**, **211**
STP 86, 87
Stroll, Lance 239
Stuck, Hans-Joachim **121**
Super Vee 146
Surtees, John 50, **50**
Surtees 107
Suzuka **177**, 202, **202**
Swedish Grand Prix 114, 116–17, **117**, 128, 130, 140–1
Swiss Grand Prix 11, 15
Symonds, Pat 193, 219
Szisz, Ferenc 137

T
TAG (Techniques d'Avant Garde) 164–6
see also McLaren-TAG
TAG Turbo 175
TAG-Porsche 169, 175
Targo Florio 19
Taruffi, Piero 32
Tauranac, Austin 64
Tauranac, Ron 62, 64, 129
Team Enstone 218
Techniques d'Avant Garde see TAG
Temple, Mark 247
Terry, Len 69
Tétu, Michel 137
Thinwall Engineering 30
Thinwall Special (modified Ferrari) 31
Thomas, Hywel 247
Todt, Jean 213, 215
Toleman 193
Toro Rosso 224, 231, 242
Toyota 224, 227, 247
Trintignant, Maurice 23, 41
Triumph Herald 63
Trulli, Jarno 219
Turkish Grand Prix 232–3, 239, **239**
Tyrrell, Ken 72, 82, 83, 86, 96–8, 114, 140–1
Tyrrell, Nora 97
Tyrrell 82–4, 87, 98, **98**, 118, 141, 193, 204, 205, 209, 227
 Tyrrell 001 97, 98, 115
 Tyrrell 002 97
 Tyrrell 005 115
 Tyrrell 007 114, 115
 Matra-DFV 72
 see also Elf Team Tyrrell
Tyrrell Racing Organisation 86, 96
 see also Elf Team Tyrrell
Tyrrell-Ford
 003 96–101, **97**, **101**
 P34 114–17, **115**, **117**, 118

U
Uhlenhaut, Rudolph 15
United States Auto Club (USAC) 86, **151**
 see also IndyCar
United States Grand Prix 41, 43, **43**, 54, 75, 90, 125, 133, **159**

V
Vandervell, Guy Anthony (Tony) 30, 31–2, 54
Vandervell Products 31
Vanwall 36, 37, 40
 Special 31–2
 VW4 30–4
 VW5 30, **30**
Varzi, Achille 11
Verstappen, Jos 193, 194, 209
Verstappen, Max 193, 240–2, **241–2**, 244, **244**, 248
Vettel, Sebastian 224, 229–33, **231**, **233**
Villeneuve, Gilles 104, 132–4, **133**, 139, 197
Villeneuve, Jacques 196, **197**, 198
Villoresi, Luigi 20
Voiturette racing 10, 11
von Trips, Wolfgang 44–7

W
W196 streamliner 6
Waché, Pierre 242
Waide, Martin 92
Walker, Dave 92
Walker, Rob 54, 75, 92
Walkinshaw, Tom 193
Walter Wolf Racing 119
Warr, Peter 94, 119
Watkins Glen 53, 97, 98, 125
Watson, John 92, 121, **121**, 129–30, 151, 154, **154**, 156, **156**, 159, 165
Webber, Mark 229–33, **233**
Weismann 150, 177
Weslake, Harry 68
Weslake & Co. 68–9
 see also Eagle-Weslake
White, Rob 219, 231
Whiting, Charlie **160**
Whitmarsh, Martin 247
Williams, Sir Frank 119, 141, 144–6, **146**, 148, 169–70, 187, 191, 196
Williams 135, 142, **148**, 150, 152–3, 164, 170, 173, 175, 183, 184, 186, 189, **189**, 192, 197, 200, 201, 205, 227, 229, 231
 FW09 169
 FW10 169
 FW15 186, 193, 196
 FW16 **194**
 FW17 196, 197
 see also Wolf-Williams
Williams Grand Prix Engineering 144–6, 169
Williams-BMW 213, 231
Williams-Ford 152
 FW06 144
 FW07 144–8, **144**, **146**, **148**, 150, 153
Williams-Honda 175
 FW11 **168**, 169–73, **170**
Williams-Renault 186
 FW14B 186–91, **187**, **189**, 196
 FW18 196–9, **197**, **199**
Wisell, Reine 92
Wolf, Walter 118–19, 145
Wolf 115, 132
 WR5 119
Wolf-Ford 113
 WR1 118–21, **118**, 145
 WR9 **135**
Wolf-Williams 146
 FW04 119
 FW05 119
Woods, Aubrey 49, 69
Woods, Ben 227
World Drivers' Championship 48, 112, 136, 140, 150, 160, 169, 180, 201–2, 222, 226, 240, 247
World Sportscar Championship 109
Wright, Peter 87, 125

Y
Yamaha 204
Yardley 104, **107**

Z
Zandvoort 30, 48, **52**, 66, **66**, 68–9, 71, 127, 134, 150
Zolder **98**, **164**
Zunino, Ricardo 151

REFERENCES

Newspapers, Magazines and Websites

Autocar
Autocourse
Autosport
Competition Car
Motor Racing
Motor Sport
GP Racing
Speed World International
The Race
Motorsport.com

Books

Stirling Moss My Cars, My Career
Sir Stirling Moss with Doug Nye
Patrick Stephens Ltd, 1987

A-Z of Formula Racing Cars
David Hodges
Bay View Books Ltd, from Motorpoint International Publishing Company, 1990

Competition Cars of Europe
Anthony Pritchard
Robert Hale & Company, 1970

Grand Prix Cars 1945–65
Mike Lawrence
Aston Publications Ltd, 1989

The Autocourse History of the Grand Prix Car 1966–85
Doug Nye
Hazleton Publishing, 1986

Grand Prix Guide 1950–2023
Jacques Deschenaux
JDx Performance/Rolex, 2024

Champion Year: My Battle for the Drivers' World Title
Mike Hawthorn
Aston Publications, 1989

Ferrari: The Grand Prix Cars
Alan Henry
Hazleton Publishing, 1989

Formula 1 Car by Car 1960–69
Peter Higham
Evro Publishing, 2017

Formula 1 Car by Car 1970–79
Peter Higham
Evro Publishing, 2017

Formula 1 Car by Car 1980–89
Peter Higham
Evro Publishing, 2018

Formula 1 Car by Car 1990–99
Peter Higham
Evro Publishing, 2021

Brabham: The Grand Prix Cars
Alan Henry
Hazleton Publishing, 1985

Cooper Cars
Doug Nye
Osprey Publishing Ltd, 1983

BRM – The Saga of British Racing Motors Vol. 1–3
Doug Nye
Motor Racing Publications, 1994–2008

Mercedes-Benz Grand Prix Racing 1934–1955
George C. Monkhouse
White Mouse Editions, 1984

Theme Lotus: 1956–1986: From Chapman to Ducarouge
Doug Nye
Motor Racing Publications, 1986

The Lotus 49
David Hodges
Lionel Leventhal, 1970

Lotus 49: The Story of a Legend
Michael Oliver
Veloce Publishing Ltd, 1999

Jim Clark: Tribute to a Champion
Eric Dymock
Dove Publishing, 2017

Gurney's Eagles: The Exciting Story of the AAR Racing Cars
Karl Ludvigsen
Motortext Inc, 2001

McLaren: 50 Years of Racing
Maurice Hamilton; Paul Fearnley
Prestel Publishing, 2013

IMAGE CREDITS

Front cover: (top) Klemantaski Collection/Getty Images; (bottom) Frank Augstein/Pool/EPA-EFE/Shutterstock; back cover (left) David Phipps/Getty Images; (middle) Heritage Images; (right) Paul-Henri Cahier/Getty Images; P3 Klemantaski Collection/Getty Images; P7 Godfrey Pitt/Action Plus/Shutterstock; P9 HarperCollins Publishers; P11 Associated Press/Alamy Stock Photo; P12 Bettmann/Getty Images; P14 INTERFOTO/Alamy Stock Photo; P16 El Grafico/Getty Images; P18 Shawshots/Alamy Stock Photo; P21 Bernard Cahier/Getty Images; P22 Klemantaski Collection/Getty Images; P25 Bernard Cahier/Getty Images; P26 Klemantaski Collection/Getty Images; P28 Bernard Cahier/Getty Images; P31 Popperfoto/Getty Images; P33 Bernard Cahier/Getty Images; P35 National Motor Museum/Heritage Images/Getty Images; P37 Bernard Cahier/Getty Images; P38 Bernard Cahier/Getty Images; P40 Bernard Cahier/Getty Images; P42 Flip Schulke Archives/Getty Images; P45 Bernard Cahier/Getty Images; P46 Bernard Cahier/Getty Images; P48 Bernard Cahier/Getty Images; P51 Bernard Cahier/Getty Images; P53 Bernard Cahier/Getty Images; P55 Klemantaski Collection/Getty Images; P56 Klemantaski Collection/Getty Images; P59 The Enthusiast Network/Getty Images; P61 Bernard Cahier/Getty Images; P63 Bernard Cahier/Getty Images; P65 Bettmann/Getty Images; P67 Bernard Cahier/Getty Images; P69 Bernard Cahier/Getty Images; P70 Bernard Cahier/Getty Images; P73 Bernard Cahier/Getty Images; P74 Express/Getty Images; P77 Rainer Schlegelmilch/Getty Images; P79 Bernard Cahier/Getty Images; P80 Paul-Henri Cahier/Getty Images; P83 Bernard Cahier/Getty Images; P84 David Phipps/Getty Images; P86 Bernard Cahier/Getty Images; P89 Rainer Schlegelmilch/Getty Images; P91 David Phipps/Getty Images; P93 Rainer Schlegelmilch/Getty Images; P95 Rainer Schlegelmilch/Getty Images; P96 Bernard Cahier/Getty Images; P99 Keystone/Getty Images; P100 Bernard Cahier/Getty Images; P102 Oleg Konin/Shutterstock; P105 Rainer Schlegelmilch/Getty Images; P106 Rainer Schlegelmilch/Getty Images; P108 Bernard Cahier/Getty Images; P110 Rainer Schlegelmilch/Getty Images; P112 David Phipps/Getty Images; P115 Rainer Schlegelmilch/Getty Images; P116 ZUMA Press, Inc. / Alamy Stock Photo; P118 Bernard Cahier/Getty Images; P120 David Phipps/Getty Images; P122 Klemantaski Collection/Getty Images; P124 Bernard Cahier/Getty Images; P126 Bernard Cahier/Getty Images; P128 Bernard Cahier/Getty Images P131 David Phipps/Getty Images; P133 Bernard Cahier/Getty Images P134 Bernard Cahier/Getty Images; P136 Magic Car Pics/Shutterstock; P138 David Phipps/Getty Images; P141 Oleg Konin/Shutterstock; P143 David Phipps/Getty Images; P145 Ercole Colombo/Getty Images; P147 David Phipps/Getty Images; P149 David Phipps/Getty Images; P151 Oleg Konin/Shutterstock; P152 David Phipps/Getty Images; P154 Bob Thomas/Getty Images; P157 LAT Images/Getty Images; P158 David Phipps/Getty Images; P160 Rainer Schlegelmilch/Getty Images; P162 Bernard Cahier/Getty Images; P165 Oleg Konin/Shutterstock; P167 Paul-Henri Cahier/Getty Images; P168 Mike King/Getty Images; P171 Bryn Colton/Getty Images; P172 Tony Feder/Getty Images; P174 Paul-Henri Cahier/Getty Images; P176 TOSHIFUMI KITAMURA/Getty Images; P178 Sutton Images/Getty Images; P181 Leo Mason/Popperfoto/Getty Images; P182 Paul-Henri Cahier/Getty Images; P185 Paul-Henri Cahier/Getty Images; P187 Pascal Rondeau/Getty Images; P188 Sutton Images/Getty Images; P190 Sutton Images/Getty Images; P192 Ercole Colombo/Getty Images; P195 JEAN-LOUP GAUTREAU/Getty Images; P197 Oleg Konin/Shutterstock/Getty Images; P198 Paul-Henri Cahier/Getty Images; P200 Attila Kisbenedek/Shutterstock; P203 Steve Etherington/Shutterstock; P205 Attila Kisbenedek/Shutterstock; P206 Michael Cooper/Getty Images; P208 Mark Thompson/Getty Images; P210 Mark Thompson/Getty Images; P212 Paul-Henri Cahier/Getty Images; P214 Alexander Hassenstein/Getty Images; P217 Oliver Multhaup/EPA/Shutterstock; P218 Michael Reynolds/EPA/Shutterstock; P221 Gero Breloer/EPA/Shutterstock; P223 Gerry Penny/EPA/Shutterstock; P225 Roland Weihrauch/EPA/Shutterstock; P226 Toni Albir/EPA/Shutterstock; P228 Sutton Images/Shutterstock; P231 Clive Mason/Getty Images; P232 Hazrin Yeob Men Shah/EPA/Shutterstock; P235 Will Oliver/Pool/EPA-EFE/Shutterstock; P236 Bryn Lennon/Getty Images; P238 TOLGA BOZOGLU/POOL/EPA-EFE/Shutterstock; P240 AlessioDeMarco/Shutterstock; P243 NurPhoto/Getty Images; P245 ANTONIN VINCENT/DPPI/Shutterstock; P246 Cristiano Barni/Shutterstock; P249 ANTONIN VINCENT/DPPI/Shutterstock

ACKNOWLEDGEMENTS

I really ought to begin by thanking BP for getting behind *The Book of Motor Racing*, published by Stanley Paul in 1959 and edited by Maxwell Boyd, a motoring journalist and broadcaster. The fuel and oil company, as one of the few players in motor sport sponsorship, lent their name to a rare publication offering an insight to a sport that, at the time, was largely ignored by the media, certainly compared with the far-reaching standards of today's exhaustive reportage.

The cover of the hard-backed book carried a superb Michael Turner painting of a BRM P25, a Ferrari Dino 246 and a Cooper-Climax T51 hustling into the hairpin at Monaco. The text inside detailed the drivers and their cars. For this teenage fan, the book not only offered an escape from the drudgery of school homework but it also instantly generated exhilarating memories of the first visit to a Grand Prix at Aintree in July 1959. Despite the diversity and colossal advance in accessible information since then, it would be lovely to think that, seven decades on, the book you have in your hands might bring a similar welcome diversion.

I am grateful to Gerry Breslin, Craig Balfour and the team at HarperCollins Publishers for expertly bringing this book together in such a beautiful way. And, as ever, to my literary agents, David Luxton Associates, for making it all happen so smoothly.

A special thanks to Martin Brundle OBE for taking the time to add his valued words in the Foreword. And to Oliver Owen for recreating our days on The Observer when, as deputy sports editor, he looked over my shoulder and kept me on the right track, both in a racing and grammatical context. Thanks, also, to Ross Brawn OBE for helping with one of the many extraordinary stories it has been a pleasure to relate.